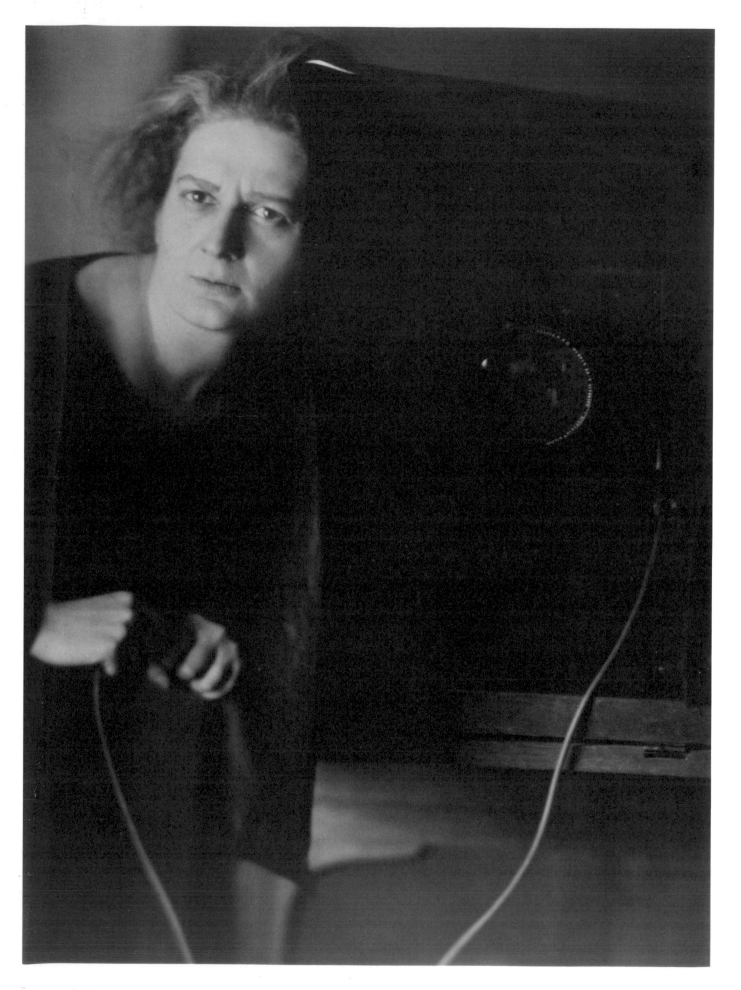

LOTTE JACOBI, Self-Portrait, Berlin, ca. 1930.

LOTTE JACOBI

Lotte Jacobi (signature)

EDITED BY KELLY WISE

ADDISON HOUSE

Danbury, New Hampshire

ISBN-0-89169-029-8 Library of Congress catalogue no. 77-91430 — hard
ISBN-0-89169-045-X — soft

Typeset by Wrightson Typographers, Inc., Newton, Massachusetts
Printed by Thomas Todd Co., Boston, Massachusetts
Designed by Carl Zahn

TO MY SON, JOHN FRANK HUNTER,

AND TO THE MEMORY OF MY HUSBAND, ERICH REISS

Foreword
and
Introduction

Foreword: Gentle Persuasions and A Benign Predator's Eye

KELLY WISE

A dragonfly plodding against the wind. That is how I felt a number of times during the year it has taken to sift out the pictures for this book, box after box. Contact sheets wrinkled and yellow with time. Negatives for which there are no longer contact sheets. Stacks of glass plates. Vintage prints and prints with no seconds or negatives—a handsome one of George Grosz painting. Newspaper clippings, postcards, and posters. "Over ten thousand pictures," Lotte had said when I began, and as I was to remember, she rarely resorts to hyperbole.

By memory, a ritual is enacted. A head of immaculate white silk, etched above sage and merry eyes, twists towards me. The lips pinch. "There's more," Lotte says with quaint sauciness. Off we trudge down from the studio, past a wood stove and the library of signed and cherished books and unanswered correspondence, up a passageway choked with cartons of crystallized honey to the kitchen, then through the workroom to a narrow storeroom at the rear of the house, where the cache of pictures is kept. Stacks of foreign-made and Kodak photo boxes reach to the ceiling, and opposite them stands a filing cabinet in whose disheveled middle drawer one afternoon we found the lovely night shot of a misty Berlin street. Names in heavy black ink ogle from the sides of the boxes: Einstein, Auden, Dulles, May Sarton, London, New York, Annemarie Renger, Thomas Mann, Asia, Peter Lorre, Hamburg, Eleanor Roosevelt, Theatre, Stieglitz, Henrietta Szold, Dance, Lotte Lenya, New Hampshire. At last, after a muttering rummage, the correct box is found, and in the dreary light we squint at something new.

Much of her work was lost, abandoned forever when she left Germany in 1935. Thousands of glass plates, countless files of negatives—reluctantly in 1930 she switched to negative film, though it "buckled in the camera"— and scores of finished prints. A half year later her mother arrived, bringing what she could. "It seemed a slew of glass plates and negatives at the time," Lotte recalls. "But afterward I realized all that was missing." A scant portion of her work crossed the Atlantic, and try as she has over the years with letters, pleas through family and friends, and leverage with European newspapers and publishing houses, none of that orphaned work has been retrieved. "Absolutely nothing," she reports matter-of-factly. But had she remained in Nazi Germany, she would have been squeezed out of photography, and "eventually I would have ended up … somewhere else." That *somewhere else* readers of Bernard Malamud and Elie Wiesel know all about.

The legacy that was legitimately hers she fought. At first she dreamed of an acting career. At eighteen, she was told by a German director that she could join his troupe if she signed on for three years. She had, he noted, a "slight lisp," but it should not be too difficult to overcome. In preparation for her new career, she studied with a well-known actress, and in three weeks Lotte had mastered the appropriate pauses and flair. Such quick assimilation troubled her—perhaps a stage life would be drudgery—so promptly she "gave up the whole venture." She has had other thoughts of other professions—beekeeping, gardening, farming—"I wanted to be a farmer's wife too," she says with mischief, "but I couldn't find a farmer." Yet she always has wandered back to photography. "It's my life, only I had to rebel against it." Then with a flick of her neck she turns fully to me. "I was to be a photographer and that was that. It did everything for me. I love people. I needed the camera more than ever I would have believed."

Surely Lotte is an acknowledgement that clarity and spunk need not be relinquished to age. She is over eighty now; the body works more slowly, she complains, but the pulse of her vigor and imagination and the energy to conduct an absorbing and rich life can still be felt. Perhaps what best I have learned in working closely beside her will translate but thinly into words. It has to do simply with the alert integrity of her approach and her deep affection for life in every form.

"My style is the style of the people I photograph," she explains. "In making portraits, I refuse to photograph *myself,* as do so many photographers." A bright, sturdy woman, she hoards knowledge like the honey from her beehives, shunning intellectual clap-trap and aesthetic sophistry of any kind. The bees sing about her home and fatten on the buckwheat planted solely for them; grosbeaks, finches, and orioles dance about her feeder as though on strings. Her approach to living is as unpretentious as her approach to the people she photographs.

While taking a picture, the photographer, Lotte believes, should scarcely be conscious of design. It comes from within and must never be foremost in one's thoughts. "I was born with it," she quips. "I never think about design; it comes automatically." In some of her portraiture, as James Fasanelli signifies, design is up-front. This is especially true in the theatre and dance work; *Head of A Dancer* is a powerful and classic example. In many of her other pictures, design is not imposed upon the subjects, but emerges naturally from them. We get the impression that her subjects are not urged to sit this way or that, to smile, leer, stroke their beards, look sultry or mellow; rather, the camera is placed serenely before them, and the photographer watches as they assume their false or true postures. (By postures, I intend attitudes of both body and mind.) "Sometimes I don't say anything," she explains. "I just set up the camera and then if they ask what they should do, I may say, 'oh, whatever you like.'" Wait and watch, we can hear her counsel herself. Exchange amenities, relate an anecdote from the past. "I wait them out, and finally they change if they are not right at first. Unless they show themselves best immediately, as some do, before they have had time to consider the camera."

Small wonder that she has used artificial light so gingerly; it has a way of beckoning the unnatural. A view camera, natural light, large negatives, exposures that depend upon a tripod—these are her chosen accomplices. In her working mode can be recognized a discipline. "Preconceived ideas" that might be pulled over the subject like a new coat are forbidden.

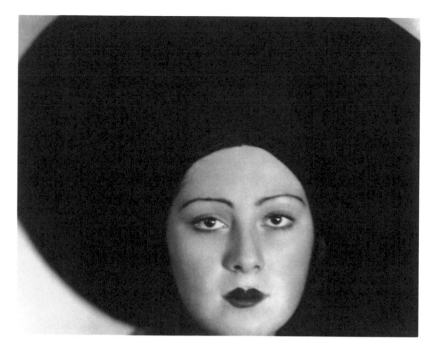

Head of a Dancer, Berlin, ca. 1929

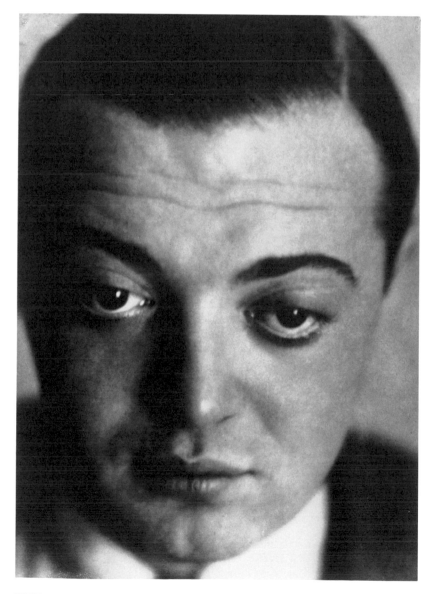

PETER LORRE, Actor, Berlin, ca. 1932

A portrait, we say. "Now there's a nice portrait of Roland." What distinguishes a picture of someone from a portrait of that person? Is it always the willingness of the subject to pose, the open consent of self? The impression of "Well, here I am," or "Last month I sat this way and we made this picture?" The contours of familiarity. Is the position of the body crucial? The eyes? Historically, the idea of portraiture carries with it unwieldly equipment, long exposures, and people straining to hold a flattering pose — or in modern times multiple lights, sophisticated cameras, assistants scurrying about an Eamesian studio. To its origins we trace formality and sobriety. No wind-swept hair and few broad-toothed grins. Generally clothes are formal, indicative of the subject's profession. And the likeness is "good" if the portrait corresponds to our knowledge of the subject or his store of postures.

At times a snapshot, something taken on the run after one of our periodic ceremonies of life — a reunion, a wedding reception, a golden anniversary party, the closing night of a play — presents itself as a portrait. At least someone may be provoked to comment about its aptness as a portrait. But then that praise may be undercut by the regret that there is a dark gravy stain on Aunt Harriet's blouse or the pet Afghan Hound has bumbled into the picture. Yet we know that certain snapshots taken hurriedly and without forethought have become enduring portraits.

Between subject and portraitist there is an implicit contract. The end of their collaboration will not be unflattering; different perhaps from what either might expect, but surely not a disparagement of the subject. Probably most often without words, like strangers who choose a slow but ephemeral dance together, they grope through matters of pose, control, distance, mood, and lighting.

A problem of control arises when photographing certain celebrities who zealously guard the kinds of images by which they are identified. Should a picture made during a sitting fall outside the normal expectations of the subject be considered also a portrait? Commissioned portraits that hang in homes and offices are those certified by the subjects. We know that other products of a shooting session may be more prized by the photographer, and eventually even some may gleam like jewels in galleries or within the pages of a book such at this (here for example, portraits of Minor White, Henrietta Szold, and Peter Lorre). But a portrait of a celebrity. What is it that attracts us? Is it the discovery of a facet of that personage as yet unseen? *Ah, she is also feisty, tentative...vain.* For some, I suspect, the portrait allows a reminiscence of a bygone hour or day. The touching nostalgia of the film "The Last Picture Show." An image to corroborate the validity of a lost moment. Our admiration may also embue it with an idiotic or maudlin power, for unmistakably some corny and sentimental portraits abide with that sanction.

And from whose perspective is the portrait to be measured? The subject wants a flattering likeness. The photographer, an image that is memorable, unique. The viewer. Certainly identification (Einstein's hair thrust up like grey, absorbent cotton; the sadness and delicacy of Lorre's eyes), the pleasure of an intimacy, the memories that attach to a name, period, a moment in time when that personage was of special consequence in one's life. And perhaps much, much more. To the viewer the aesthetic quality of

a portrait, its pull upon the mind, is not always correspondent with its private and emotional quality.

Alcohol evaporating in the hand. When does a person slip out of customary postures, the wardrobe of the familiar? Is a portraitist to be judged upon the record of a characteristic likeness or upon the capture of a startling new face? It has been alleged that some portraitists can penetrate the exterior layers of their subjects and like magicians evoke unseen mysteries of being. Glib contention, at best. Human personality is too multiform and individual for even the most alert or accomplished portraitist to hope to catch its definitive revelation. We all have unguarded moments, privacies beheld only by the angels. Forms, postures, faces — whatever we term them — that we may assume during these moments are simply unknown to others until they are surprised with a click of the shutter. For what indeed is the true self? Something minted by human longing? A fabrication of photographers who seek a misguided but ideal form? A portrait may become definitive to our minds — I think quickly of Yousuf Karsh's fine Ernest Hemingway or Georgia O'Keeffe — but that is only an indication of our preference, nothing else.

Let us be honest: every portraitist is limited by his methods and the conventions of portraiture. Those spots of artifical light sculpting the face (Karsh), the problem of positioning the hands, the caricature that can result from a rigged profile (Karsh again), the obsession with environments (Arnold Newman), the concern about skin texture and make-up (Francesco Scavullo), the fear in the gut of appropriating the ordinary (all artists).

Newman, a celebrated portraitist, has a distinctive style, unequivocally *haute couture*. His work exults in stratagems of art. Often he relies upon props, staged environments, and symbols. Although his subjects may be encouraged to participate in his invention, there are many instances in which they are dominated by him. An aggressive frontality exists in much of his portraiture, a product of cutouts, dark clothing, and occasional suppression of the middle range of photographic tonalities. Sometimes his subjects look like faces tacked to a backdrop. As with the portraits of Willem de Kooning, Adolph Gottlieb, and Franz Kline, the subjects peek through a tear in a paint-spattered drape or appear as semi-dark blobs in abstract paintings. Everything, subject and drape or painting, crowds to the edge of the portrait. Newman is fond of incorporating the natural surroundings and props of his subjects in the picture (the White House for John F. Kennedy; a Russian newspaper for Harry Schwartz, *New York Times* expert on Russia) and then gathering the whole together in a bold, frequently imaginative design. Telltale symbols flit through his portraits; a teapot and curtains (Grandma Moses), a glowering chandelier (Andrew Wyeth), and blurry smoke like the trail of a jet (Max Ernst). Some of his most memorable portraits, however, are bereft of props, supportive environments, and symbols — those of Pablo Picasso and Arnold Toynbee — or they use the environment principally as the subject's space and not as an emphatic element of design.

Partly because of her freedom from preconceptions and also because she has taken little from the work of other portraitists, Lotte's portraits have a fresh, less adhesive trademark. Certainly they are more terrestrial and not so elaborately fictive as some of Newman's. Some even set themselves up

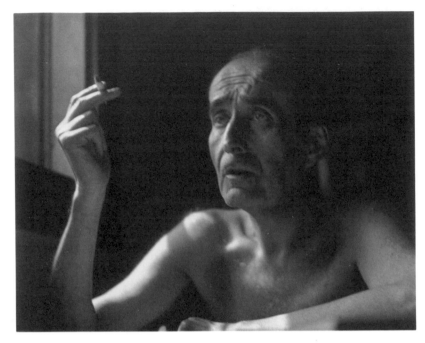

ERICH REISS, Publisher, Deering, N.H., 1950

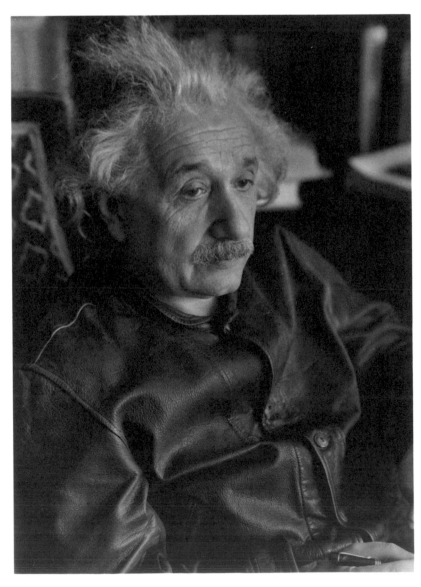

ALBERT EINSTEIN, Physicist, Princeton, N.J., 1938

10

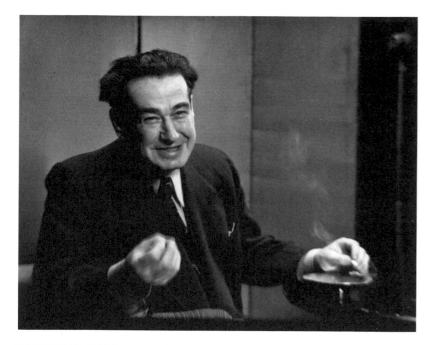

EGON ERWIN KISCH, Journalist, Berlin, ca. 1930

as snapshots and informals. Most often she avoids the slick charisma of a magazine portrait. ("The people at *Life* didn't like me," she delights in recalling. "I told them off several times!") Her Robert Frost simply lounges in his study or ambles about the farm, a man who will soon invite her to join him for a chat and ginger beer. Her Marc Chagall is a father unabashedly proud of his daughter. Though I prefer Lotte's portraits of these subjects to those of Newman, the point is not that Lotte's work is better, but that the working concepts are disparate. At times, a parakeet, a cane, or an easel will appear, but generally props and environments are incidentals. Seldom is there the impression that anything has been contrived to enhance the portrait, nor do we infer unforgiving strictures about focus or the position or distance of the camera, as we may with other portraitists. Gentle persuasions and a benign predator's eye hold sway in her work.

Lotte maintains that for her there is no difference in photographing men or women—perhaps no difference to her in approach to the sexes, but decidedly there appears a difference in the result. Whether they peer openly at us or choose to reveal themselves more obliquely, her portraits of men are among her choice creations. Einstein, Casals, Albers, Planck, Karow, Lorre, Nurmi, Hölz, Grock, Reiss, Steichen, Robeson, Dreiser, Liebermann, Chagall, Kisch, Frost, Valentin, Lederer, Nearing, Stieglitz, Renger-Patzsch, Scharl, Granach, Michoels, Siskin. Something grand or unique or playful has been discovered by Lotte or offered by the subject in the presence of her camera. Her willingness to observe rather than to direct is clearly evident. The ease and accessibility of these portraits are deceitful. They last for us because they are animated by the spontaneous, the unrehearsed, the human.

In many of these portraits, we sense that the subjects are caught slightly off-guard. Dreiser really is vulnerable but unbowed at his age. Einstein and Reiss, one in leather jacket, the other stripped to the waist, in exquisite moments, are lost to this world, absorbed. Note that in the gag portrait of Valentin and Karlstadt, only one of the duo is ready for the photographer's quick perception. A very democratic mind is at work here, one unawed by the great and famous. (Don't they get dressed each morning like the rest of us?) Lotte refrains from elevating them; their blemishes are not secreted by make-up, nor are camera angles, props, or environments devised to exaggerate their importance.

End of ruminations about portraiture. An indulgence prompted no doubt by narrowness and condescension in some quarters, for in all the ballyhoo about the art of photography today, an elegant and alluring portrait of a human being, one with sinews of emotion and substance, is astonishingly undervalued.

From a great grandfather forward, the male lineage of photographers behind her cannot be discounted. The work of Alfred Stieglitz, Paul Caponigro, Otto Steinert, Albert Renger-Patzsch she admires (admittedly, that of Berenice Abbott and Barbara Morgan, too). Books by Loren Eiseley, Robert Frost, and Heinrich Mann enjoy special niches in her library. It was Otto Steinert and Renger-Patzsch, fellow German photographers, who provided her with her first significant patronage in the European art world. Steinert included her in a widely viewed group ex-

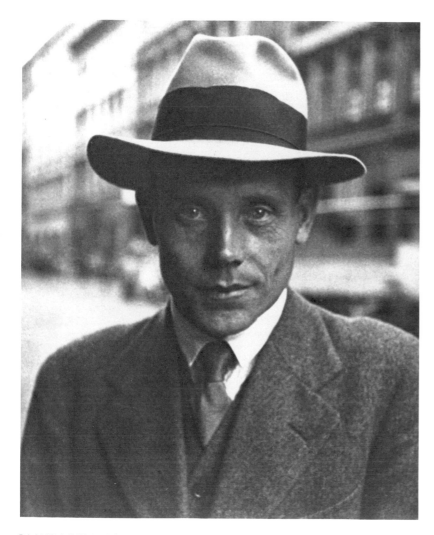

PAAVO NURMI, Olympic Marathon Runner, Berlin, 1930

hibit at the Museum Folkwang, Essen, in 1970; four years later he staged a large exhibit of her portraits at the same museum and published with it an illustrated catalogue. Renger-Patzsch, influential in publicizing her work, spoke of "loving Lotte's portraits," but was put off by the photogenics. In America, Minor White, editor of *Aperture*, was also helpful. He published a number of the photogenics in an issue of *Aperture* (1962) and later included her in his well-known group shows at Massachusetts Institute of Technology, but he showed only minimal interest in the portraits. In their preferences, both Renger-Patzsch and White were true to their private aesthetics.

One man has been most influential in her life: Erich Reiss, a German publisher, whom she married after he came to New York. For years in Berlin, though they had mutual friends, the Kisches, they avoided each other. Egon Kisch, the journalist, tried to introduce them. "One day Kisch and I were talking in his study, and he mentioned that he had to meet with his publisher. He insisted that I should join him and finally I agreed. I had heard of Erich before, many times, as he had heard of me. When Mrs. Kisch came in and announced that Kisch should change for the meeting, I said, 'Well, if Kisch has to dress up to see Mr. Reiss, I don't want to go. What kind of man is this?' I know now that I jumped to the wrong conclusions, for I should have gone; it would have spared us some painful years apart. And I know that Erich Reiss wouldn't have cared at all if Kisch had arrived *without* clothes.... I didn't meet Erich that day; I met him later at a birthday party I gave for Kisch in New York. Kisch invited the guests, but Erich wouldn't come; he didn't like parties. That evening Kisch and another friend locked their arms through Erich's and dragged him out of a bus and to the party....I was 44 and Erich was 53 and suddenly there was love." Reiss, an experienced businessman, a man of pride, good breeding, and little rodomontade, took over the accounts and management of Lotte's studio in New York. "He really wasn't such a great businessman," she remembers. "But in comparison to me, he was a *genius*. He set things in order quickly."

It is to Max Brod, friend and subsequent biographer of Franz Kafka, that we owe the disquieting feast of Kafka's work. Erich Reiss has done a similar favor. The caustic, soft-spoken, prescient Reiss dissuaded Lotte from jettisoning the photogenics that she had created in their non-camera class with the artist and teacher, Leo Katz. The class had been arranged by Lotte to amuse and occupy the ailing Reiss. (Later Lotte would study again with her friend Katz, this time etching and drypoint, at Katz's instigation "to get your mind off Erich's death.") "Keep them," Reiss advised. "They are damned interesting." The study in photograms had failed to sustain her interest, so Lotte decided "to move the light around" and to experiment with glass, cellophane, and paper cut and shaped in odd ways. "The experience was a marvel," she says. "With the photogenics, I felt young again."

The photogenics are rich with her inventions. "They're more real than your others," Edward Steichen was to remark. Excitement clings indelibly to them. Sometimes so subtle as hardly to register on photographic paper, sometimes so jauntily masculine, at other times so aloof and coy and staunchly feminine. The play of light and unfettered intuition. These enchanting forms partake of human, animal, and floral morphologies. They are starkly different from her other work. Lyricism, reversals of form, metaphors of unut-

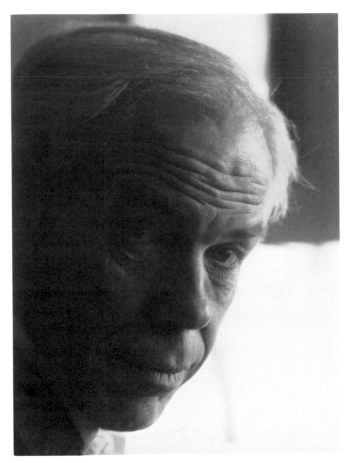

MINOR WHITE, Photographer, Teacher, Deering, N.H., ca. 1962

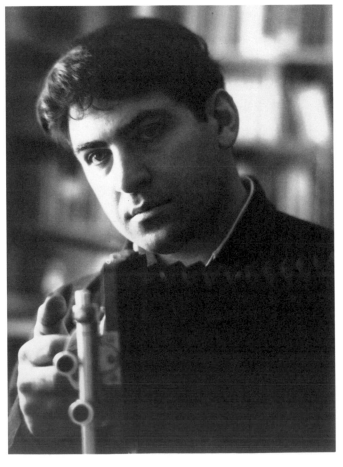

PAUL CAPONIGRO, Photographer, Pianist, Deering, N.H., ca. 1965

12

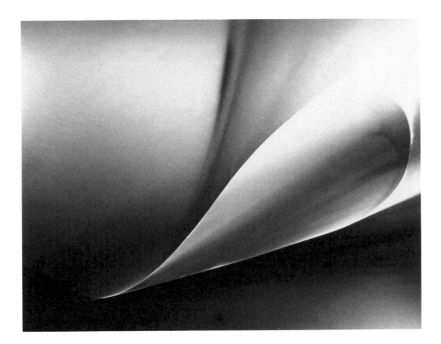

Photogenic, New York, n.d.

tered sentiment — a fragile lambence ignites them. To me, they are the expressions of the uncharted and bold depths of a resourceful woman.

Pictures, we have come to understand, can nudge us from our complacencies, warm our hearts, goad us to despair. Less and less these days do we encounter ones of strength that are also humanizing. A token of our preoccupied and ungenerous age, perhaps. Lotte's work in general and notably the photogenics draw me back to the wonder of art, imagination, the photographic process, the wild miracle of the eye itself. In them is something life-enhancing, direct, and unexcused.

To have photographed passionately for the past sixty years is to have amassed an enormous body of work. Most every picture in her possession I have seen. Wistfully she has said, "For another one," meaning for another book, when a favorite picture that did not fit the scheme of this book was laid aside. Various broad categories have been omitted: animals, flowers, Peru, landscapes, London, New York, Central Asia. She has given me full reign for which I can offer only a tip of the hat and warm thanks.

Of all those pictures in the storeroom, here is only a modest serving, but one fair, I hope, to the breadth and integrity of her vision.

Kelly Wise

September, 1978
Andover, Massachusetts

10/3

Drypoint, New York, 1962

13

LOTTE JACOBI:
Photographer

JAMES A. FASANELLI

Lotte Jacobi's great grandfather, Samuel Jacobi, visited France between 1839 and 1842 and obtained a camera in Paris, a license to commercially use it, and some instruction from Daguerre. The vaguest element in this legend of origins is the instruction. He returned home to Thorn, in West Prussia, where he had been a prosperous glazier, set up shop, and prospered more. His son Alexander, after whom Lotte and her brother were named, became a photographer upon leaving military service, eventually taking over the studio. He did better than his father. Alexander established his three sons in studios in different towns: Julius, the youngest, remained in Thorn, Franz went to Hohensalza, and Sigismund, the eldest and Lotte's father, moved to Posen, in 1898, when Lotte was two years old. Her family remained there until 1921, when they moved to Berlin after Posen became part of Poland. In Berlin, the Jacobis lived and had their studio in the heart of Charlottenburg at Joachimsthaler Strasse 5 where they stayed until 1932 when they moved, first to Kurfürstendamm 216 for about a year, and then moved to Kurfürstendamm 35, from which location Lotte departed in 1935.[1]

This is the family background of what might be called a "birthright" photographer, but there are no rights in art which are not earned, especially when art emerges from commercial circumstances. Sigismund Jacobi had more difficulty in establishing his children in his profession than did his father.[2] Lotte made her first pictures with a pin-hole camera (made to her father's specifications) in 1908-09, but her career began in the family studio when she returned from Munich, in 1927, upon the completion of her formal training there in the *Staatliche Höhere Fach-Schule für Phototechnik*.[3] She had already been married (1916), had a son, John (1917), lived through a World War and its aftermath, and divorced her husband (1924), after a long separation. She put her son in school in Bavaria in 1925 and went to school herself. Munich was good for her; she grew there.

Lotte was independent. She studied photography with Hanna Seewald but rejected the values her teacher stressed, like balance of tone and composition. There are two photographs Lotte showed Seewald which document a minor trial in her education. Both are of landladies photographed at the end of Lotte's stay in Munich and date, therefore, from the summer of 1927. The first, *Landlady I,* is softer, tones are generalized, massed and balanced, more three dimensional, while the second, *Landlady II,* a more uniformly clear and severe print, is more linear, grey, and flatter. The first had the approval of her teacher and the other did not. The student preferred the second for its honesty and lack of commentary upon the subject (the first resembles now the kind of formula one associates with studio portrait photography). Neither of Lotte's prints approximates Seewald's own work, an example of which is the painter Max Colombo, of 1928 (p. 21), which in technical complexity was probably beyond the student at this stage of her

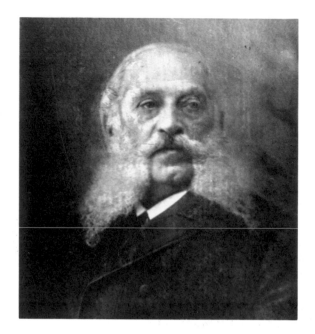

SAMUEL JACOBI, great-grandfather

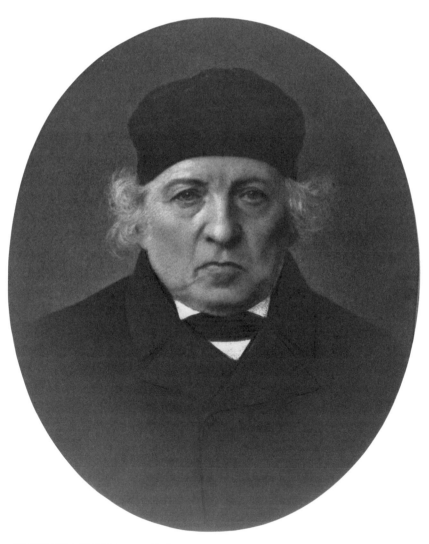

ALEXANDER JACOBI, grandfather

development, but we may assume that this soft artfulness, so current at the turn of the century (Annan, Coburn), was rejected also.[4] But Hanna Seewald's work may have represented something in art Lotte accommodated to later on in Berlin on her own terms, for her portraits there often mirror in style and composition the art her subjects practiced and stood for. Lotte remained a loyal friend to her teacher. These two student pictures of Lotte's represent poles between which her work vacillates for the rest of her life.

Her work in cinema in 1926-1927 allowed for experimentation beyond that offered by the more formal and restrictive training in photography. When asked, years later, what she had learned from working in film she replied, "It taught me to work fast." She made four films then, two of which were about friends in Munich she admired.[5] The most important of these was a *Portrait of the Artist*, a theme that would have abiding interest for her, whose subject was Josef Scharl, whom she met in 1926.

Lotte's picture of him, *A Portrait of Josef Scharl* (p. 22), made shortly after they met, is a better indication of her work as a photographer than the two pictures she made for her teacher. Her picture of Scharl is a warm record of their friendship and pays homage to the influence he had upon her. Scharl made Lotte aware of the culture of her own time, especially its criticism and art. He introduced her to the writings of Karl Krauss, whom she would later meet and photograph in Berlin. If Scharl did not open her eyes to modern art, he heightened her awareness of it. This picture of him is comparable to the work of other professional photographers of the time, for example, August Sander's portrait of *The Composer Paul Hindemith* (p. 22), also of 1926.[6] Both Lotte and Sander observed the same preliminary conventions in portrait photography. Scharl and Hindemith strike similar poses, both look directly into the camera, and both suspect the intent. The pictures are different not only because the relationship between the photographer and the subject was totally different but also because the prints were made differently. The Sander print was developed so that darker tones of jacket and trousers would fuse and flatten out, converting bulk into distorted mass, isolating the head and face against a neutral background above collar and bow tie. Hindemith is a man reluctantly sitting for his picture on a three-legged chair. Scharl waits indulgently. His print was developed so that his thin, lithe body would flow within the space of the picture. The background is blurred and there is a soft tonality over the whole surface. He is as flexible as his hands. He sits securely in one corner of the picture on an unknown support, but we hardly notice this. To Golo Mann, Sander's achievement was in capturing "types" which were largely self-conceived, the subjects being utterly serious about themselves, static, and humorless. This may be true, but it is not the whole truth. Both photographers used the same conventional tactics for contrary reasons. For Lotte a pose or gesture was an excuse for getting a subject to reveal himself. For Sander the conventions, as much as the subject, make the picture.[7] No one would question the veracity of Lotte's portrait of Scharl.

From around the Munich period, photographs of Lotte's come forth whose professional character points to the future. The *Odenwald* (p. 19), made in Spring of 1928 while her son was at school there, is a landscape where a small, young tree, just before bloom, stands out against the simplified forms of land, forest, and sky. The picture is tilted so that all, even the building,

must conform to the tree's axis. It is the pulling force. There is more here than the unity of *Kunst und Natur* (the subject of many photographic books on nature at the time), a lifelong ideal for Lotte.[8] She is more symbolic in this period than she is later on. *A Church Interior in Bavaria* (p. 19), made earlier in 1924, reveals a grasp of the fundamental importance of light in her art, not as a symbol alone, which it may be called in this instance, but as a defining element to be revered in its own right. The picture of the dancer, *Claire Bauroff* (p. 153), made in Berlin in 1928, is more purely about form, movement, and light. The sensual figure and her shadows move past poles of cast shadow which zone the pictorial field, at once accelerating and arresting her movement. Light repeats form and creates a sequential commentary upon itself. In her most abstract pictures, called *photogenics*, light is free to "develop its own art," as she once put it, but these pictures come later.

Munich crystallized qualities in the work of Lotte Jacobi that would sustain her career for the next half century, first in Berlin, 1927-35, then in New York City, 1935-55, and in New Hampshire, 1955 to the present. Although all kinds of pictures were made throughout her career, each period had its own character and may be typified as follows: Berlin, theatre and art; New York, celebrities and abstraction; New Hampshire, freedom and nature.

Berlin

Berlin in the twenties was a dazzling cultural capital. The Jacobis' move there coincided with a cultural migration to the great city drawn from all over Central Europe. "The city drew strength from its illustrious immigrants and in turn gave strength to them," Peter Gay writes. "To go to Berlin was the aspiration of the composer, the journalist, the actor; with its superb orchestras, its hundred and twenty newspapers, its forty theatres."[9] The brilliance of this world is reflected in Lotte's photographs. Part of the family business was the supply of pictures to many of those newspapers of celebrities and events, not only from the realm of theatre and art, but from science, government, literature, criticism, even the military.[10] Photographing artists in the theatre fulfilled a long-standing interest for Lotte, and she seems to have specialized there, extending that interest into concert halls, dance, and eventually film. To further her work indoors, and photograph without flash, she bought a special camera, an Ermanox, 9 x 12 cm., in 1928-29, of which only nine were ever made.[11] She came to know many of the famous people she photographed: Einstein, Kurt Weill, Lotte Lenya, Anton Walbrook (who came to the Jacobi's aid in 1933), Brecht, Käthe Kollwitz, the Pechsteins. Lotte remained an incurably curious observer, developing her art while she looked at all kinds of people and things. Her *Self-Portrait* frontispiece, made about 1929, is probably a truthful image of the way she felt about herself in her profession at the time. She seems overwhelmed by the task at hand, as she probably was at the beginning by work in the studio and the exciting life outside.

Her portrait in action of *Moholy-Nagy on a scaffold* (p. 149), directing camera work with other associates, was made in the Nollendorf Platz Theater where the film being made was to be used as part of the set during performances of Walter Mehring's *Der Kaufmann von Berlin*, produced by Piscator in 1929. The desire to report truthfully about how art was

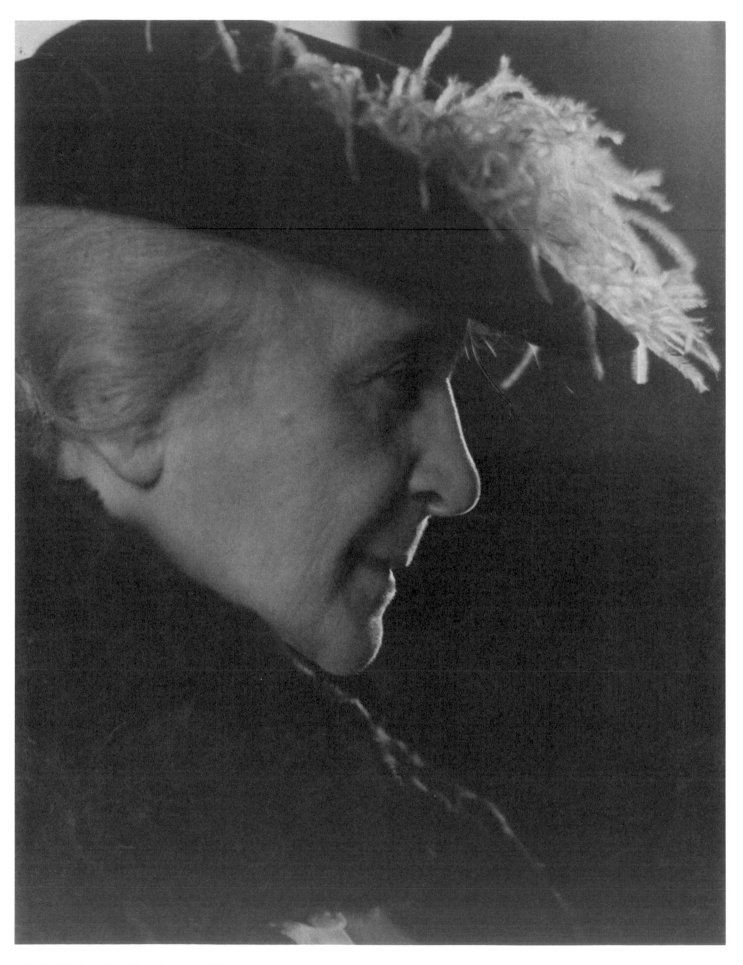

MIA JACOBI, mother, New York, ca. 1940 16

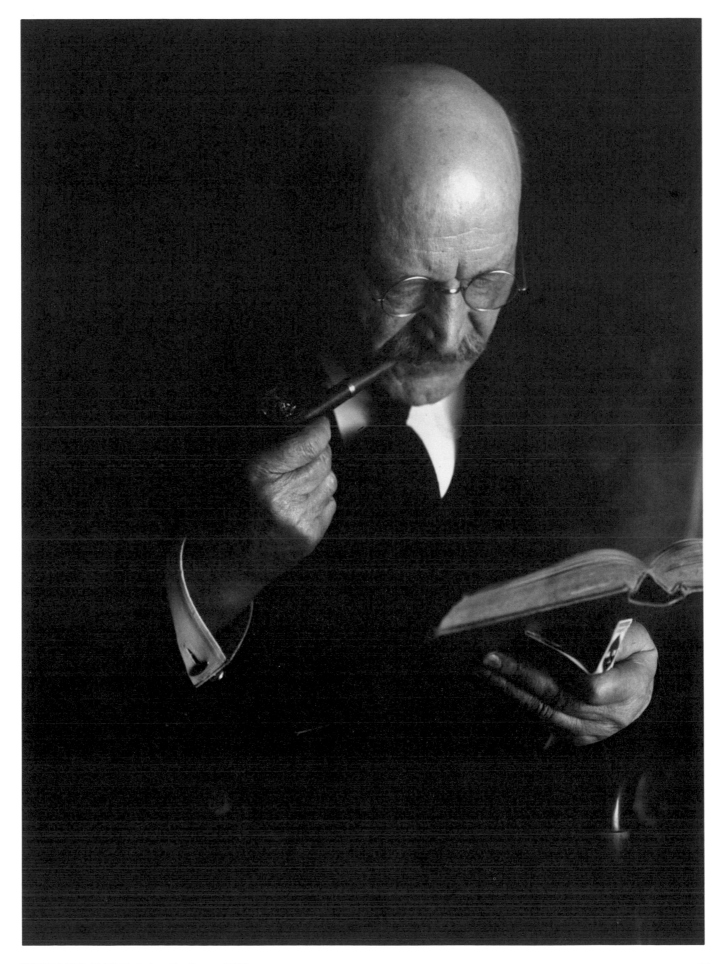

SIGISMUND JACOBI, father, Berlin, ca. 1930

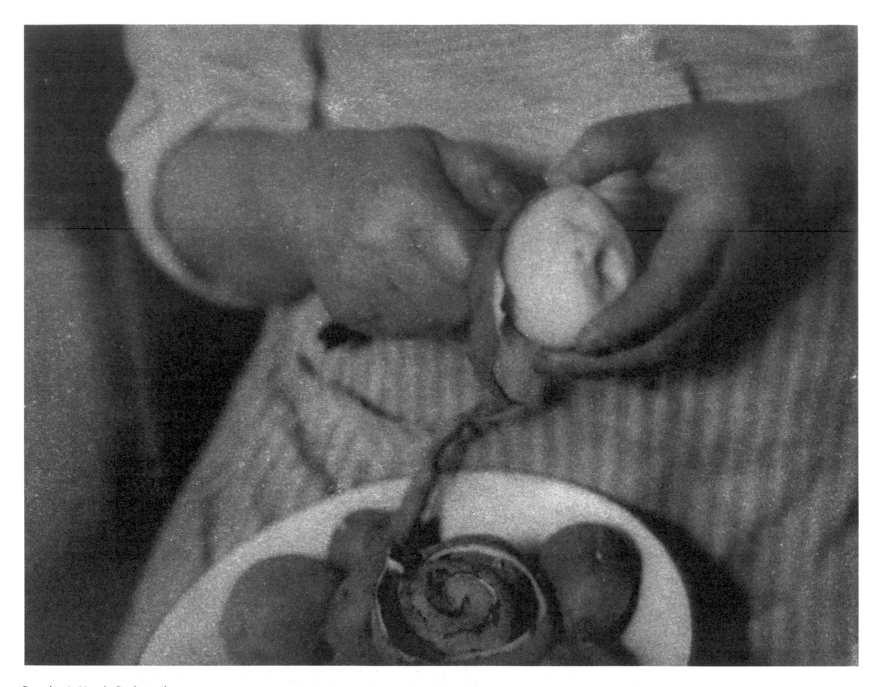

Bemchen's Hands, Berlin, n.d.

made, how people look when they work together, how they are, not as symbols but in fact (at an intense moment within their own world, not one separate from them as in the case of *expressionist* images) is represented by this picture. These aims coincide with a new impulse in art at the time, *neue Sachlichkeit* (new objectivity), some of whose values Lotte seems to have shared, although it is difficult to place her in the movement.[12]

"Every photographer should start working with a large camera," Lotte recently advised students, so that one might become "used to seeing the image on the groundglass." This was her own experience in the family studio, and her remark documents, beyond her intent, a genuine stylistic concern in Berlin where she translated ideas derived from painting into photographic terms. There are few of her pictures as stylized as the *Portrait of Lotte Lenya* (p. 139), or as relatively free of artful composition as the *Portrait of Käthe Kollwitz* (p. 36). Both are style-conscious. The first represents an absorption of geometric ideas borrowed from modern painting (French as well as German), while the second pays homage to a noble woman who was also a great artist and to her art, which is direct, strong, fully disclosed. All style tends to mask reality. The circumstances help to explain why the pictures look as different as they do. Lotte Lenya was photographed on stage in the midst of many other photographers during a break in rehearsal for the first performance of Brecht and Weill's *Dreigroschenoper*, in 1928.[13] The photographer and her subject were friends, but there is no hint of this in the picture. The abstract style of the portrait, so like a mask in composition to fit the mask-like face, was the result of theatrical conditions, the actress's own art, a realization of the possibilities of composition with the camera, and some fatigue. Käthe Kollwitz was photographed in the studio for a magazine, *Die Schaffende Frau*, in 1931. She came wearing a lace collar and most of the pictures were made with it close around the neck. Toward the end, Frau Kollwitz reluctantly removed the collar. The monumental image that resulted is almost without formal design in contrast to the picture of Lotte Lenya, but informality here is deceptive.[14]

Sophisticated design and composition served as vehicles of emotional expression however muted. The heavy-lidded, expressionless visage in the *Portrait of Franz Lederer* (p. 39), seems weighed down by its very elegance, the dark derby hat and the vertical bands of light and dark which rise above and behind like a scale of values. In this case, we are not looking at a "stage portrait," as familiar as Lederer and his type of role was to a German audience. The picture was made in studio shortly before the actor left Germany for Hollywood (c. 1929). Behind the somewhat decadent face in this handsome design was apprehension perhaps, and even sadness, with which the photographer could sympathize although she herself had not yet thought of departure. There was no one Lotte ever photographed whom she loved more than Bemchen, who had been a second mother to her and the family cook from the early days in Thorn. There is a portrait of her which is almost pure idea, called *Bemchen's Hands* (p. 18), made in Berlin without date, that is a combination of design and simple act. We look into Bemchen's lap while she peels potatoes. To Lotte, Bemchen was *A Simple Heart* who did everything right without effort. In the picture we do not see her face. We look into a frame of care, love, and perfection cast in a compelling design.

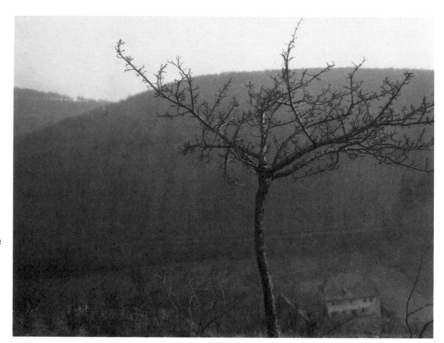

Odenwald, Germany, ca. 1928

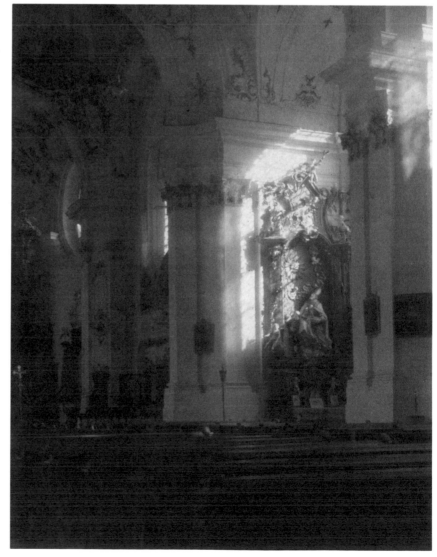

Church in Bavaria, Germany, 1924

19

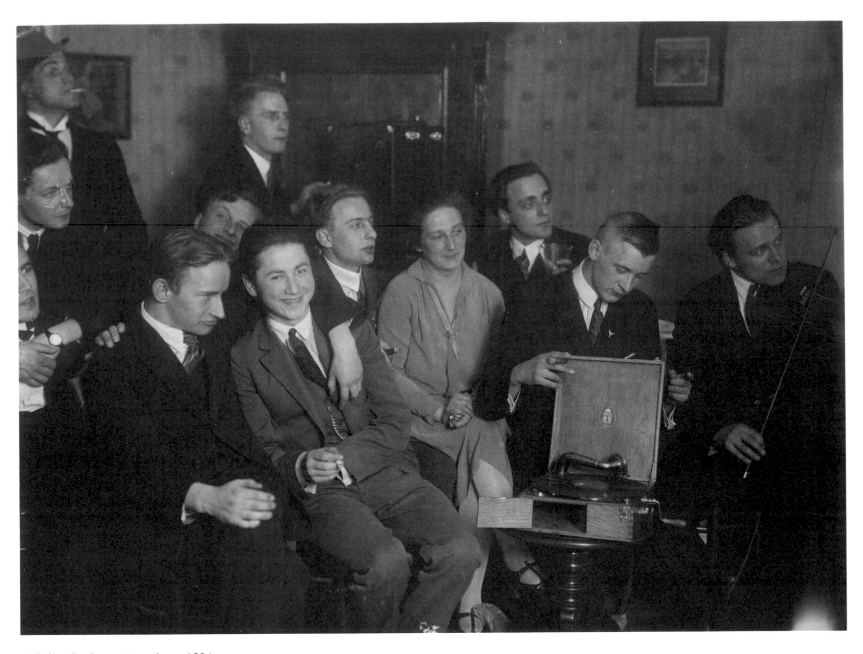

With the Film Group, Munich, ca. 1926

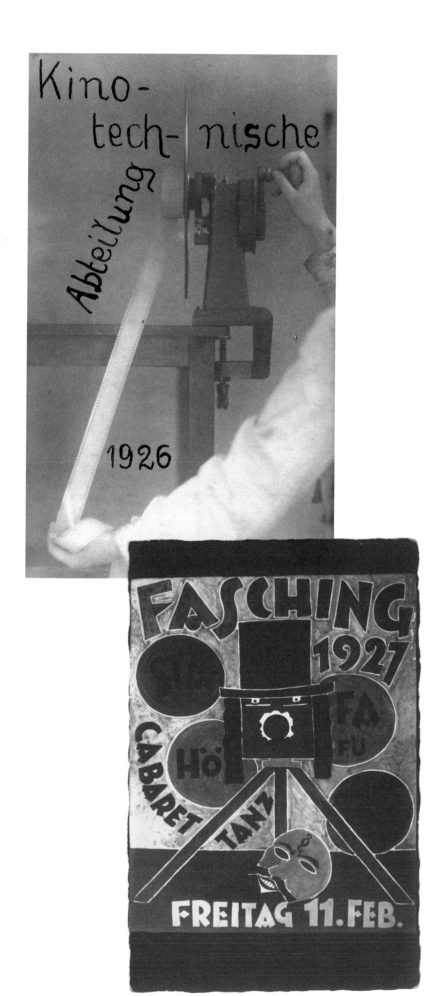

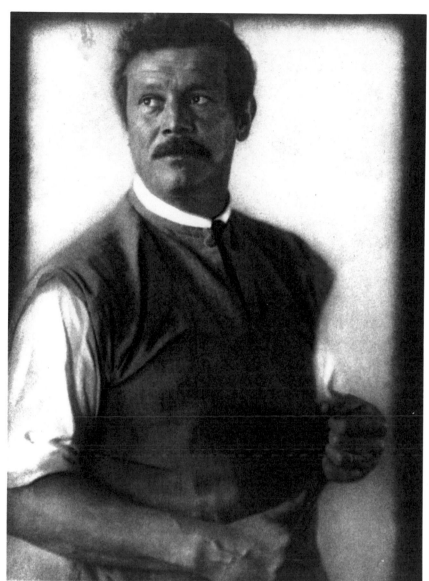

Hanna Seewald, THE PAINTER MAX COLUMBO, 1928

Mementoes from Munich days, 1926-27

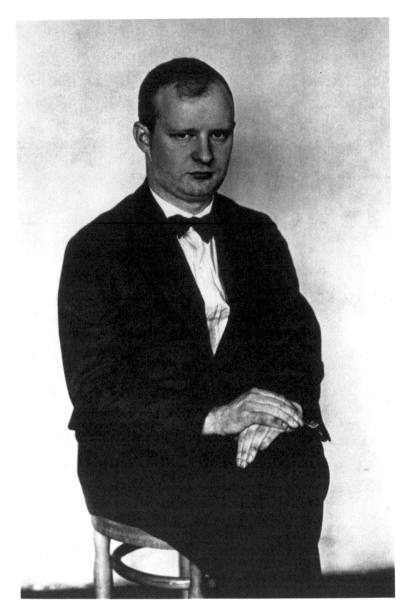

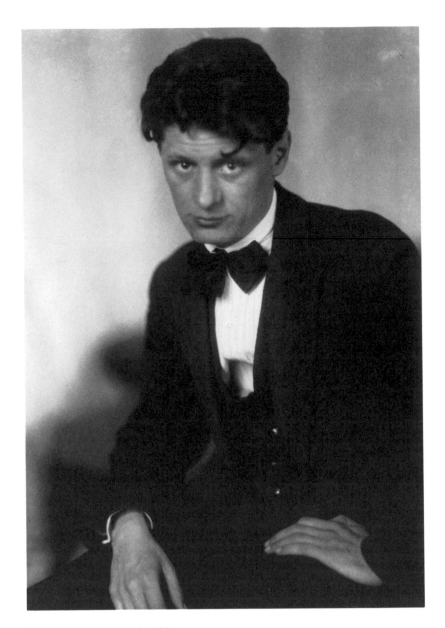

August Sander, THE COMPOSER PAUL HINDEMITH, Cologne, 1926

JOSEF SCHARL, Munich, 1926

By 1930 the character of life in Germany changed, the "golden years" of the twenties were over, the economic depression touched everybody, and the politics of the country had become alarmingly polarized. The rise of Nazi power in the elections of September 14 was ominous. Lotte's work shows little of this upheaval but she was affected by the tide of events. In the elections of March 13, 1932, when Hindenburg got over eighteen million votes and Hitler over eleven, Lotte made photographs for Ernst Thälmann, the Communist candidate for President.[15] She made more pictures for him than he or his party could pay for and rather than press for payment, Lotte suggested, half in jest, that Thälmann arrange a trip for her to Russia. He did. She left Berlin in September, returning early the following year. Most of her time in the Soviet Union was spent traveling in Central Asia. She responded to the people and places she saw in the provinces of Tajikistan and Uzbekistan as if they were out of the *Bible* or the *Thousand and One Nights*. The corpus of her work in this brief time of four months (Oct. 1932–Jan. 1933) is like a travelogue covering a wide range of subjects, people, cities, ancient customs. She easily monumentalized portraits as in the case of this *Tartar Head* that looks like the kind of shot one would find at the beginning of *Alexander Nevsky*, Eisenstein's great film (1938).

Hitler came to power January 30, 1933. When Lotte returned in Feburary she found the new location of the studio undesirable, and they moved to Kurfürstendamm 35 in October. But securing a better location in Berlin was was the least of their troubles. The part of their business that supplied photographs for publishing houses now needed an Aryan name.[16] The truth of their jeopardy was inescapable. What held up departure from Germany was the illness of her father, but when Sigismund Jacobi died in March 1935, they made plans to go, Lotte and her son John, leaving on September 1 or 2.[17]

New York City

Kodak in London had arranged with the British Home Office for permission allowing Lotte Jacobi to practice commercial photography in England. All plans were to remain there. But Lotte had a visitor's visa and a return ticket to the United States, so after three weeks in London, England, she sailed for New York where she arrived on September 29, 1935. She wanted to see the country where her grandfather had lived and that he loved so much. After a short time, she knew she would stay. As if in confirmation, she photographed American Indians the first day here during ceremonies of their own departure from Manhattan to Upstate reservations. She made these pictures, as an innocent observer, since she did not know what the ceremonies were all about until later.[18] She would not use the other half of the ticket for nearly thirty years.

Life was quickly established along familiar lines on west-side, mid-town Manhattan. Lotte opened a studio with her sister Ruth on the corner of 6th Avenue and 57th Street in October 1935 and then flourished in a succession of studios on her own, finally settling in 1941 at 46 West 52nd Street where she remained until she left the city in 1955.[19] Soon Lotte was selling pictures to publishers. She became a celebrity; a refugee witness of German culture before the Nazis. Her pictures appeared in the Sunday sup-

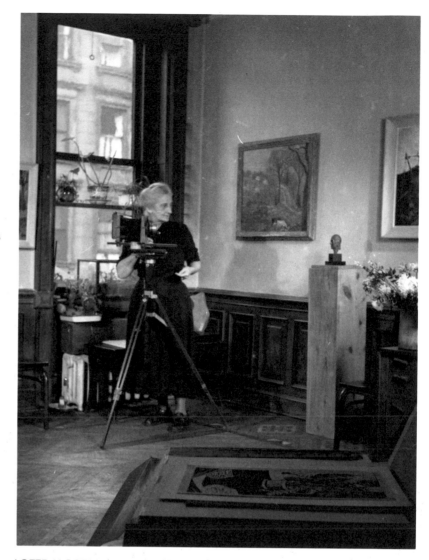

LOTTE JACOBI in her studio, New York, photo by Frank H. Bauer, 1955

plement of the *Herald Tribune* shortly after her arrival.[20] She was the first woman to photograph on the floor of the New York Stock Exchange before 3 p.m., in 1938. That a woman was there at all during trading hours caused a minor disturbance. The world of theatre seems to have been closed to her in New York, as music and art were not. Her location in the city was ideal. Famous people were drawn to her, not only old friends, but representatives of established professions of all kinds.

The appearance of Lotte's photographs in newspapers and magazines was not that frequent, probably because it was difficult to relate her work to photographic ideas prevalent at the time, like documentary photography and photo-journalism. *Life* magazine took two pictures in 1937 but she was never more than an occasional source for them.[21] The famous picture of *Albert Einstein in a Leather Jacket* (p. 100), was made for *Life* magazine at the Einstein home in Princeton, N.J., in 1938, but was not published by *Life*.[22] The picture records an unusually humble dress for so great a mind. It symbolized Einstein's abhorrence of ceremony and pretence of any kind. Later, after the summer of 1945, other photographers, like Eisenstaedt, would see Einstein in this informal way.[23]

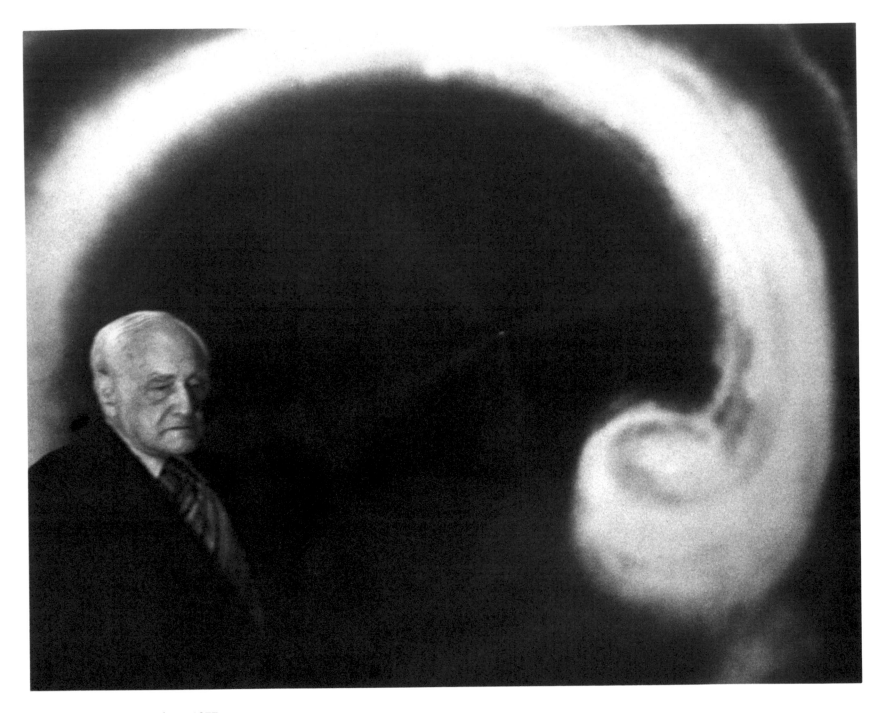

LEO KATZ, Artist, New York, ca. 1977

What this portrait represents for Lotte is a certain freedom and lack of ceremoniousness in her own work in New York and a freedom of another kind. While fully aware of what might be called "social pressures," Lotte ignores them even when making a picture of someone who might then be experiencing those pressures. She made the *Portrait of Paul Robeson*, (p.78) in 1952, when he came to the studio to be photographed with his godchild.[24] She asked if she could take his picture. When this portrait is compared to *Portrait of Peter Lorre*, an uncropped picture made in Berlin in 1931, one sees in the Robeson image a relative looseness in tones which allow his easy power and intelligence to come through. Lorre is imprisoned by the frame; Robeson scarcely contained by it. These were troubled times for Robeson, the height of the McCarthy era, but characteristically there is nothing of this in Lotte's picture. It came out of familiar circumstances in the studio and is not a "stage portrait," as Steichen made of him, nor a tract for the times.[25] The same loose, informal quality is found in Lotte's *Portrait of Alfred Stieglitz*, (p.111) whom she reveres as a master. She made a series of pictures of him at An American Place, in 1938. In them, he is a relaxed, untidy, somewhat self-indulgent, wise visionary.

The most important event in Lotte's life after her arrival in New York was her marriage to Erich Reiss on October 7, 1940. Until he died eleven years later this distinguished man, famous as a publisher in Germany, remained at the center of her life, and her career became richer.[26] Lotte's *photogenics* connect with her lifelong interest in light. While these abstract pictures cannot be credited to her marriage to Erich Reiss, they come out of the simplest of life's circumstances centering on him. He became ill in 1946 and as a barrier against boredom, his more than hers, Lotte persuaded Leo Katz, a painter, master teacher, and printmaker, to give them a course on the essentials of photography where all participants worked without camera. Among other experiments, they made *photograms*, sensitized paper exposed to light with the use of objects placed upon the surface to create design and composition. Lotte was the first to get bored, and, as she puts it now, "began moving things around." *Photogenic* was the term Fox Talbot used to mean images which were "light generated" or "light formed."[27] It was Leo Katz who applied this name to the abstract pictures that emerged from Lotte's experiments, and she has never called them anything else. What she did was to combine light and motion as she had done earlier in the picture of *Claire Bauroff* (p. 153), but now the object was to capture the movement of light, shadow, and the forms they create in an instant's exposure. There is a flawless, sensual beauty in these pictures, which was from the start a fulfillment and a new beginning. These abstract pictures conjure up the experience of the darkroom, to which Lotte never was partial, and brought her back to the fundamentals of her art. Thomas Beck has written recently that seeing them is like "standing in a dark room where all that is beyond one's finger tips is unknown."[28] The willingness to improvise, play with materials, be disarmingly captivated by experiment is contained in these non-objective pictures, among the purest that exist.

Lotte adjusted to the death of Erich Reiss, in 1951, by involving herself further in her profession, expanding her interests. She continued photographing, as would be expected, but the following year began exhibiting the works of artists (painters, sculptors, printmakers) in her studio on 52nd Street, something she had done before in Berlin but not on this scale.[29] And she continued exploring the fundamentals of art, focusing now upon printmaking with Leo Katz, at Atelier 17, working off and on there for the next four years. As in Berlin, she seemed unaware of the inevitable departure, but when it came, moved easily. She left New York in the summer of 1955 with her son John and his wife Beatrice for Deering, New Hampshire, and began a new life, at first with them and then on her own when John built her a studio nearby in 1962.[30]

New Hampshire

While in New York Lotte's life reflected the patterns of the past and although these persist, her attitudes away from the city seem altogether different. In New Hampshire she discovered the country, the people, and their patterns of life, and adapted to them. She attended her first Town Meeting in Deering on March 13, 1956, and discovered the heart of American politics. It was like photographing the Indians that first day in New York. She became one of the tribe. Now she lives close to the land, keeps bees, a garden, watches birds, and is a natural food enthusiast. *Kunst und Natur* is lived, and this affects her work, what she exhibits at the studio, and the eventual recognition she receives.

"I am involved in seeing," Lotte told students recently, and her work shows it. She photographs children as if she were a part of the family, suppressing whatever professional associations one might expect her to make. Once in photographing *Elizabeth Walmsley*, (p. 27) in 1973 or 1974, the young girl sat at the end of the session and lowered her eyes thoughtfully. To Lotte she looked like Dorothea Lange's image of the *Korean Boy*, which once seen can never be forgotten. "Should I take it?" Lotte thought, "should I take it? I took it. It was so beautiful." As she is more free she is more hopeful. A recent *Portfolio* of ten portraits, eight from the Berlin period and two from New York, is of Gods of the past who were scarcely understood or were rejected altogether.[31] Lotte photographed *Robert Frost*, (pp. 119-122) in 1959, as if he were a friend with whom she had spent the afternoon. There is a picture of him lecturing in the landscape with all nature his audience. The complexities of the man, of course, are not present. He is a vigorous sage who had a voice and was heard.[32]

While John built her studio Lotte went to school again in preparation for her first trip back to Europe. She took courses at the University of New Hampshire, Durham, 1961–62 in horticulture, languages, printmaking, even television. Her trip in 1962 served multiple purposes. She returned to Thorn, visited old friends there and in Germany, and traveled south through Switzerland and Italy. But she also worked for about four months with Stanley William Hayter at Atelier 17, in Paris, actually beginning and ending her trip there. She photographed him and other artists like Osip Zadkine and Marino Marini. She visited Albert Renger-Patzsch and Otto Steinert, both of whose work she had admired for years but whom she had never met.[33]

On her return she opened the studio that summer with an exhibition of *Photographs of Frances Hubbard Flaherty*, the wife of Robert Flaherty, the

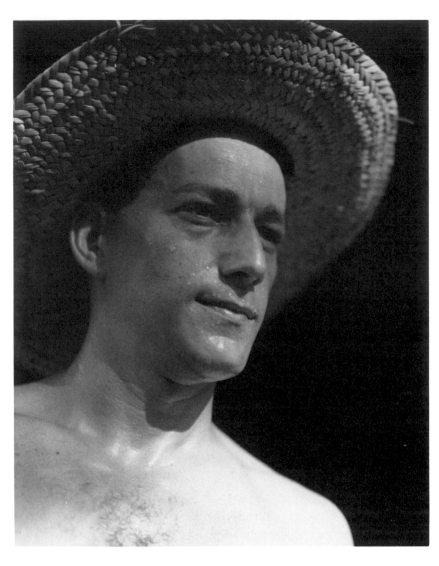

JOHN FRANK HUNTER, son of Lotte Jacobi, Deering, N.H., ca. 1955

film-maker, which became symbolic of all Lotte's exhibitions in New Hampshire. Almost all were of work insufficiently recognized or by artists forgotten altogether. Frances Flaherty had been overshadowed for years by the brilliance of her husband and many of her photographs (made as production stills for his films) are mistaken as his even now.[34] But the photographs by Flaherty himself were relatively unknown and a selection of his early *Studies of the Hudson Bay Region* followed next year.[35] The photographs of William H. Manahan and L.M.A. Roy, both local photographers for over fifty years, were early exhibitions as was the work of a local craftsman, John Herrick, who had once lived down the road, whose violins were in use in symphony orchestras.[36] Lotte identified herself with these artists. Frances Flaherty's idea of "non-preconception" as the central core of the way Robert Flaherty worked in film with people coincided with Lotte's thoughts of the way she worked in photography.[37] In New York the exhibitions were like a review of the past; in New Hampshire they were were insights into herself.

As Lotte discovered the country and a new life, she was discovered all over again. The University she had attended as a special student awarded her an Honorary Degree, in 1973, and she has just received another from New England College.[38] This belated recognition has come to her for two reasons: she represents something in art which is paid lip-service to but has grown rare, and New Hampshire was the watershed. In this age of technique she tells the students, "all the technique you can learn and you should learn everything you can — you should have it here in the fingers not here in the head — and then," she adds, "you forget about it." It is not easy to forget technique. Lotte is a committed professional who after years of work and struggle has freed herself from the fetters of her profession. She had her first New Hampshire "one-man show" in a museum at the Currier Gallery, in Manchester, in 1959, an exhibition consisting of about two hundred photographs selected by Charles Buckley, Director of the Museum, and the following year another retrospective exhibition was hung by Christopher Cook at the University of New Hampshire just before she went back to school. From this time on her work has been in constant exhibition, not only here but in Europe as well.[39] Yet the richness of her work was not quickly grasped even by those photographers who knew her, like Minor White and Edward Steichen, both of whom had exhibited her *photogenics*.[40]

At the Hamburg exhibition of a cross-section of her photographs, in 1973,[41] Lotte was approached by Otto Steinert, who was impressed with the early German portraits. He asked if she had other pictures of notable German figures of the twenties and thirties whom the Hitler regime had tried to wipe from memory. Learning that she had, Steinert suggested they make another exhibition restricted to portraits alone, which would amount to an album of the Weimar Republic and, of course, be fragmentary. What recommended these pictures to Steinert was the fact that Lotte's portraits were at the service of the subject rather than agents of criticism. She imposed no brief upon a face. Her style shifted with the character of her subject. She does not make a perfect print. Her pictures do not document social conditions in the world around her or her subjects. She was faithful to what she saw. In the catalogue Steinert called her an "innocent critic,"

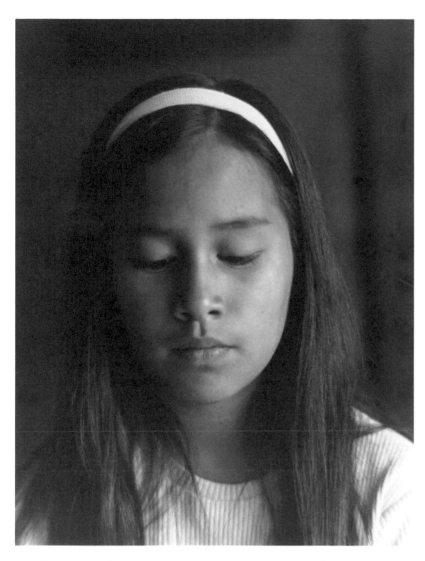

ELIZABETH WALMSLEY, Native American, Deering, N.H., 1970

and she was perfect for his purpose. To him the exhibition which followed in 1973 was a "chronicle of an era."[42] When one thinks of the magnitude of the intellectual migration from Germany and Central Europe to this country in the 1930's it is not surprising that what Steinert wanted could still be supplied by a woman who lived in New Hampshire. "When we think of Weimar," wrote Peter Gay, "we think, above all, of the exiles who exported Weimar culture all over the world."[43] Lotte Jacobi is one of the exiles.

All information in this essay concerning Lotte Jacobi, her life, her family, and her works and their dates is a product of a chronology of facts and events which she and this writer compiled in March 1978. She has made much material available to me over nearly twenty years, for which I am grateful. Any errors are, of course, mine.

1. Johanna Alexandra Jacobi Reiss was born in Thorn, West Prussia, August 17, 1896. Lotte was a nickname which caught on at home. She has always used the name Lotte Jacobi professionally. She married Erich Reiss in 1940.

2. Lotte was the oldest of three children but not the first to enter the profession, her sister Ruth preceding her. Their brother, Alexander, died in 1922 at the age of 20, and was not a photographer.

3. Lotte married Fritz Honig May 21, 1916, their son John was born March 26 the following year, and Lotte was divorced in 1924, retaining custody of her child. She lived in Munich from October 1925 to September 1927.

4. cf. FOTOGRAFINNEN: Beispeile aus der Arbeit von Fotografinnen in Deutschland seit 1925, Museum Folkwang Essen, Jan 26–March 1, 1970 (Dir. Otto Steinert), Pl. IV (Lotte Jacobi Pl. XVI).

5. March — April, 1927 under Koch: the first two were portraits, the earliest Josef Scharl (10 min.); the second, Dr. Kutscher and family at breakfast, which was a gift (Kutscher was an art historian at the University where Lotte took courses in the subject); the last two films were more experimental and overlapped in time, the first was the most scientific made under a gifted teacher whose name Lotte has forgotten, and the last an animated film on which Scharl helped.

6. cf. G. Sander, August Sander Photographer Extraordinary, foreword Golo Mann, London, 1973: "Trades, Classes and Professions 3," The Composer Paul Hindemith (Cologne, 1926).

7. ibid., p. 7; and, Anthony West, "Who are these Unmasked Men," (rev. Men without Masks; Faces of Germany 1910–1938 by August Sander — same book new title publ. USA), The Washington Post, Jan. 1, 1974, C4: "the real Hindemith was utterly unlike the dotty brute Sander made him into."

8. cf. Albert Renger-Patzsch, Die Welt is schön, Munich, 1928, and Karl Blossfeldt, Wundergarten der Natur, Berlin, 1932, see V. Kahmen, Art History of Photography, NY, 1974, pls. 282; 229-233.

9. cf. P. Gay, Weimar Culture; the outsider as insider, NY, 1970, p. 128.

10. The Jacobi studio provided photographs for many publications, Die Dame, UHU, and Querschnitt among others, and the studio did almost all the work for a weekly radio magazine, Die Funkwoche. John Heartfield was a customer from 1929-32 and Lotte made photographs for him, some for his montages and some for bookjackets.

11. Now at the Museum Folkwang, Essen.

12. cf. P. Gay, op. cit., p. 122-123.

13. cf. M. Esslin, Brecht, the man and his work, NY, 1961, p. 270: "August 31. First night…Theater am Schiffbauerdamm;" the photograph was made there shortly before.

14. cf. H. Bittner, Käthe Kollwitz Drawings, NY, 1962, p. 14, it is possible that this picture influenced Kollwitz's own self-portraits after 1931.

15. cf. P. Gay, *op. cit.*, pp. 136-138, and 158-164.

16. *ibid.*, p. 144, and on reaction of Ullstein Verlag, pp. 137-138. Three solutions were attempted and none succeeded in keeping the Jacobi studio united with that part of the business that supplied photographs to publishers. First, Ernst Fuhrmann consented to the use of the name of his archive, Folkwang Archiv, on condition that it be housed at the studio in Berlin and the caretaker, a photographer named Koch, accompany the collection and be provided for. This arrangement lasted half a year. Anton Walbrook then suggested another solution: his friend, Alexander Bender would give his name to the enterprise in exchange for training in photography. This didn't work because it was discovered that Bender was insufficiently Aryan (a Jewish ancestor being found a few months later). The third solution was to detach the journalist element from the studio, and a Mr. Behm took it over; thus this part of the business then bore the name of *Behm's Bilderdienst*, where formerly it was called *Bender und Jacobi*, the name which served all studio activities c. 1934-35.

17. Since Lotte came to the USA on a visitor's visa she went to Toronto, Canada, January 20, 1936, entering the United States from there a few days later (held up only because she forgot passport photos). Lotte's mother arrived in New York, Feb. 20, 1936, and John, Sept. 4th. Only Bemchen remained behind, Lotte's greatest regret.

18. Lotte's sister and husband lived on Post Avenue near what was called the Inwood Section around 207th Street, New York City, the ceremonies taking place in that part of the city.

19. S.W. corner 6th Avenue and 57th Street, Oct. 30, 1935. All other studios were Lotte's alone. She moved to 24 Central Park South, Sept. 19th the following year and then to 35 West 57th Street two years later (Sept. 2, 1938). Lotte stayed there for 13 months and then moved (Oct. 1939) to 127 West 54th Street where she remained for two years. The following October of 1941 she moved to 46 West 52nd Street and left the city June 22, 1955.

20. cf *New York Herald Tribune*, Dec. 29, 1935 (Sunday) Gravure Section VI, p. 5: *Gerhard Hauptmann; A Young Star of the German Screen; Lil Dagover; Rosy Barsony; Emil Jannings; Carsta Loech; Luise Ullrich;* and, *Trudi Schoop.*

21. Jan. 28, 1937, *Life* took two pictures of Karl Radek who was being tried for treason in Moscow, sentenced Jan. 30th, and died in an Arctic labor camp two years later, cf. R. Conquest, *The Great Terror, Stalin's Purge of the Thirties*, London, 1968, pp. 254-255. The photographs (made in Moscow Jan. 1933) were never published by *Life* and the magazine did not cover the trial.

22. cf. *Life*, Aug. 20, 1945, p. 92: *Einstein* is a cropped version of Lotte's *Portrait of Albert Einstein*, another one of the pictures she made of him in 1938. *Einstein in a Leather Jacket* was exhibited at the *Museum of Modern Art, 20th Century Portraits*, 1942.

23. cf. *Life*, Dec. 29, 1947, pp. 55-59.

24. March, 1952, Mr. and Mrs. Mordecai Baumann, son, Joshua.

25. cf. Edward Steichen, *A Life in Photography*, London, 1963, pl. 120.

26. cf. *Erich Reiss Verlag, Klingspor Museum*, Offenbach am-Main, Germany, 1969.

27. cf. B. Newhall, *Latent Image: The Discovery of Photography*, NY, pp. 68-70. The course was taught with another friend present, Dr. Wm. Wolff. Some of the early *photogenics* were made on War surplus paper (1946-49) and have turned yellowish, but others were not and, therefore, the yellowish color is a limited criterion for dating an early *photogenic*.

28. cf. *Lotte Jacobi, portraits & photogenics, University of Maryland Baltimore County Library*, 1978, pp. 4-5.

29. cf. *Art News* (Summer 1953), p. 51: "Six artists (Jacobi to June 15) present a distinguished exhibition to initiate this gallery.... Benjamin Benno, Si Lewen, Jason Seley, Josef Scharl, Robert E. Mueller, and Johannes Molzahn." Lotte exhibited

the etching and sculptures of Louise Nevelson (Jan. 1954), and the last exhibition in 1955 was of her own *photogenics*. In Berlin, Lotte showed the photographs of Tina Modotti at the studio in 1930 (April-May), cf. M. Constantine, *Tina Modotti An Illustrated Biography*, NY, 1975, p. 185.

30. Lotte bought her place on Old County Road, Deering, N.H. in 1958, and moved there shortly before she left for Europe in 1962. John began building the studio addition in July before she left and it was finished on her return in May 1963.

31. cf. Lotte Jacobi, *Portfolio I: Portraits before 1940*, Deering, N.H. 1978, 25 copies; *Albert Einstein*, no. 1; and *Alfred Stieglitz*, no. 8, from New York period.

32. Sept. 9, 1959, Ripton, Vermont for E. S. Sergeant, *Robert Frost, The Trial by Existence*, NY, 1960, fig. 24.

33. Sept. 1962 to Europe, worked in Paris with Hayter until shortly before Christmas when she went to Germany and Poland, traveling then in 1963 as far south as Sicily, returning to Paris in April when she photographed Hayter, Osip Zadkine, (April-May, 1963) and Marino Marini in Milan earlier in the year. She met Albert Renger-Patzsch and photographed him in 1963, and visited Otto Steinert around the turn of the year.

34. July 15-Aug. 6, 1963. Frances Flaherty began making stills for *Moana of the South Seas*, 1923-25, examples of which can be found in six issues of *Asia* (May-Dec.), 1925, see especially, *Asia* (May), 1925, pp. 393-400. Lotte's exhibition included work for four films: *Moana of the South Seas; Man of Aran*, 1933-34; *Elephant Boy*, 1936-37; and, *The Land*, 1940-41.

35. cf. *Robert Flaherty's Studies of the Hudson Bay Region*, Aug. 11-31, 1964 (21 items): recent research by Monica Flaherty Frasetto makes it clear that her father was occupied with photography from early youth.

36. cf. *A Selection of the Photographic Work of William H. Manahan jr.*, Aug. 12-31, 1963 (17 photographs, Gum, Bromide and Platinum prints), opened studio Hillsboro, N.H. Feb. 23, 1899, retired 1953, was 86; *A Selection of Photographs of L. M. A. Roy*, June -21, 1964 (26 photographs), early student of Carl Rau, worked in photography since 1912, was 81; *The Craftsmanship of John Herrick*, Sept. 5-21, 1963 (41 items: iron, wood, copper, pewter, silver, jewelry), 100th anniversary of birth, last thing he made was a cello (d. 1959).

37. cf. Frances Hubbard Flaherty, *The Odyssey of a Film-Maker, Robert Flaherty's Story*, Urbana, Illinois, 1960, p. 10.

38. University of New Hampshire, Durham, N.H., June 1973; New England College, Henniker, N.H., May 21, 1978.

39. Notable exhibitions since 1960: *The Sense of Abstraction*, MOMA, NY, 1960; Brandeis University, Waltham, Mass. (retrospective) Sept-Oct, 1960; University of Ohio, Athens, Ohio, (retrospective) May 1-15, 1961; University of Chicago, Chicago, Ill., April 3-May 5, 1965; Washington Gallery of Photography, Washington, D.C., Nov 3-Dec 1, 1974; University of Maryland Baltimore County, March 1978 (portraits & abstractions); and abroad, Le Iven Salon National D'Art Photographique, Blois, France, 1963.

40. cf. *Light*[7], Hayden Gallery, MIT, 1968; *SUBJEKTIVE FOTOGRAFIE: 2*, Saarbrucken, Nov 27, 1954-Jan 27, 1955, no. 104 (Otto Steinert); *Aperture 10: 1*, 1962 (article by Leo Katz); *Women of Photography, An Historical Survey, San Francisco Museum of Art*, April 18-June 15, 1975 (Margery Mann and Anne Noggle).

41. cf. *Fotogalerie, Staatliche Landesbildstelle Hamburg*, Hamburg, Germany, Jan 3-31, 1973.

42. cf. *Menschen von gestern und heute, Fotografische Portraits, Skizzen und Dokumentationen von Lotte Jacobi, Museum Folkwang Essen*, Dec 12, 1973-Jan. 13, 1974, p. 5.

43. cf. P. Gay, *op. cit.*, p. xiii, and *The Intellectual Migration, Europe and America, 1930-1960*, ed. D. Fleming and B. Bailyn, Cambridge, Mass., 1969.

Portraits

HAUPTMANN	MORGAN
WEILL	ABBOTT
LORRE	PEARS
HÖLZ	BRITTEN
BUBER	AUDEN
KOLLWITZ	DREISER
SLEZAK	NEWHALL
ZWEIG	REINHARDT
LEDERER	THIMIG
WALTER	ROOSEVELT
FURTWÄNGLER	MOORE
De FIORI	SZOLD
CHRISTIANS	WEIZMANN
PECHSTEIN	EHRENBURG
LIEBERMANN	REISS
PISCATOR	HORNEY
LANG	Du BOIS
SCHÜNZEL	GRAHAM
MENDELSOHN	ROBESON
KRAUS	CASALS
PLANCK	STRAND
VON OSSIETZKY	BEECHAM
VON SCHLEICHER	HESCHEL
MÜHSAM	WHITE
STANISLAWSKY	RENGER-PATZSCH
RADEK	STEICHEN
BARBUSSE	STEINERT
VALENTIN	HAYTER
KARLSTADT	FLAHERTY
ZUCKMAYER	SARTON
MARINETTI	EISELEY
GROSZ	NEARING
KISCH	CAPONIGRO
HART	

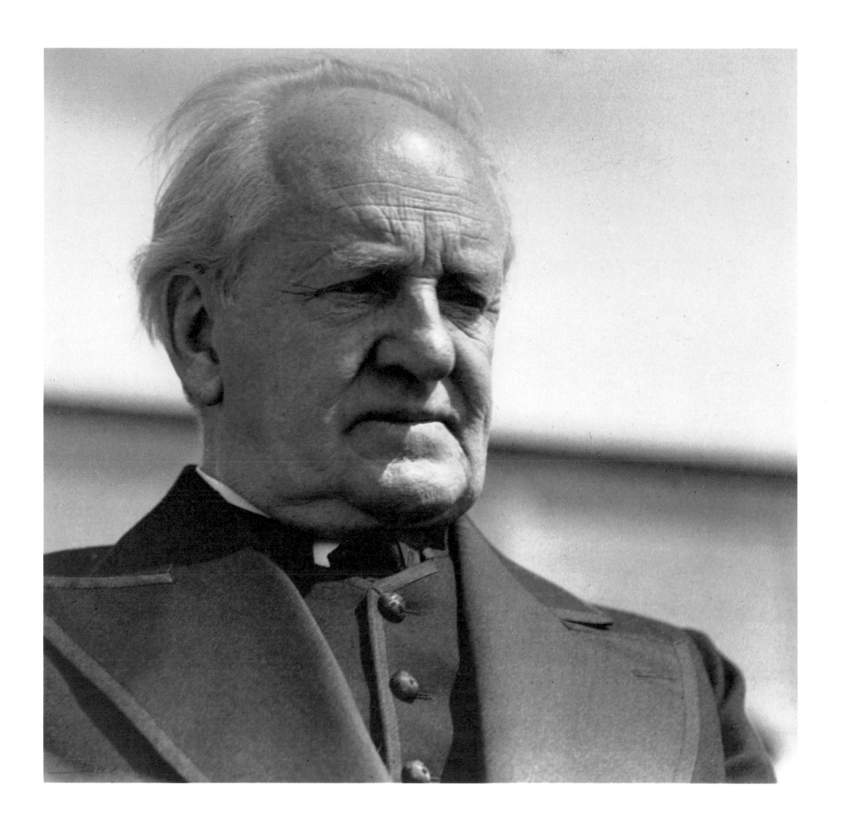

GERHART HAUPTMANN, Dramatist, Berlin, 1933

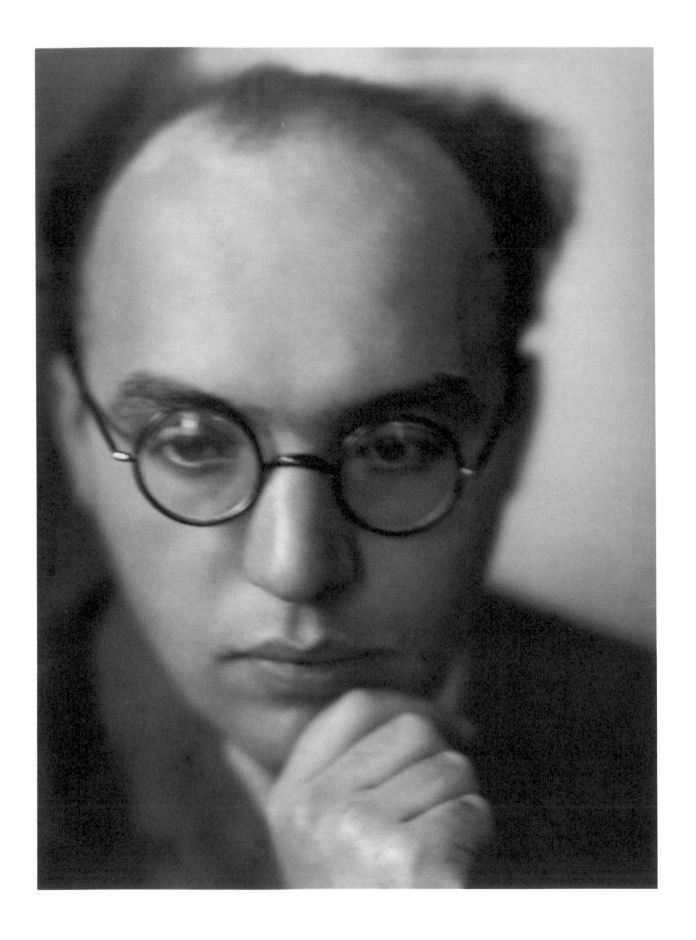

KURT WEILL, Composer, Berlin, 1928

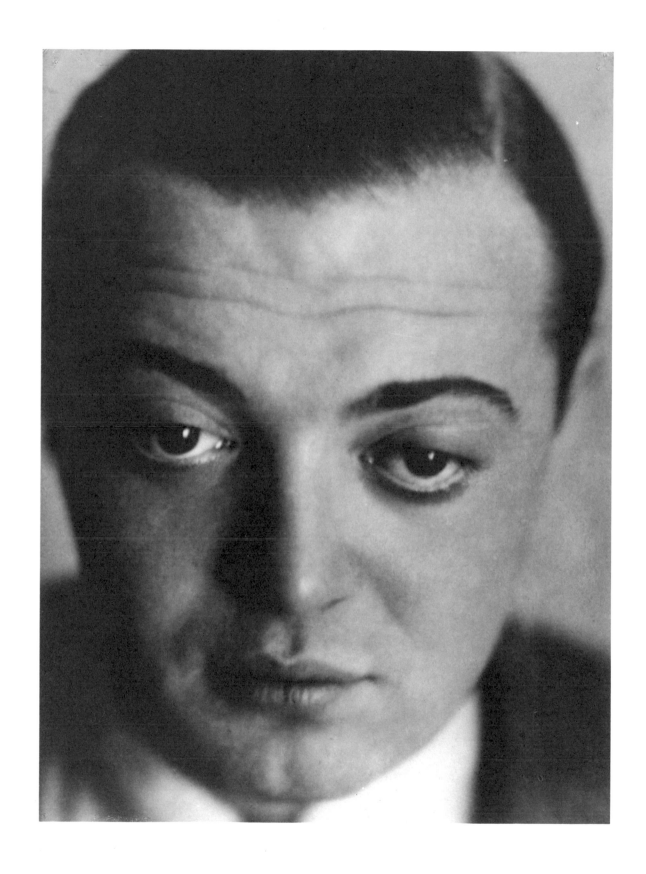

PETER LORRE, Actor, Berlin, ca. 1932

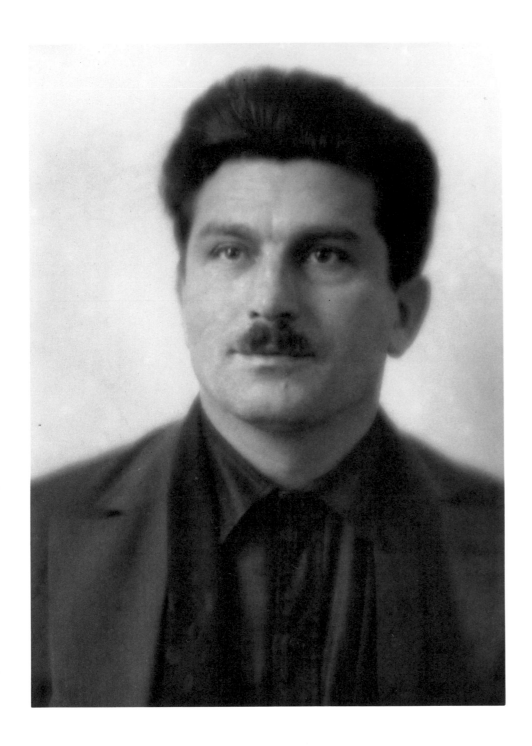

MAX HÖLZ, Revolutionary, Berlin, ca. 1930

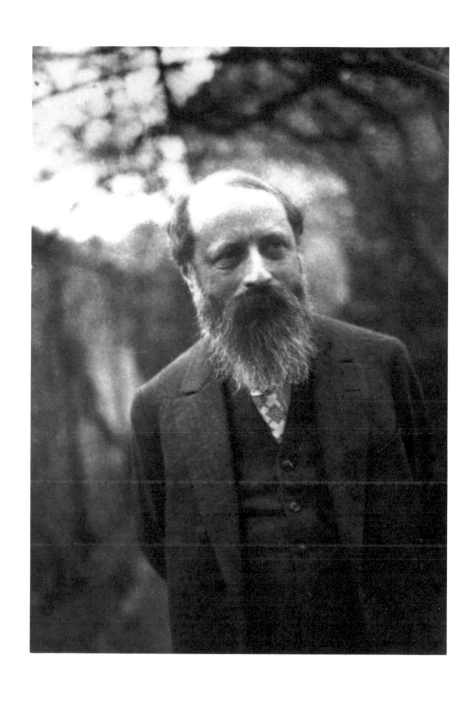

MARTIN BUBER, Writer, Theologian, Odenwald, 1928

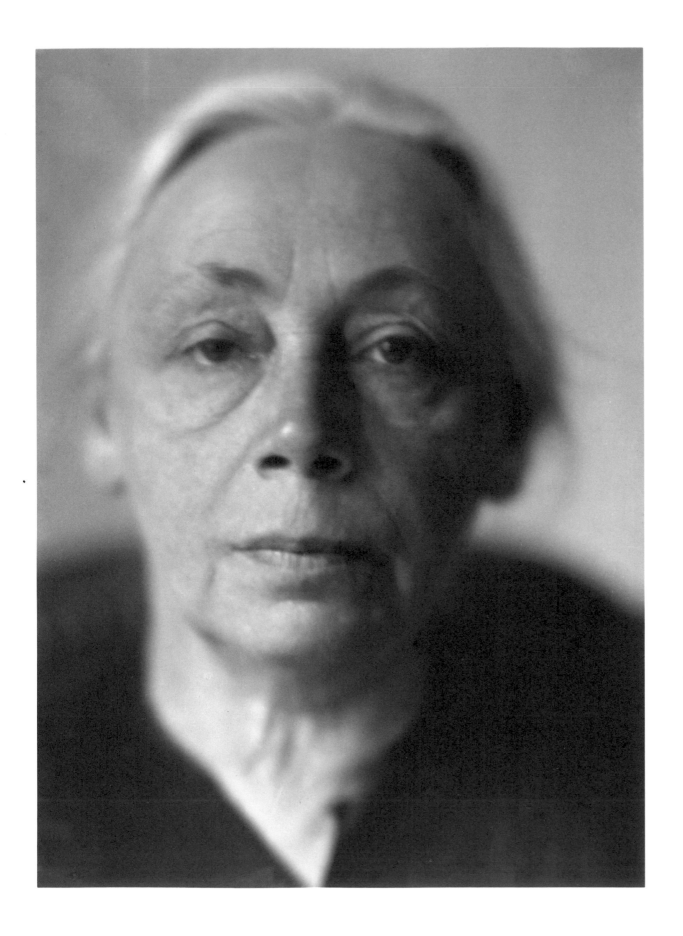

KÄTHE KOLLWITZ, Painter, Sculptor, Berlin, ca. 1930

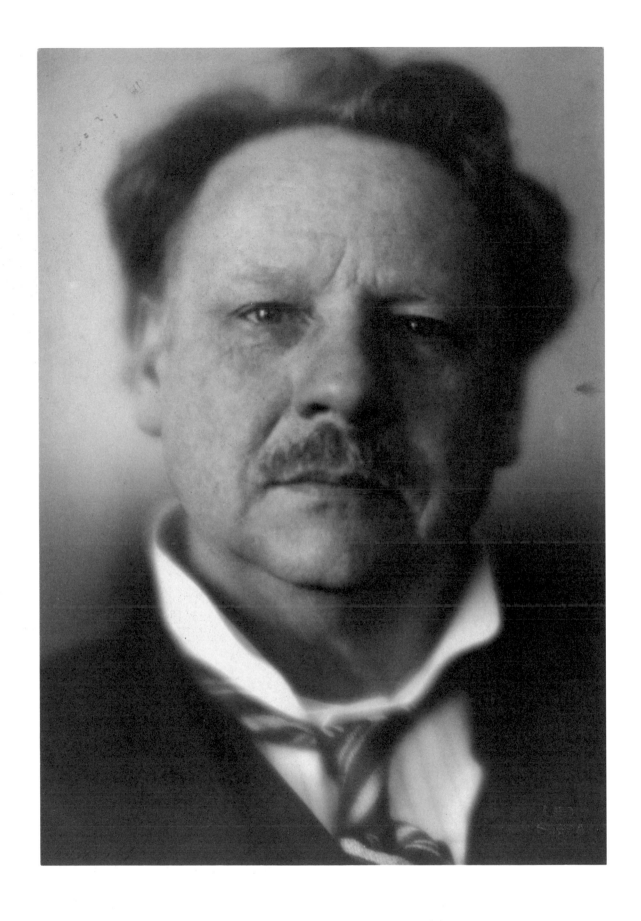

LEO SLEZAK, Singer, Berlin, ca. 1930

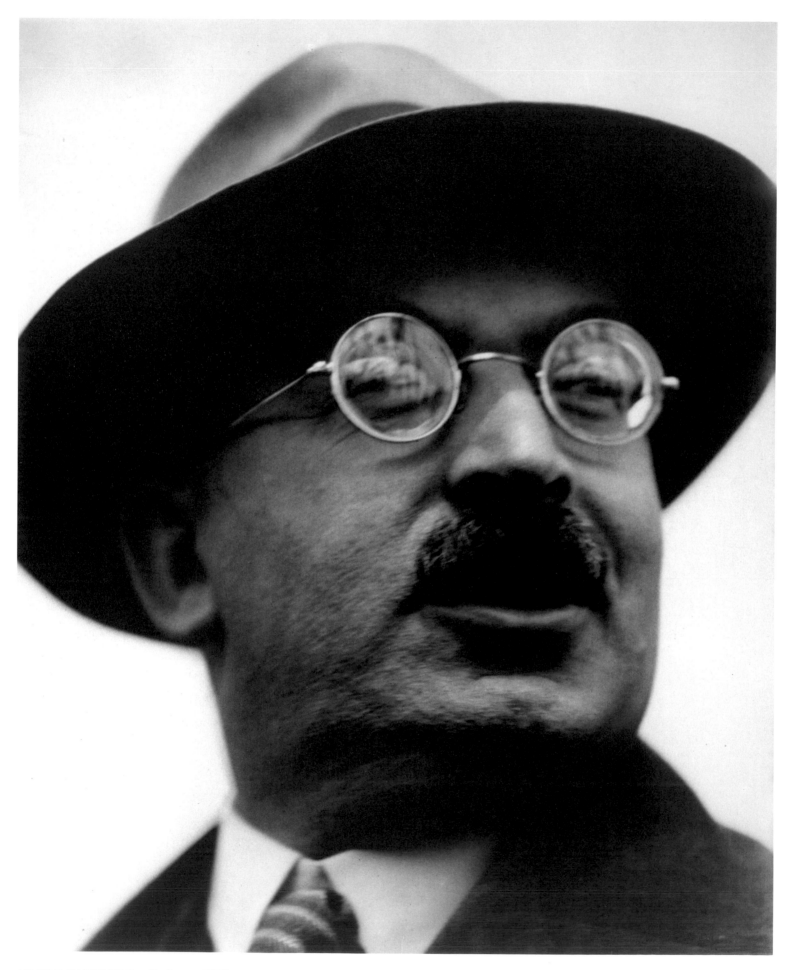

ARNOLD ZWEIG, Writer, Berlin, ca. 1930

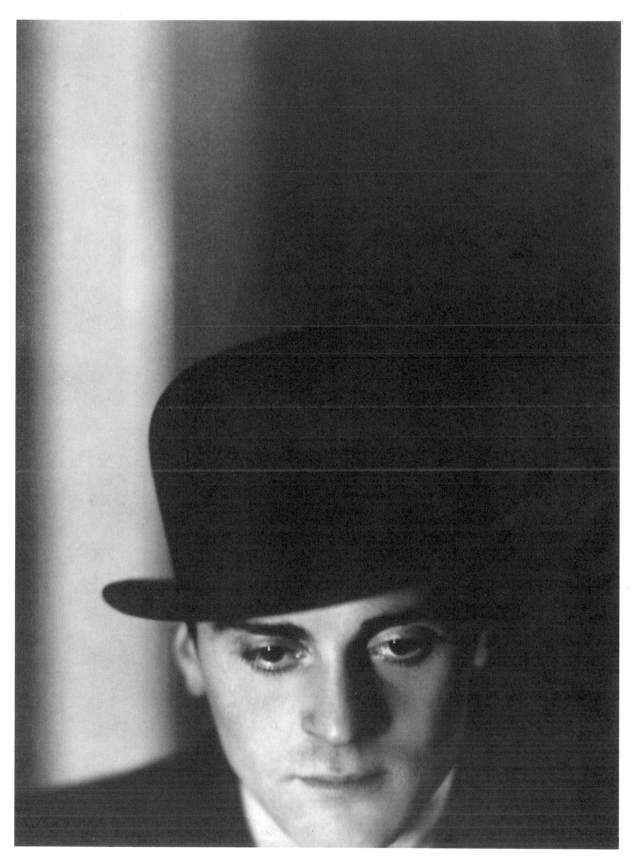

FRANZ LEDERER, Actor, Berlin, ca. 1929

BRUNO WALTER, Conductor, Berlin, ca. 1930

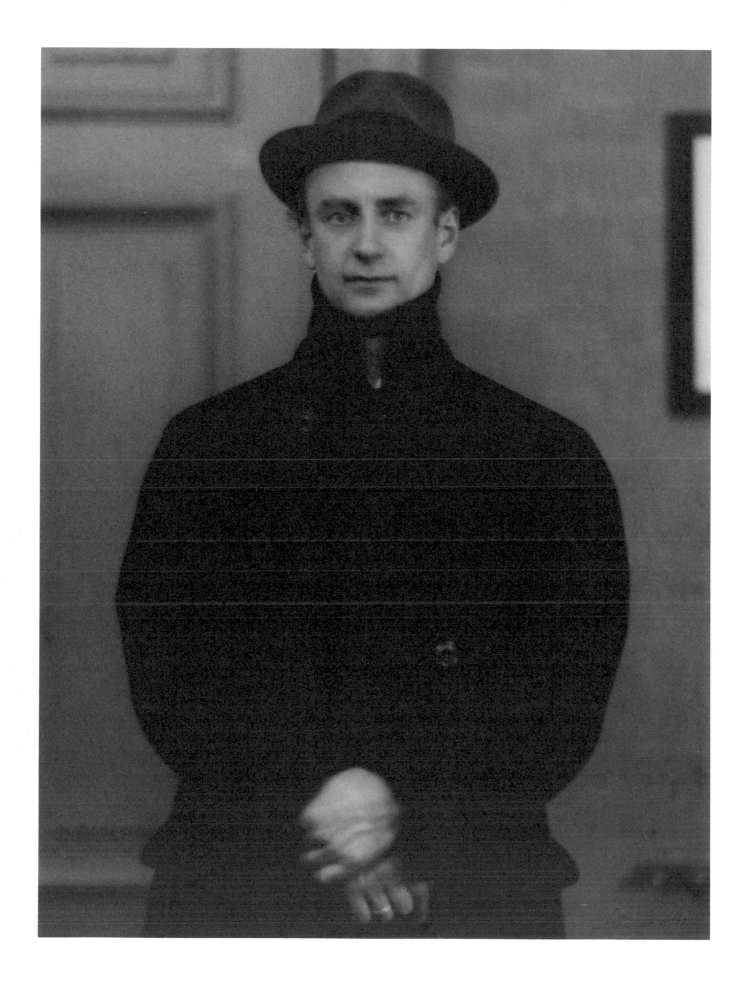

WILHELM FURTWÄNGLER, Conductor, Berlin, ca. 1930

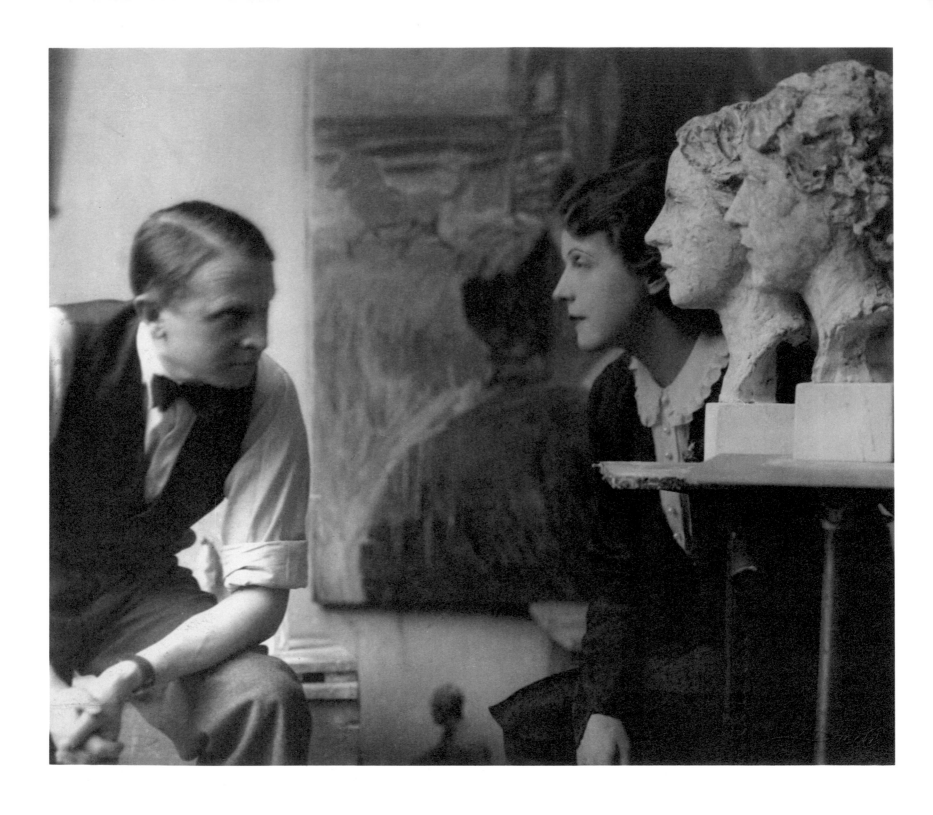

ERNESTO DE FIORI, Sculptor, with MADY CHRISTIANS, Actress, Berlin, ca. 1930

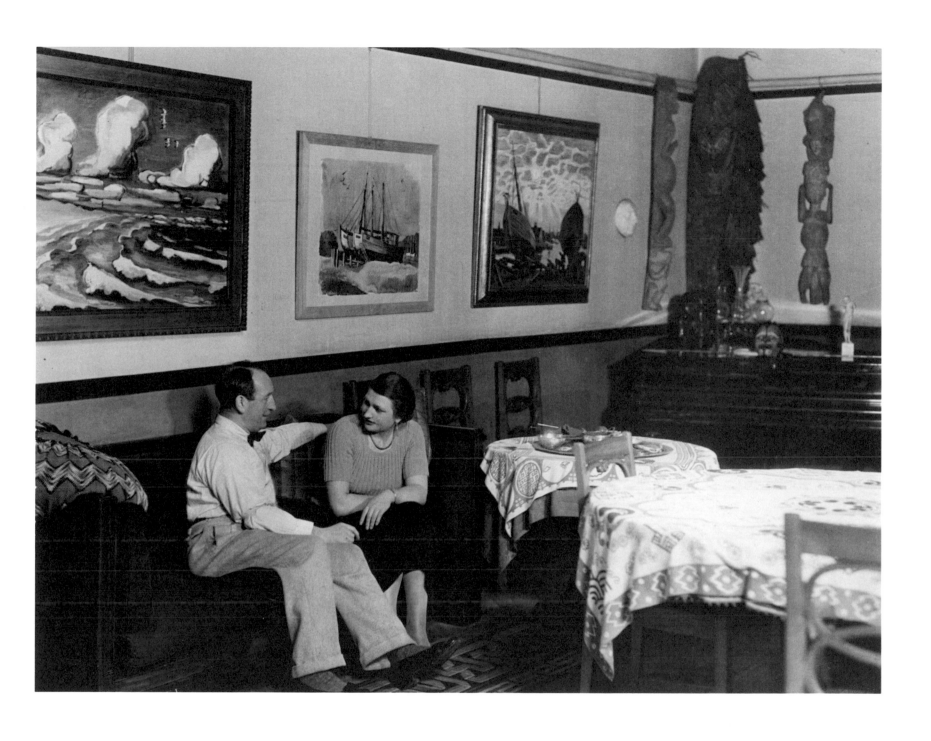

MAX PECHSTEIN, Artist, with his wife, Berlin, ca. 1930 43

MAX LIEBERMANN, Artist, Wannsee, Berlin, 1931 44

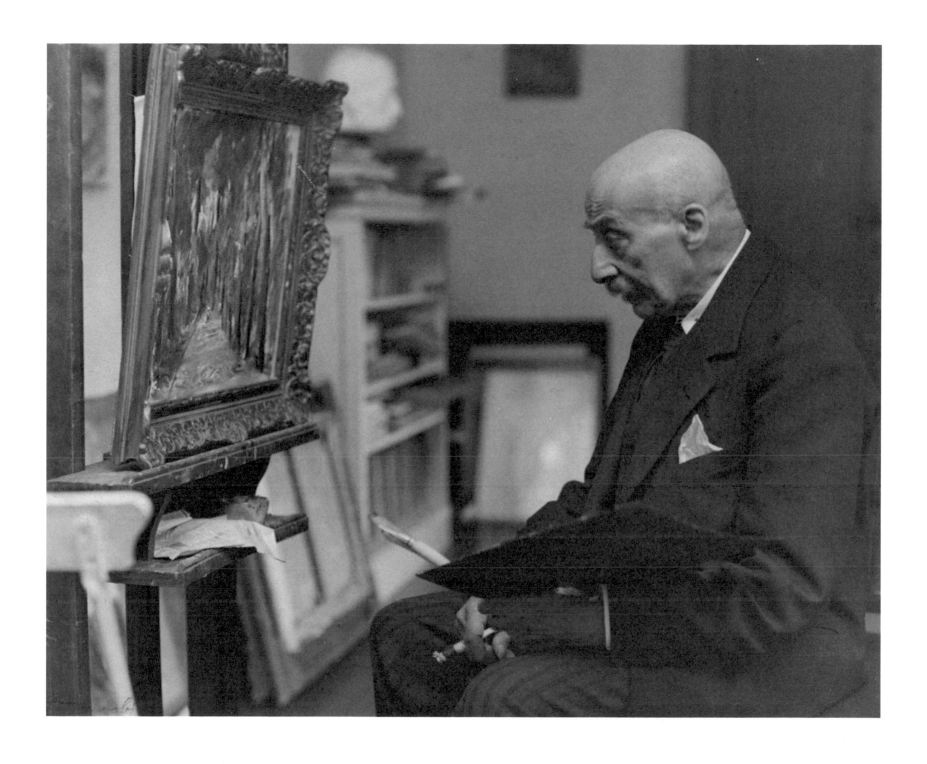

MAX LIEBERMANN in his studio, Berlin, ca. 1931 45

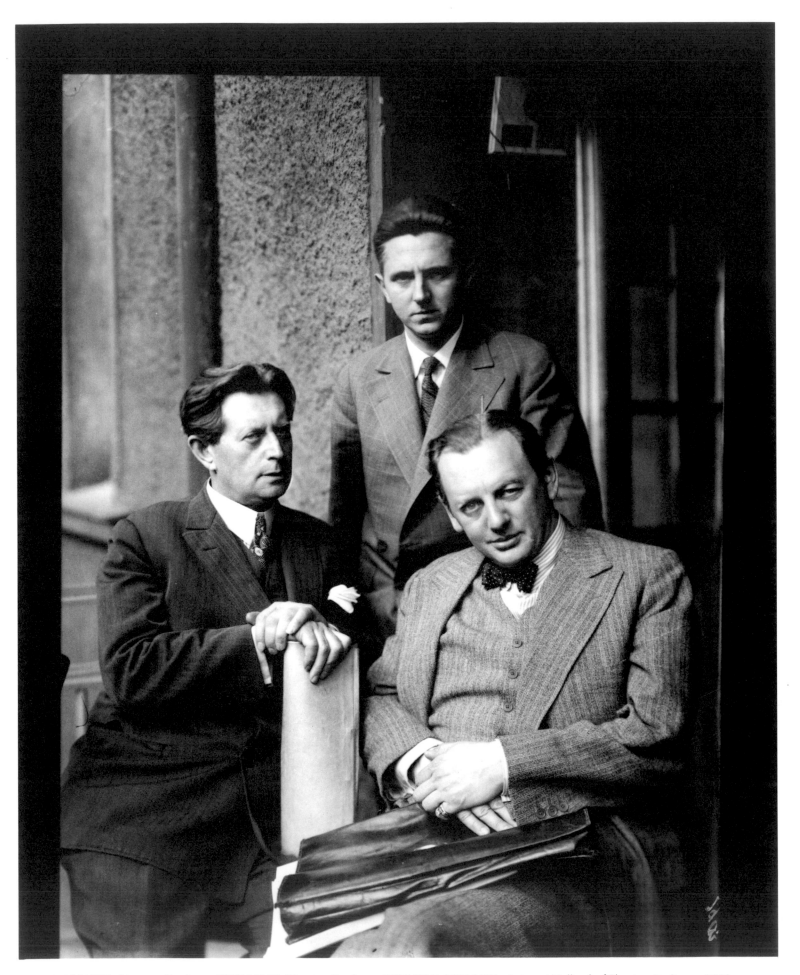

ERWIN PISCATOR, Director, Producer; FRITZ LANG, Director, Producer; REINHOLD SCHUNZEL, Actor, at Nollendorf Theatre, Berlin, ca. 1929

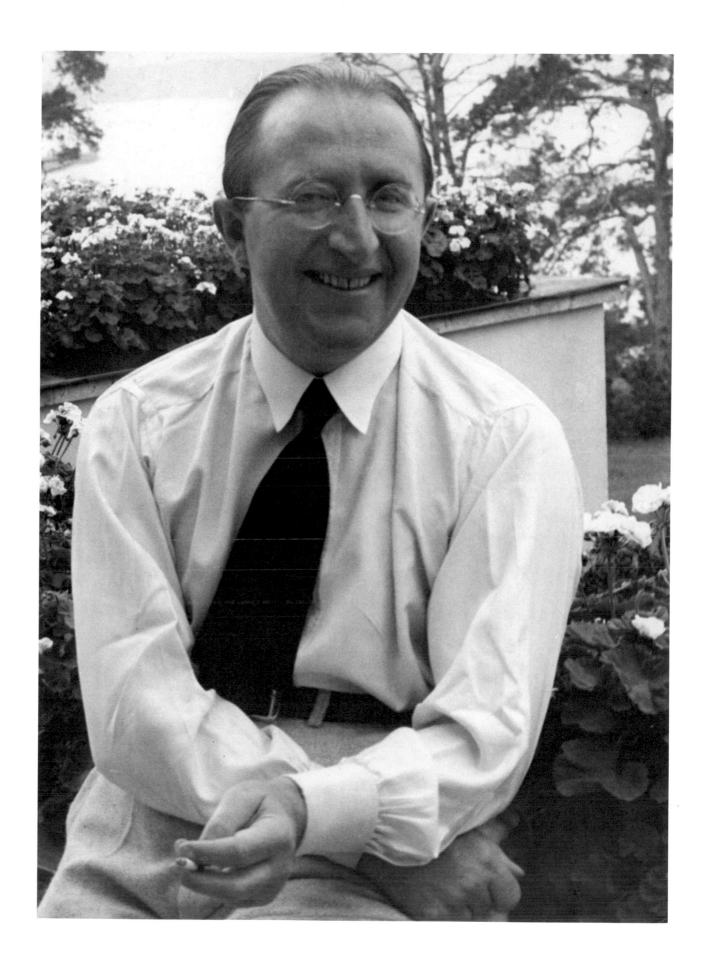

ERICH MENDELSOHN, Architect, in his garden, Berlin, ca. 1930 47

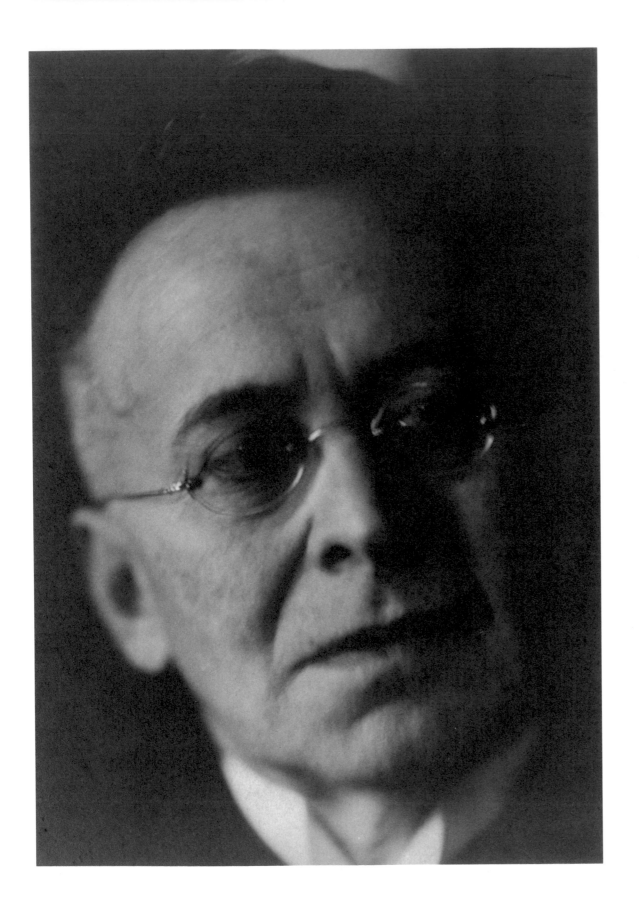

KARL KRAUS, Poet and Critic, Berlin, ca. 1930

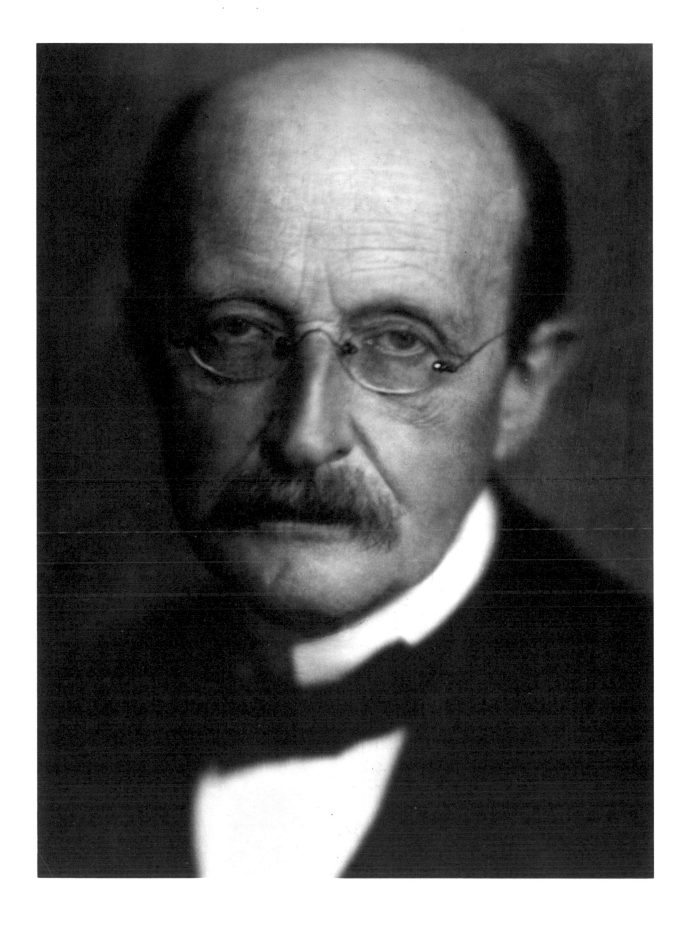

MAX PLANCK, Physicist, Berlin, ca. 1930

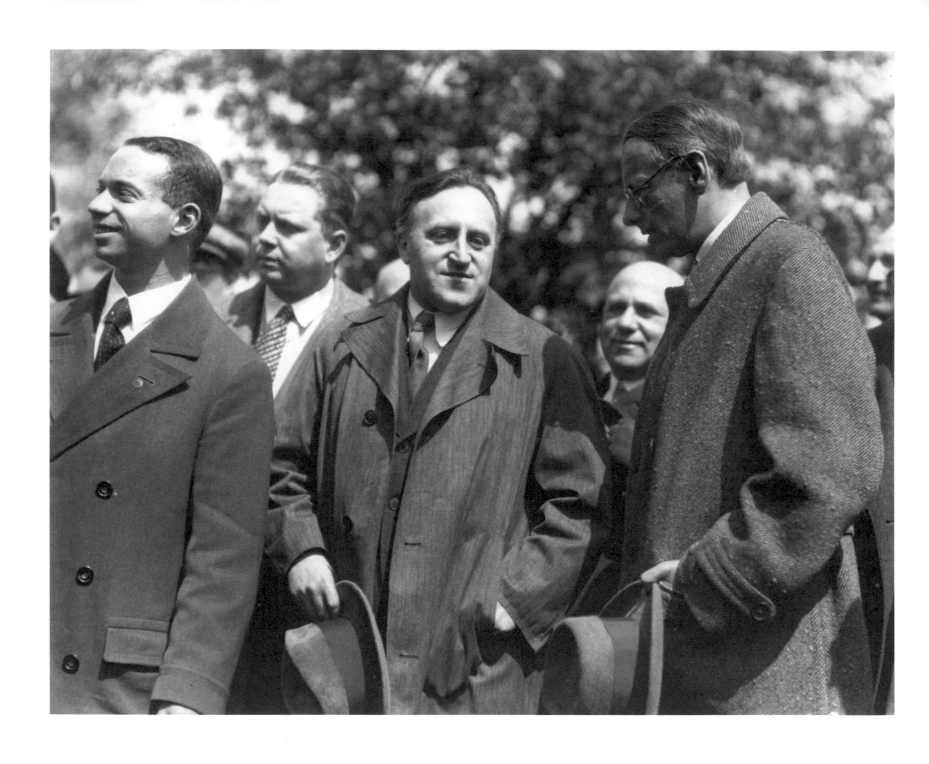

CARL VON OSSIETZKY, Writer, Nobel Prize Winner, Berlin, 1933.

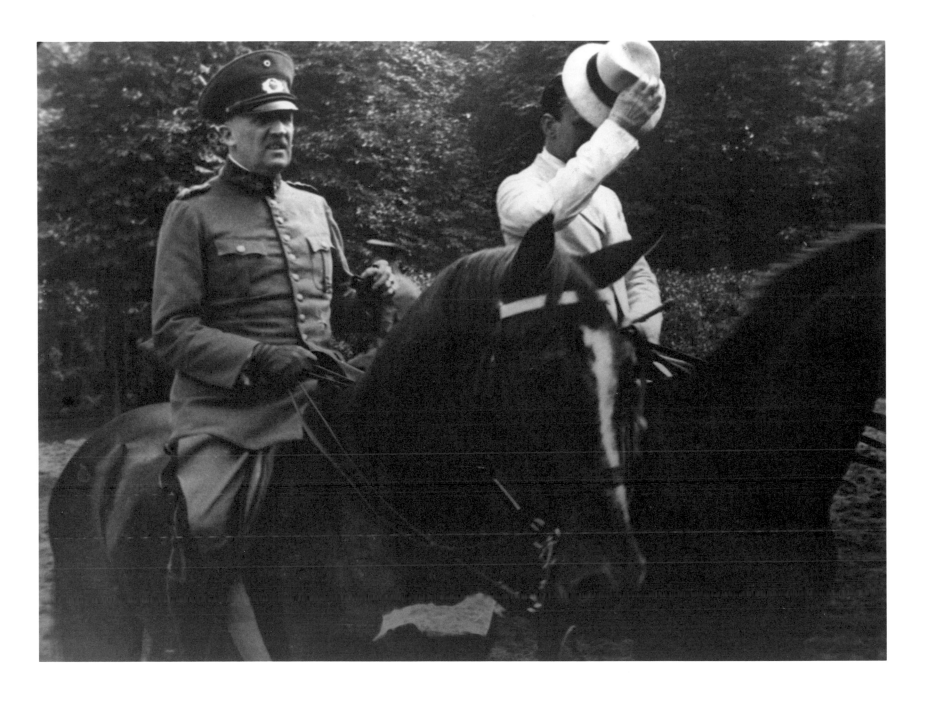

General KURT VON SCHLEICHER, Tiergarten, Berlin, ca. 1930

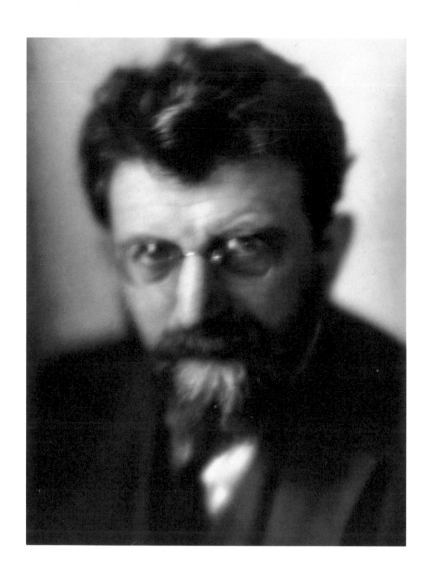

ERICH MÜHSAM, Poet, Berlin, 1929

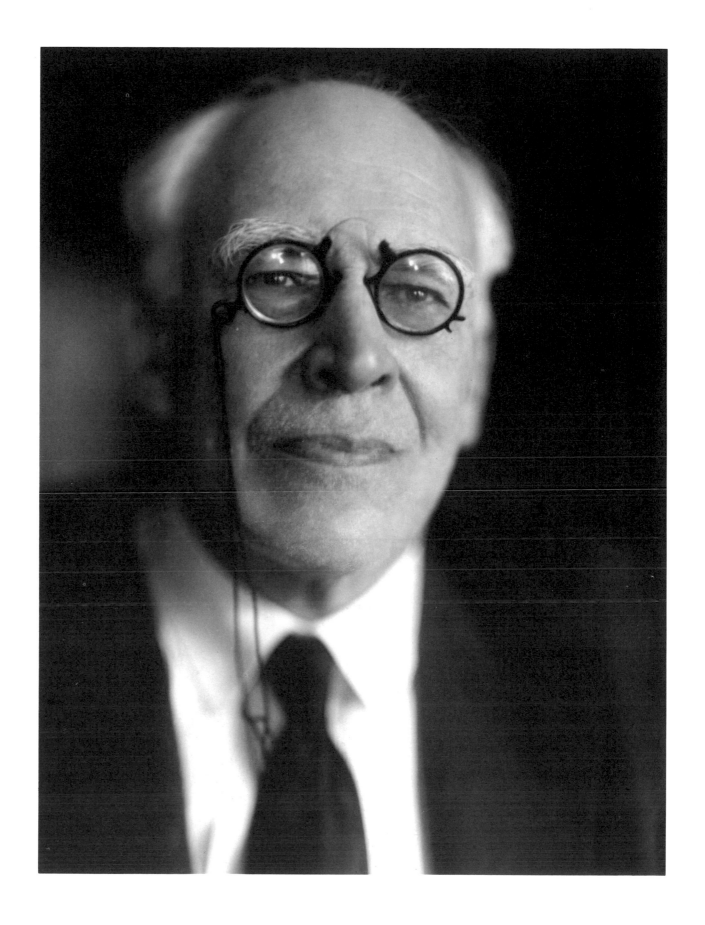

KONSTANTIN STANISLAVSKI, Director, Actor, Producer, Berlin, ca. 1930

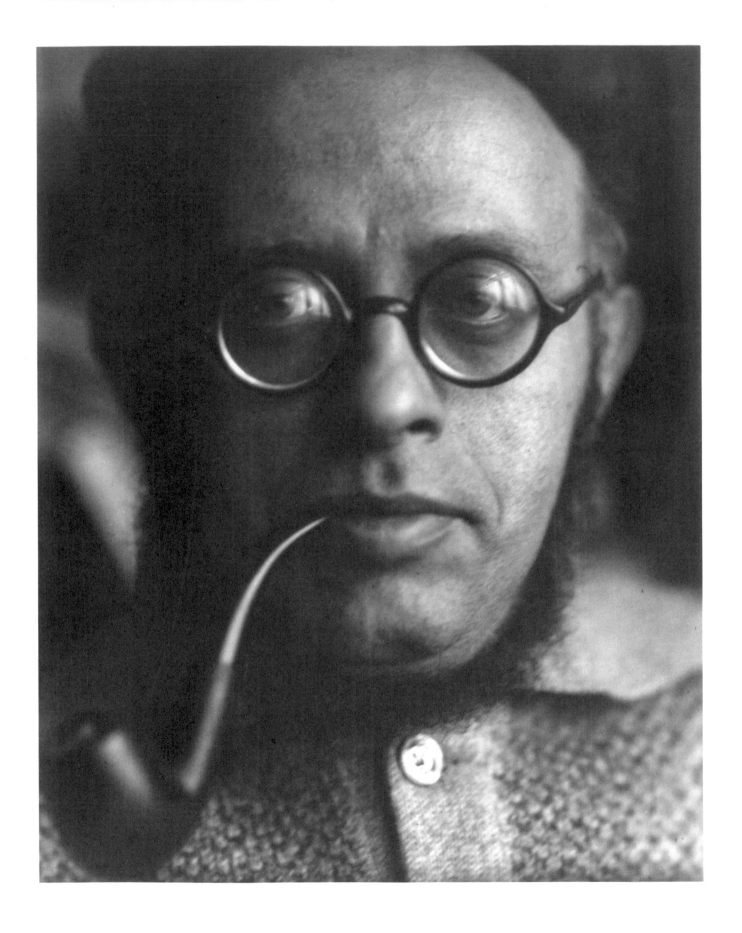

KARL RADEK, Journalist, Russian Revolutionary, Moscow, 1933

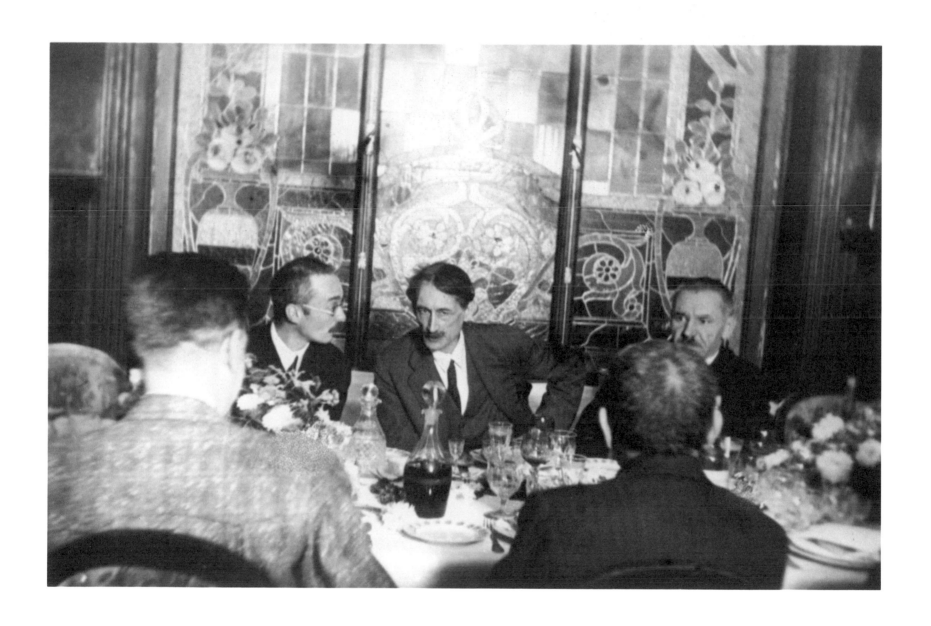

HENRI BARBUSSE, Writer, Moscow, 1933

KARL VALENTIN and LIESL KARLSTADT, Comedians, Berlin, ca. 1930

CARL ZUCKMAYER, Dramatist, and his family, Berlin, ca. 1930

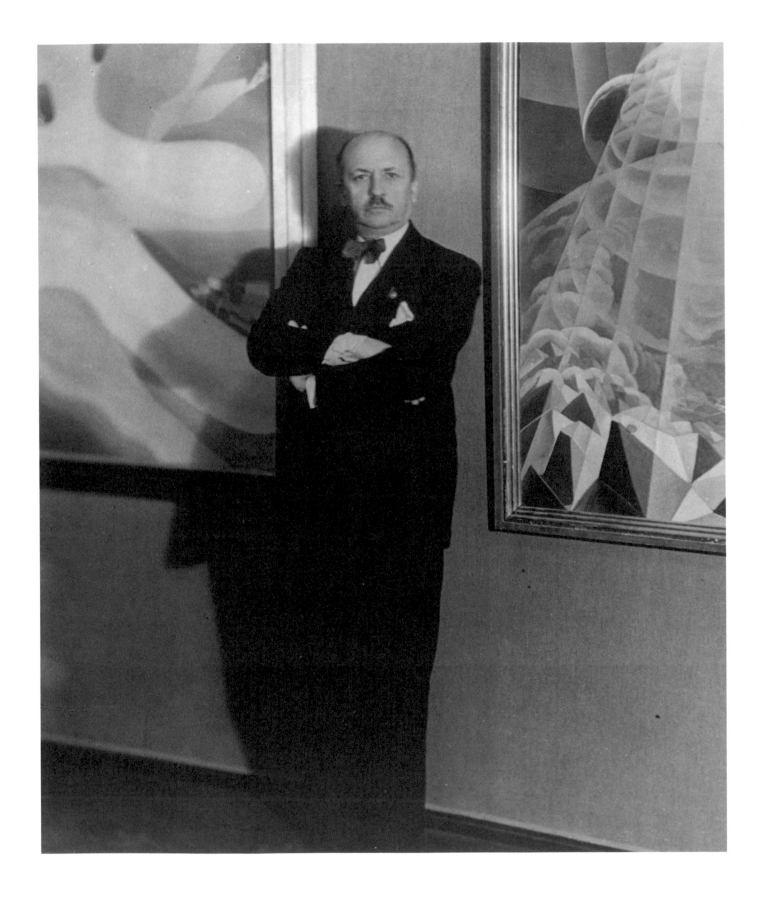

MARINETTI, Italian Poet, Berlin, 1929

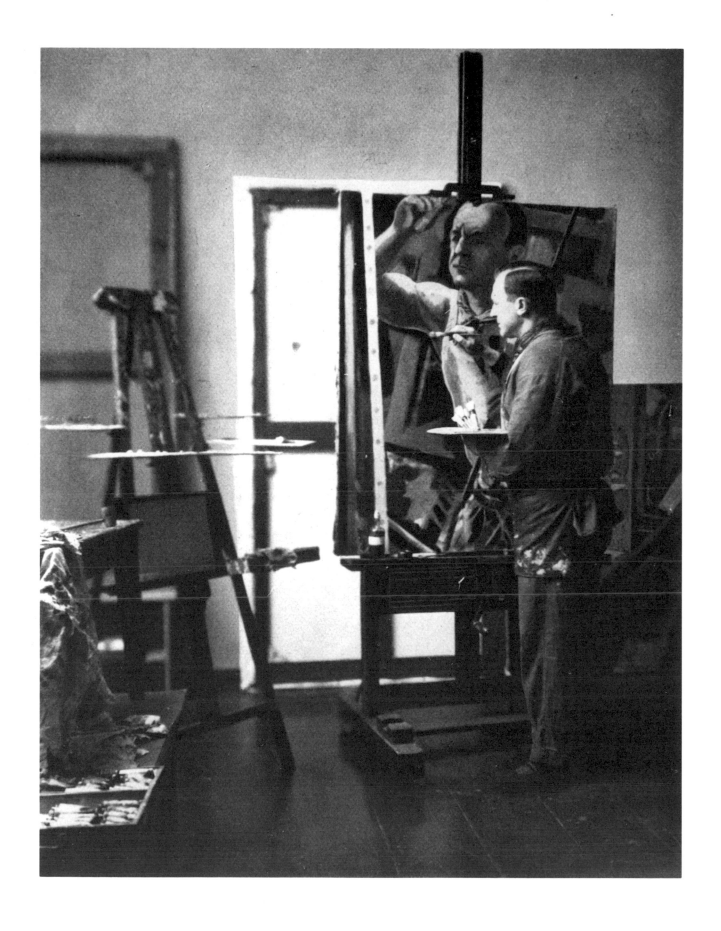

GEORG GROSZ, Artist, Berlin, ca. 1929

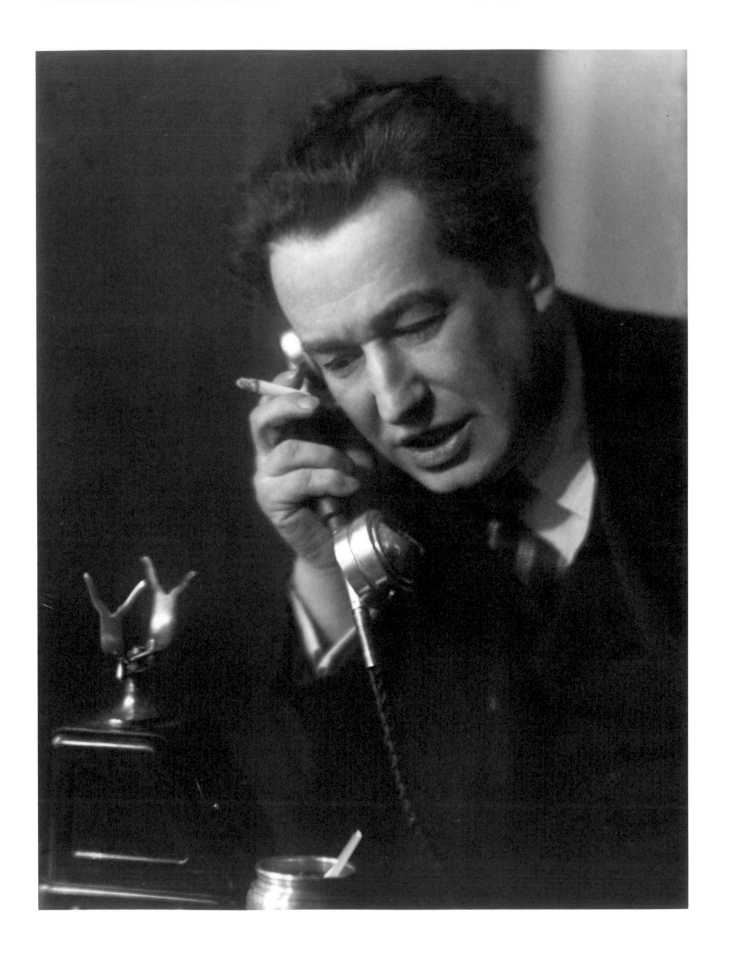

EGON ERWIN KISCH, Journalist, Berlin, ca. 1930 60

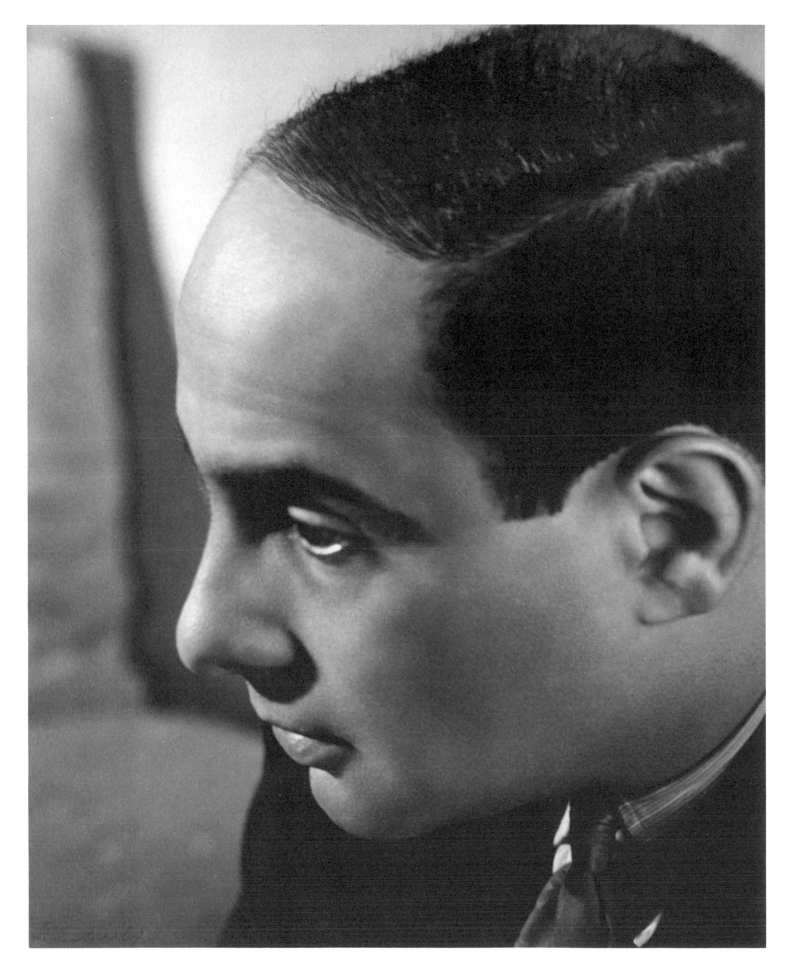

LORENZ HART, Lyrics Writer, New York, ca. 1950

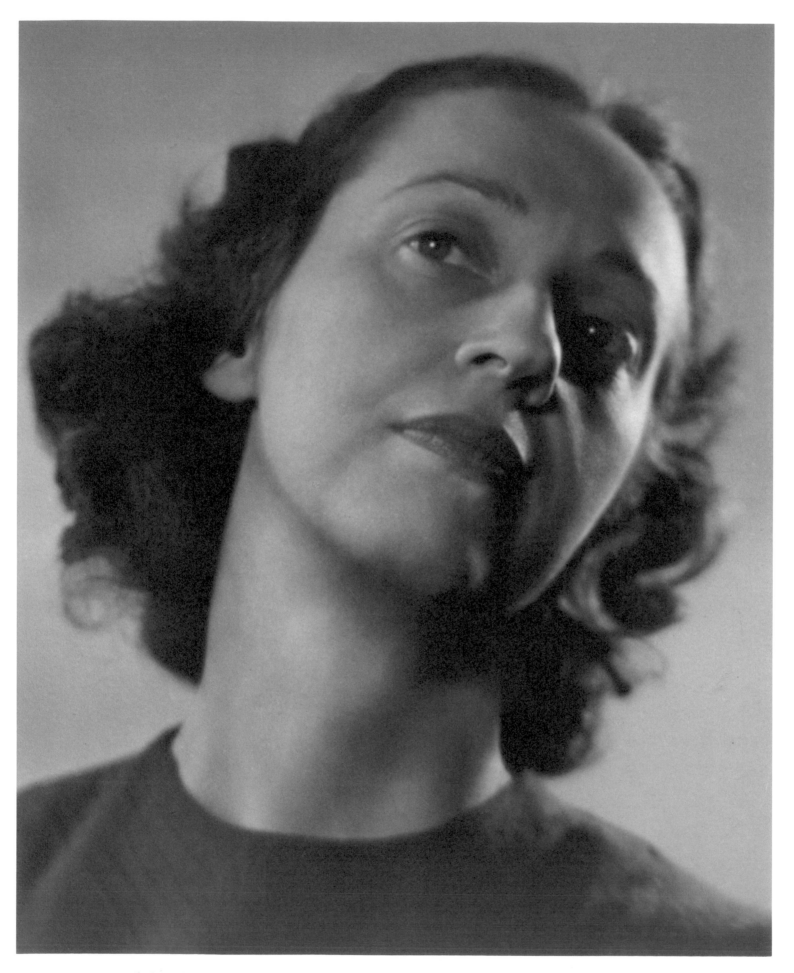

BARBARA MORGAN, Photographer, New York, 1944 62

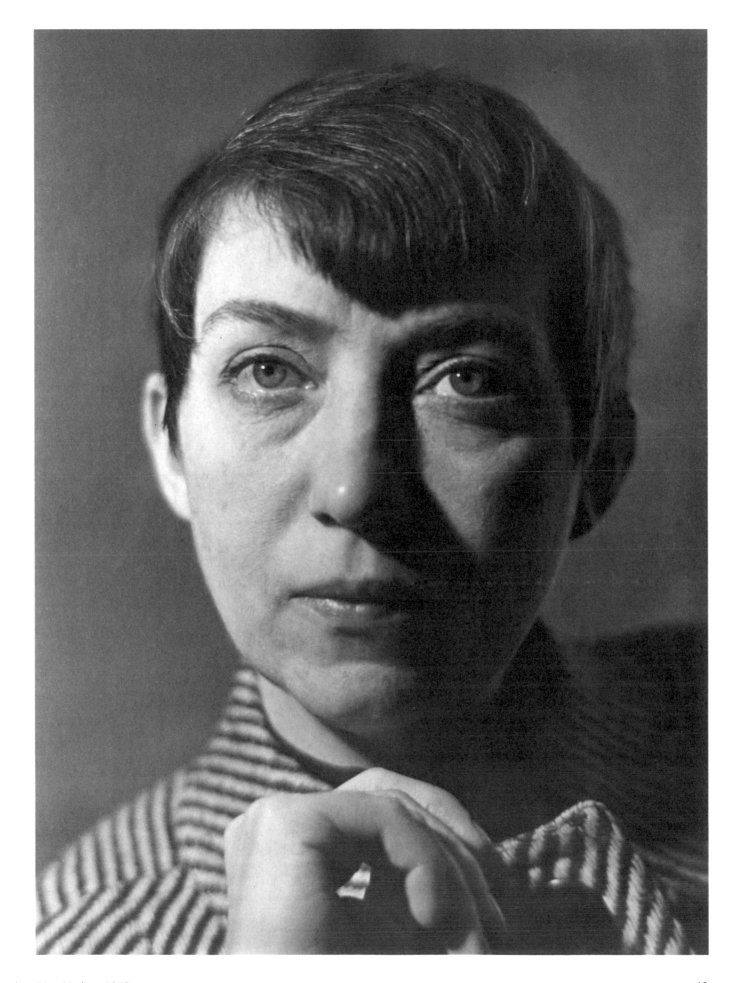

BERENICE ABBOTT, Photographer, New York, c. 1943 63

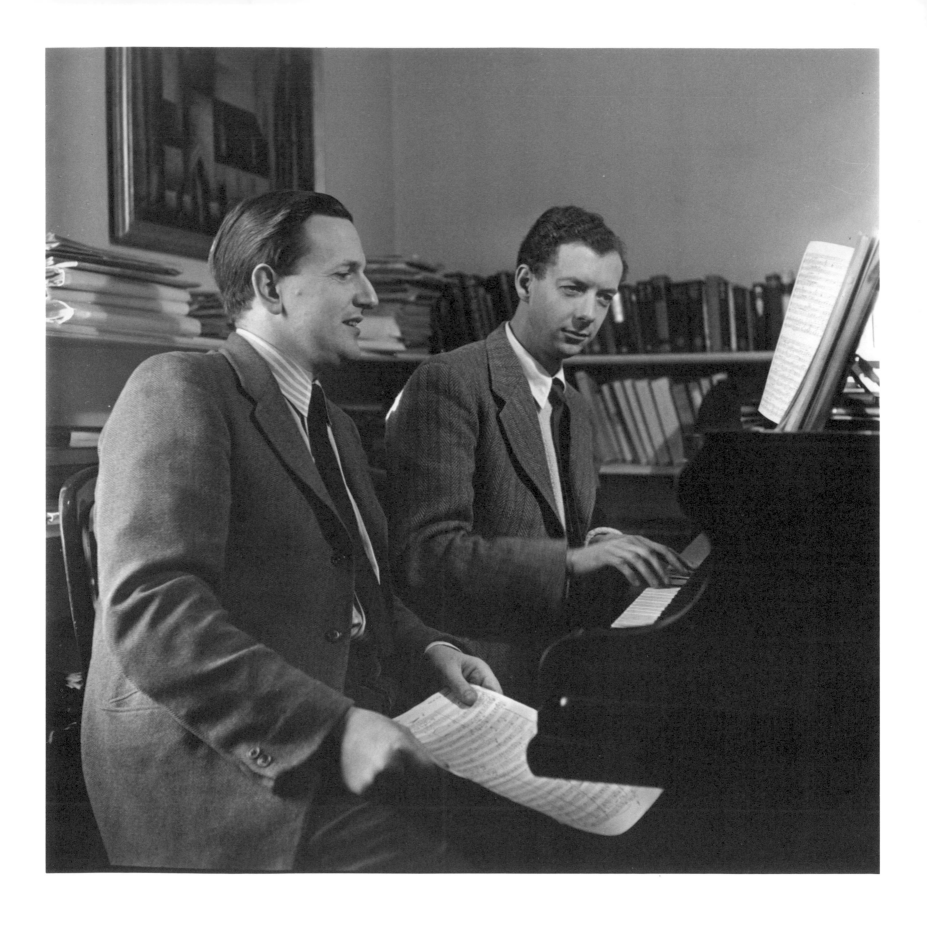

PETER PEARS, Singer, and BENJAMIN BRITTEN, Composer, Amityville, Long Island, New York, 1939

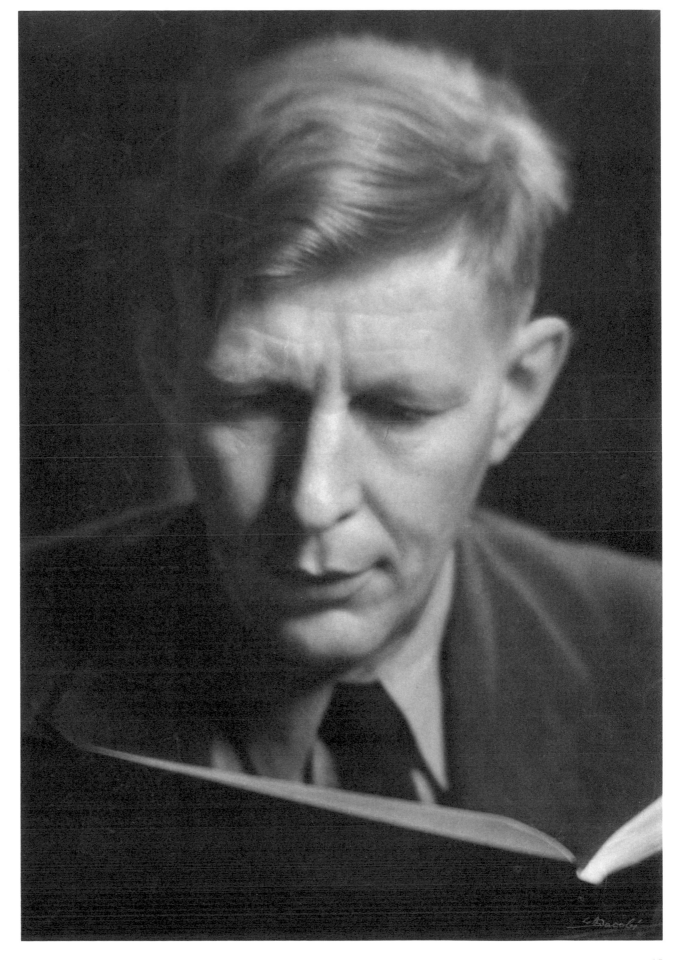

W. H. AUDEN, Poet, New York, 1946

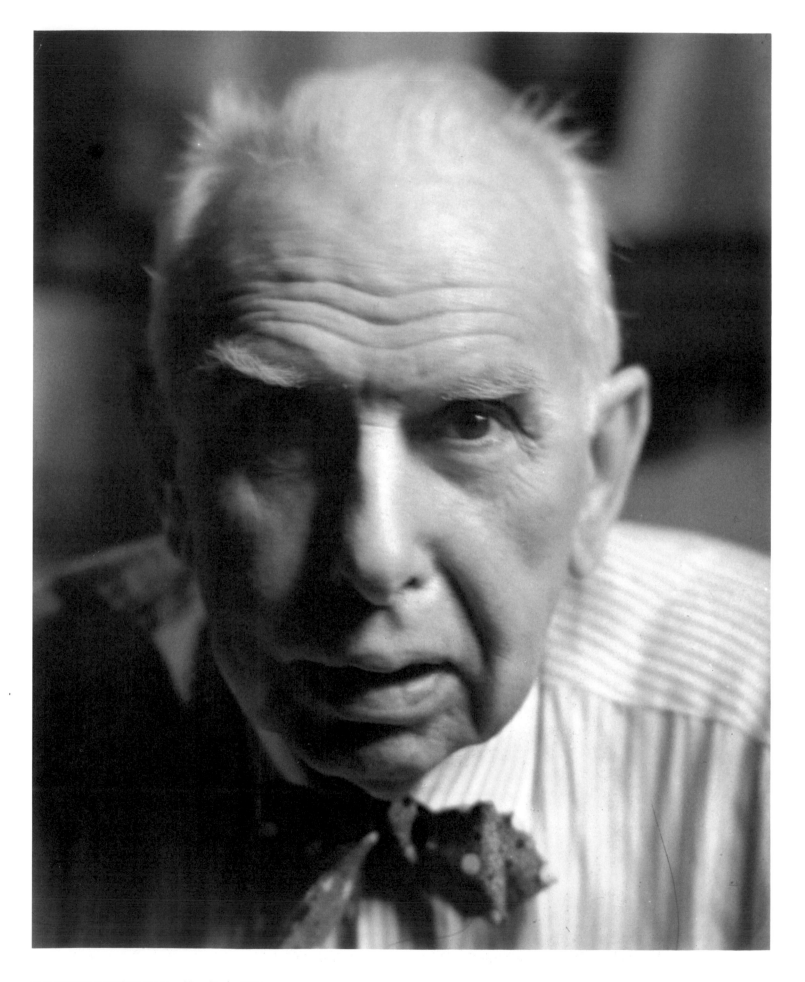

THEODORE DREISER, Writer, New York, 1944

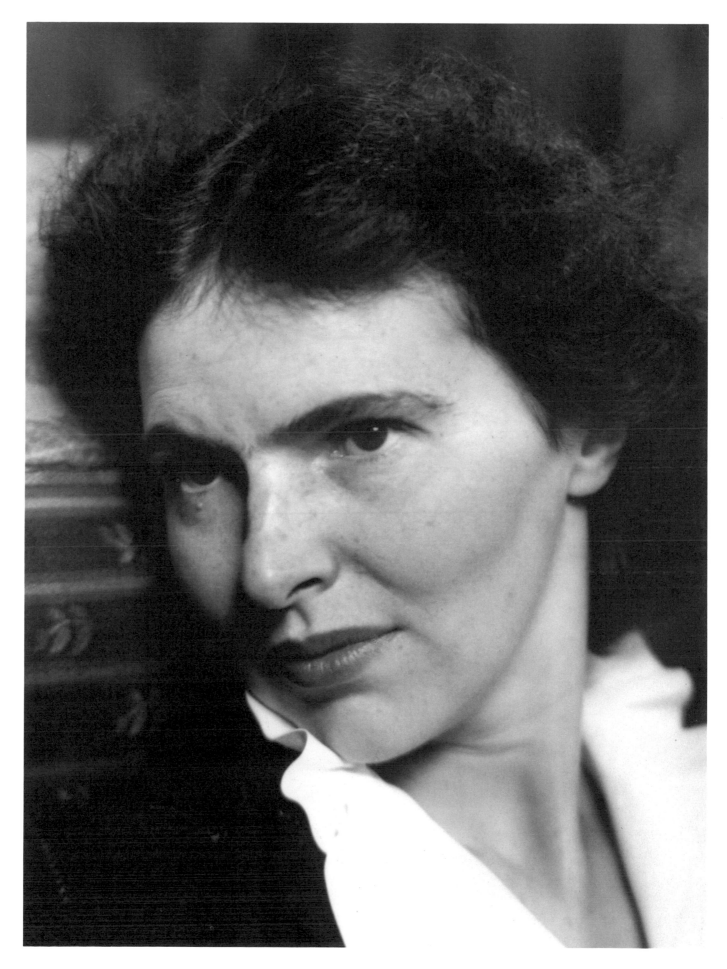

NANCY NEWHALL, Writer, Curator, New York, 1943

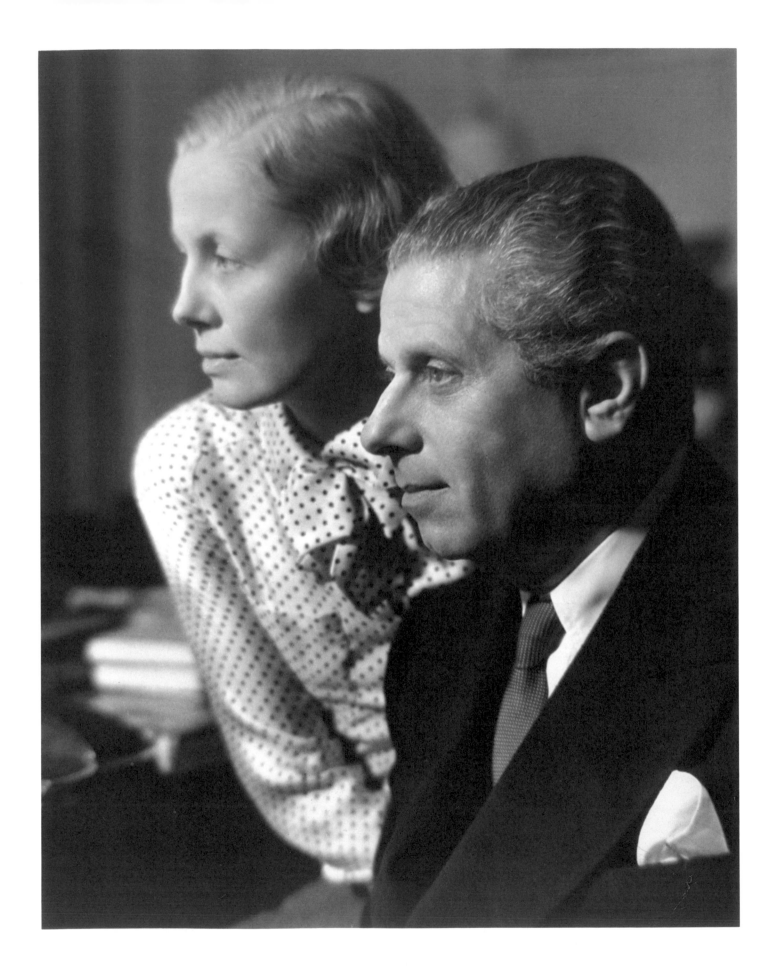

MAX REINHARDT, Director, Actor, Producer, and wife, HELEN THIMIG, Actress, New York, 1936

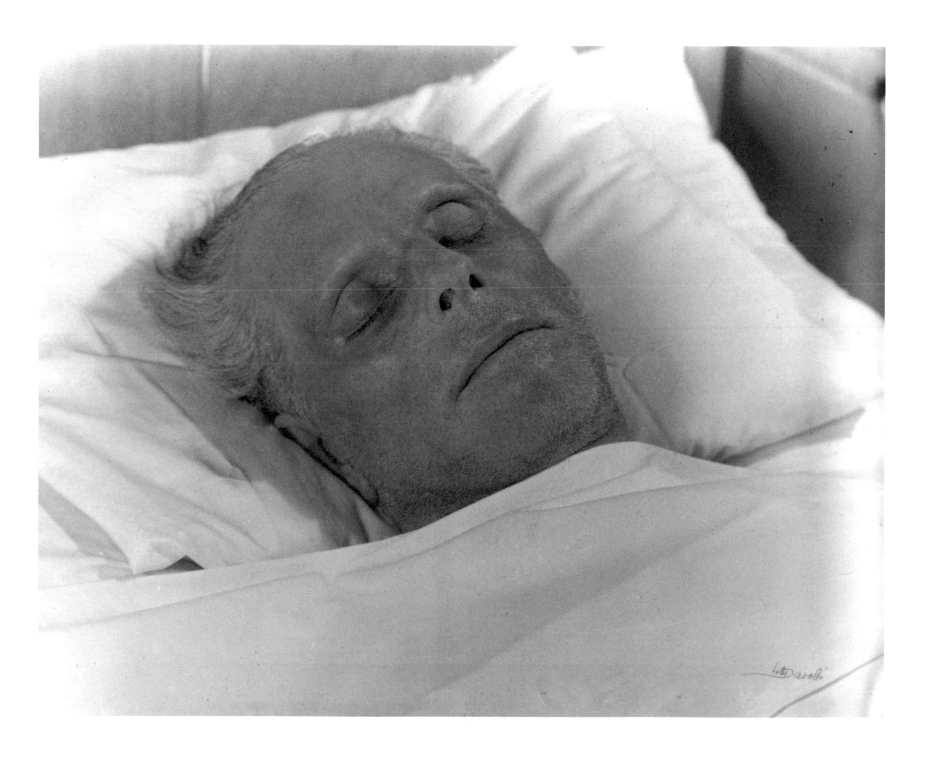

MAX REINHARDT, death portrait, New York, 1943

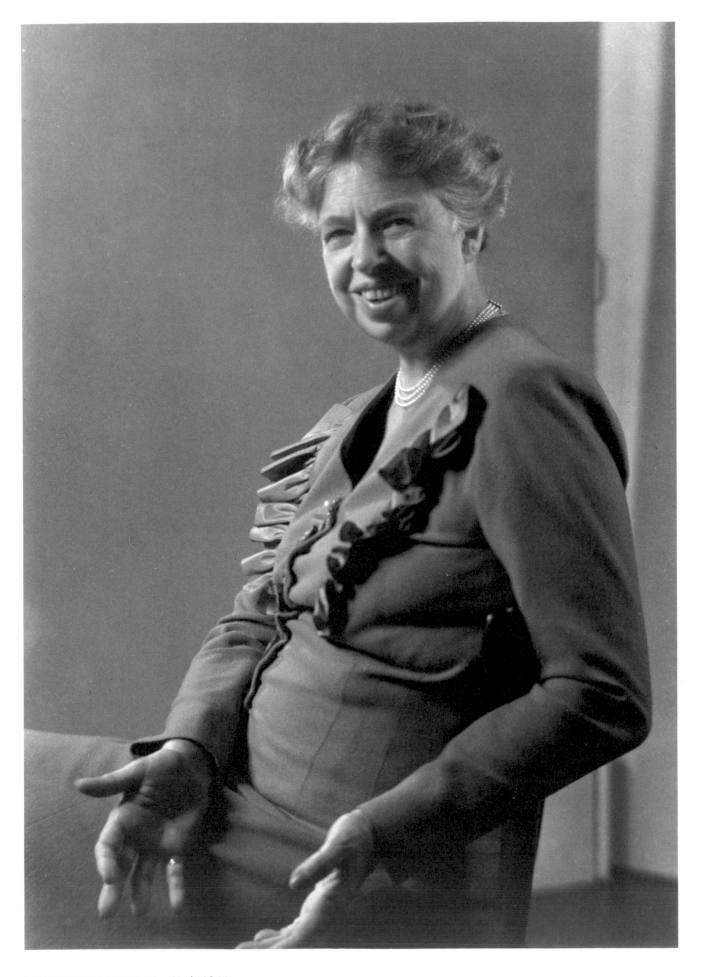

ELEANOR ROOSEVELT, New York, 1944

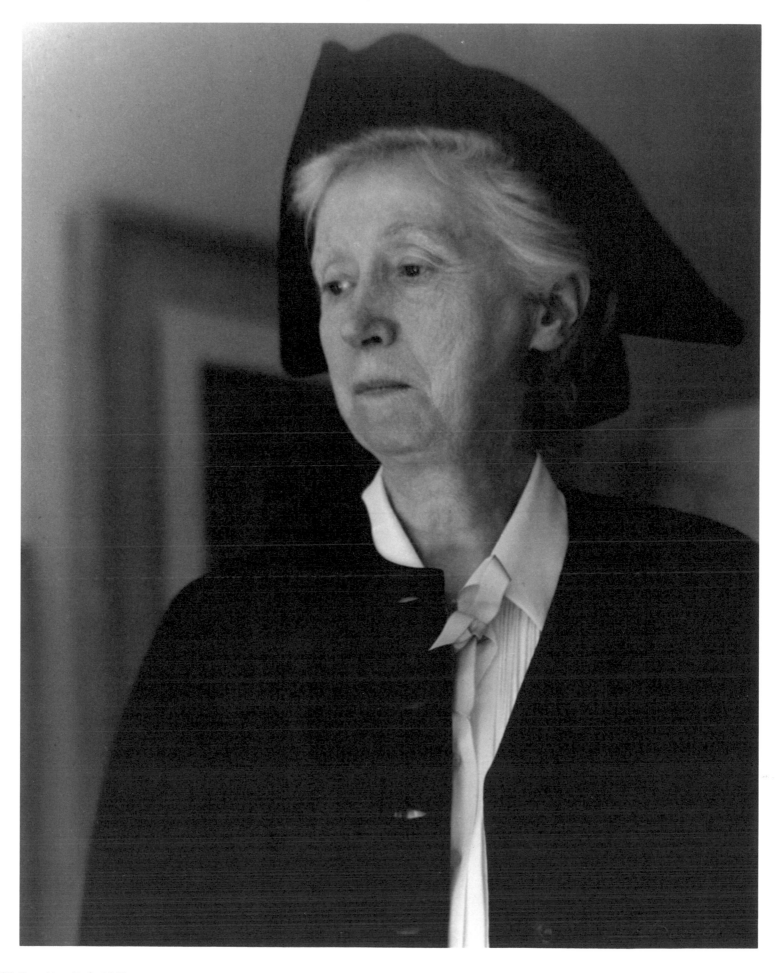

MARIANNE MOORE, Poet, New York, 1945

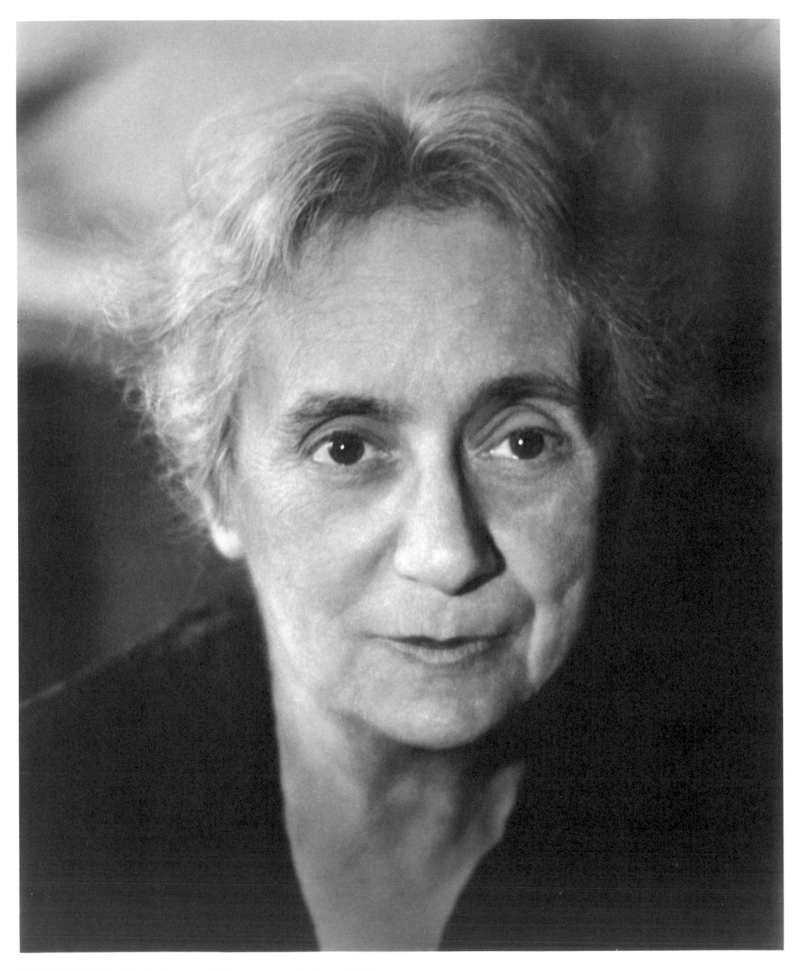

HENRIETTE SZOLD, Zionist, Founder of Hadassah, New York, ca. 1938

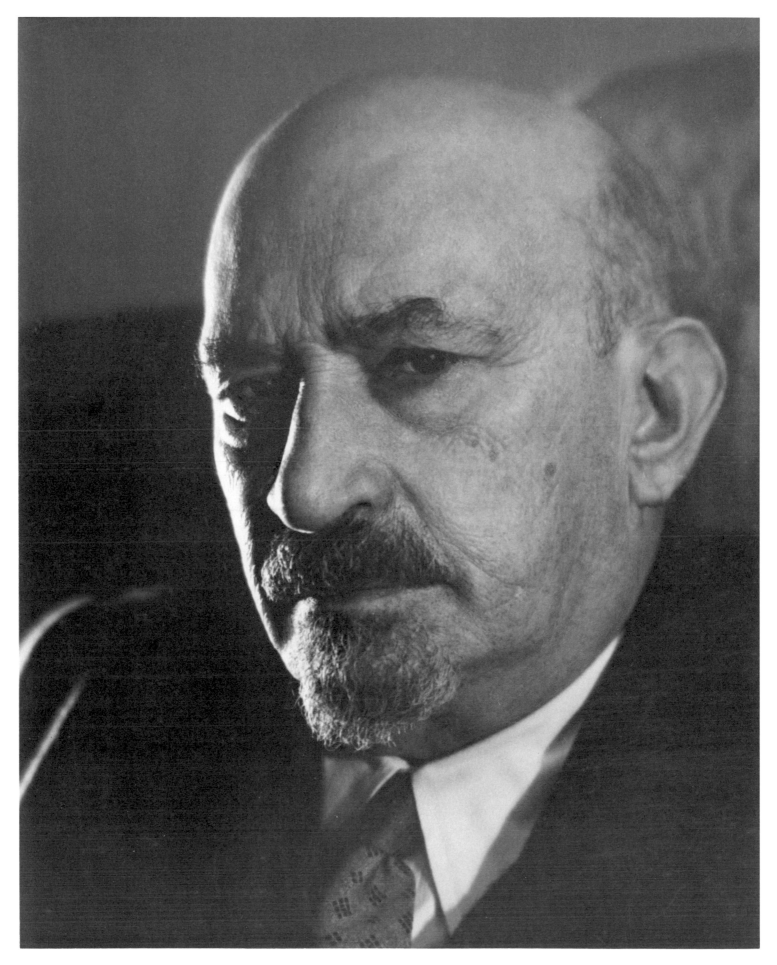

CHAIM WEIZMANN, First President of Israel (official portrait), New York, 1948

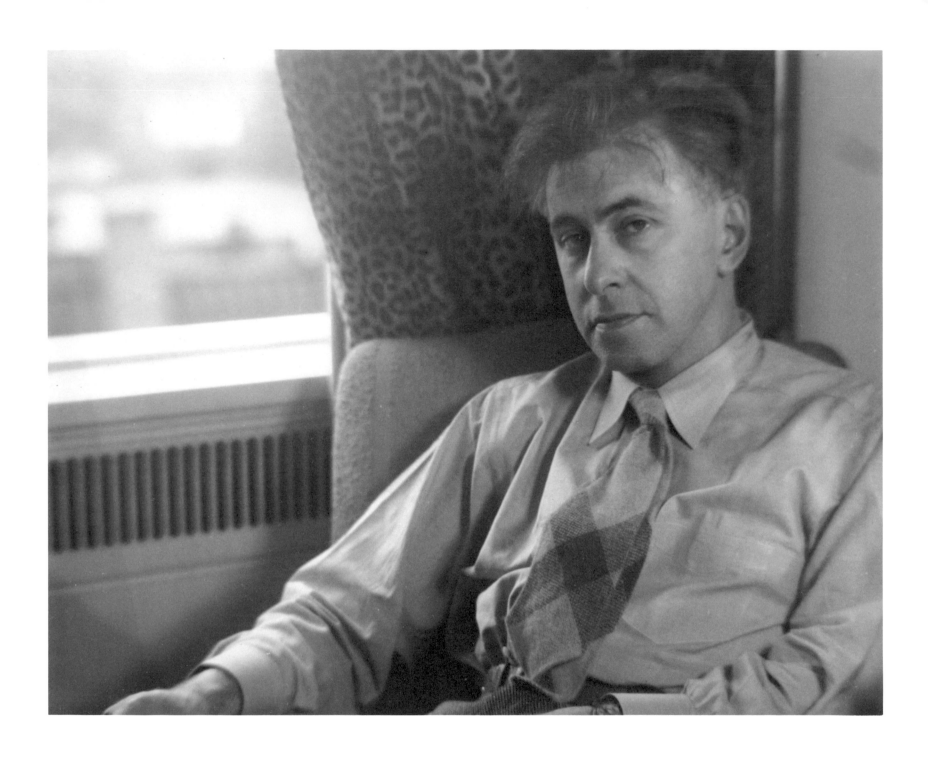

ILJA EHRENBURG, Writer, Waldorf-Astoria Hotel, New York, ca. 1947

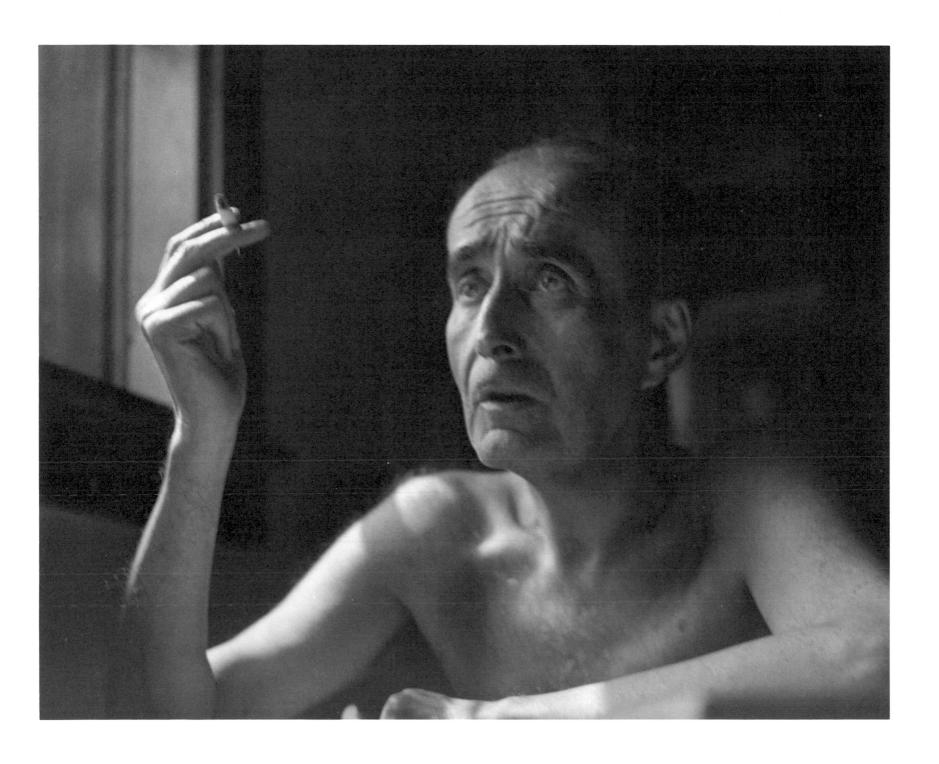

ERICH REISS, Publisher, Deering, N.H., 1950 75

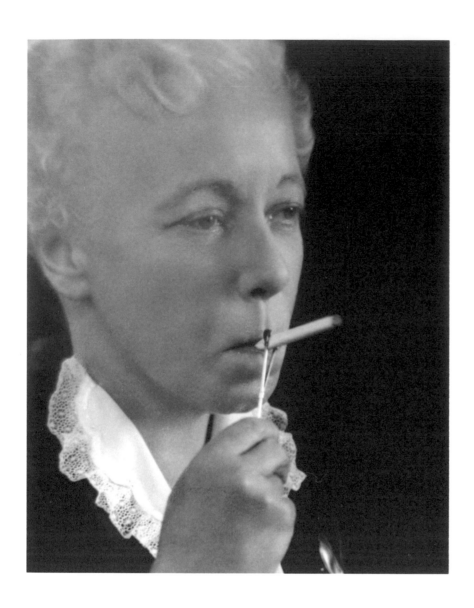

KARIN HORNEY, Psychoanalyst, New York, ca. 1947

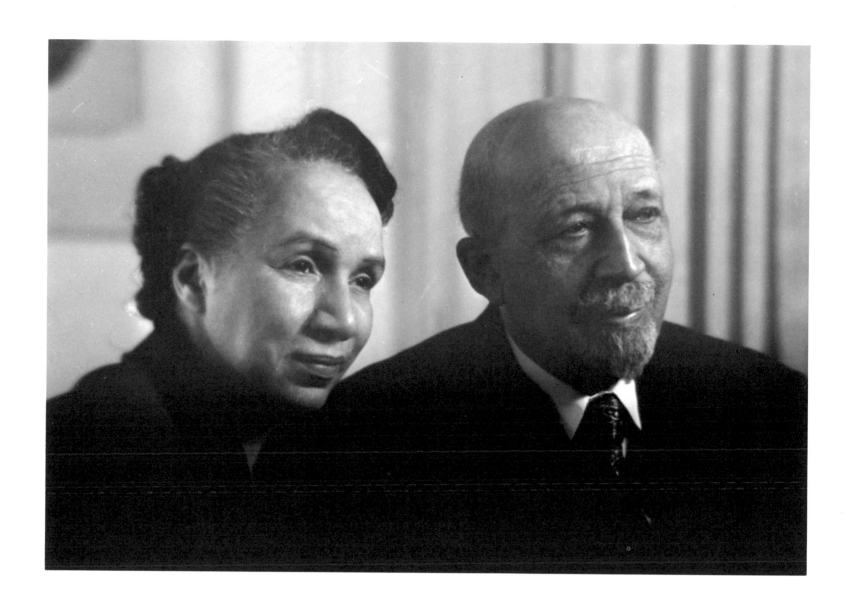

WILLIAM E. DuBOIS, Historian, Writer, and wife, SHIRLEY GRAHAM, Writer, New York, ca. 1950

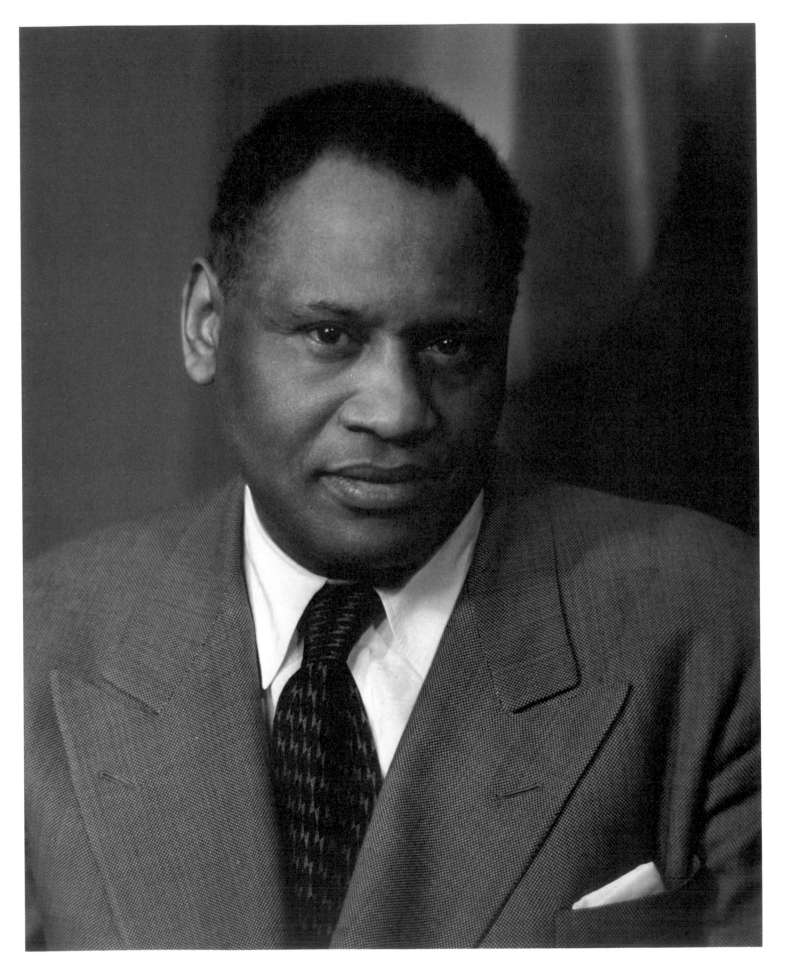

PAUL ROBESON, Actor, Singer, New York, ca. 1952

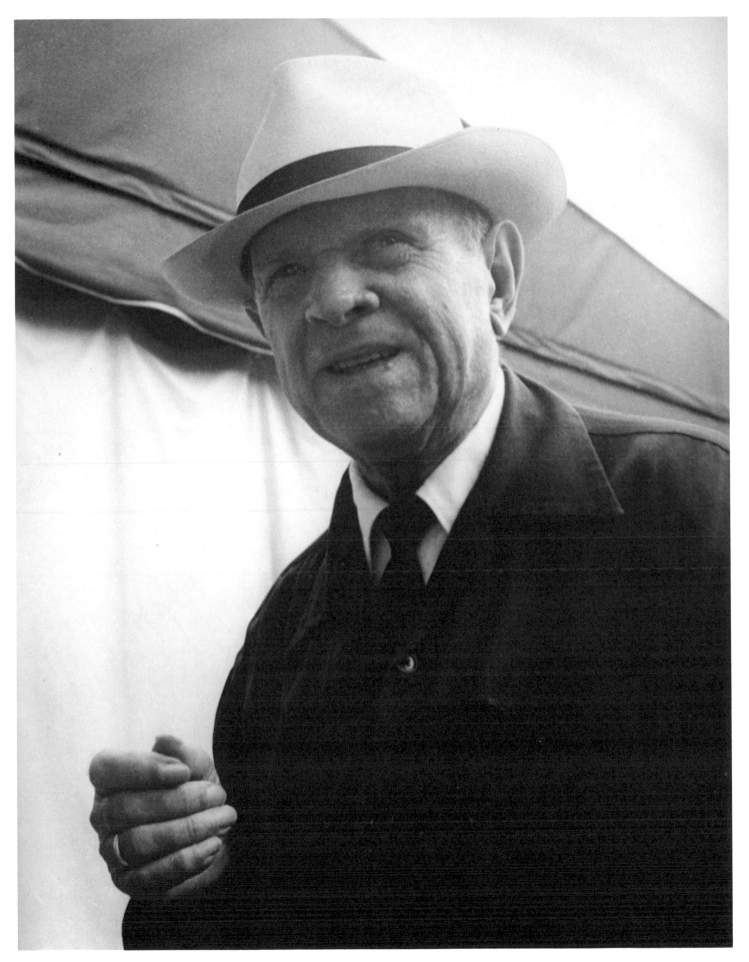

PABLO CASALS, Cellist, Marlboro, Vt., 1967

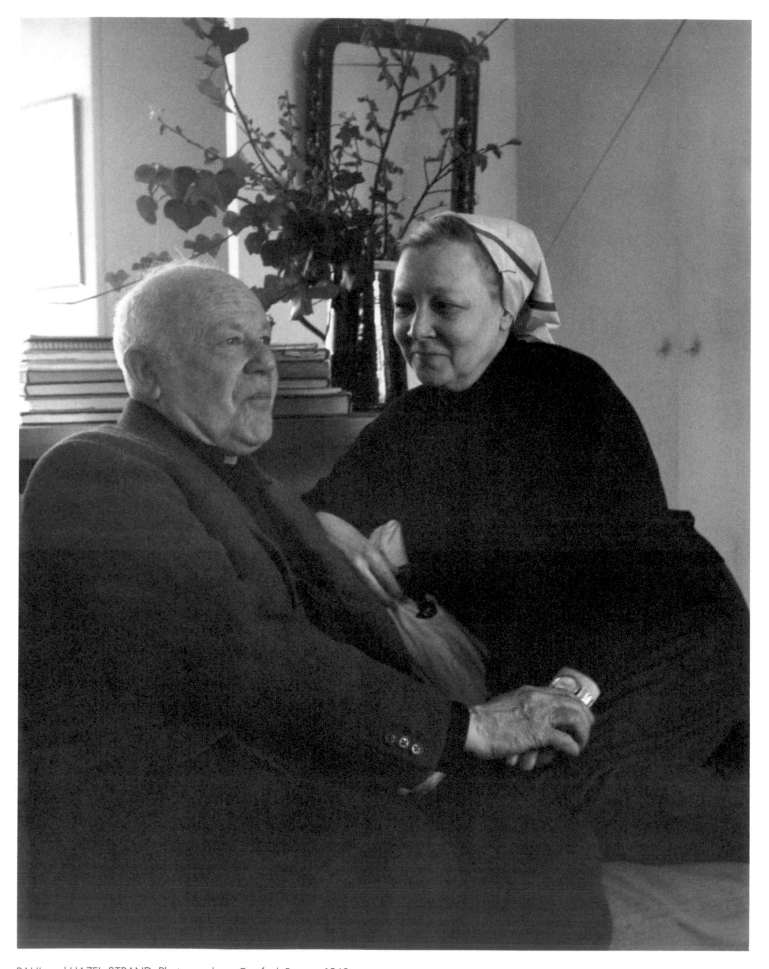

PAUL and HAZEL STRAND, Photographers, Orgéval, France, 1963

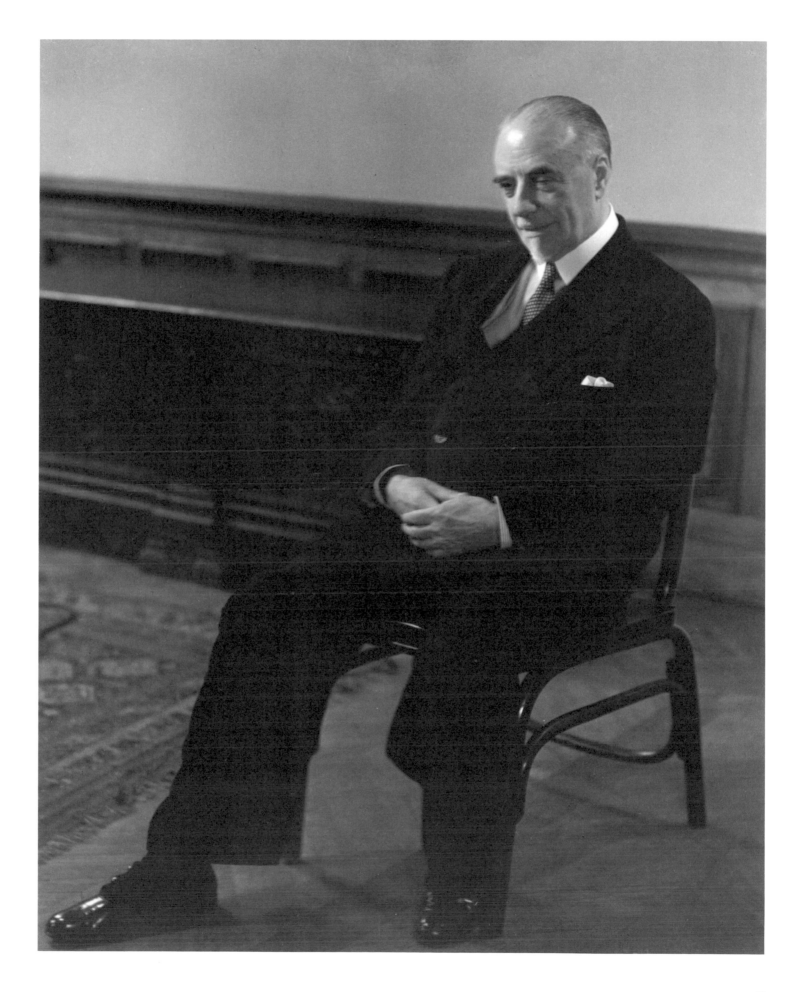

SIR THOMAS BEECHAM, Conductor, New York, ca. 1942

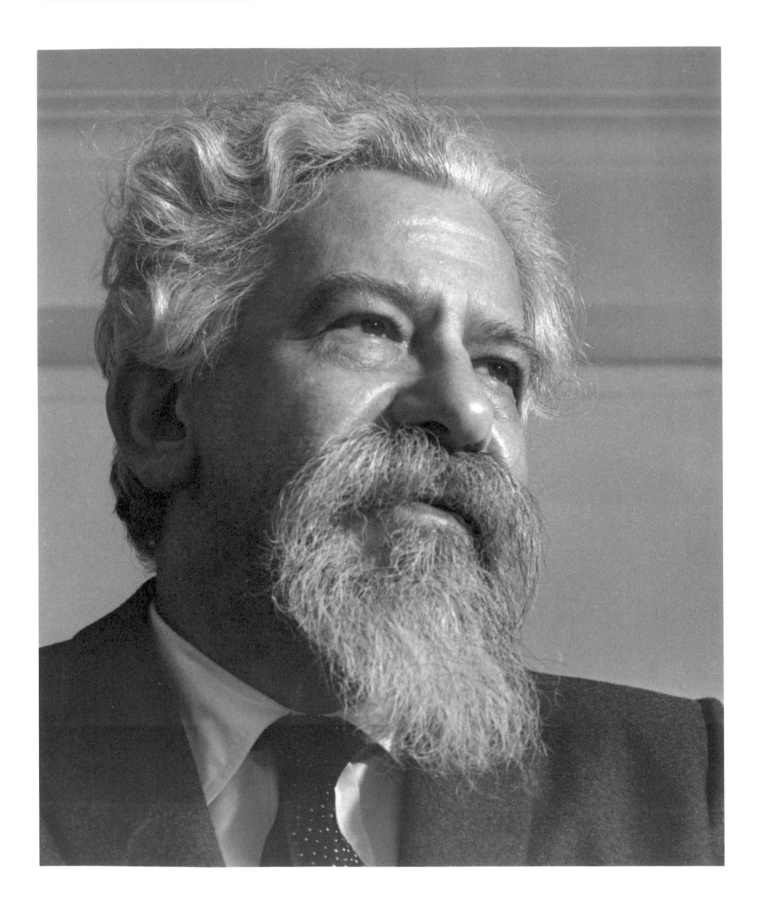

ABRAHAM HESCHEL, Rabbi, Writer, Teacher, New York, ca. 1955

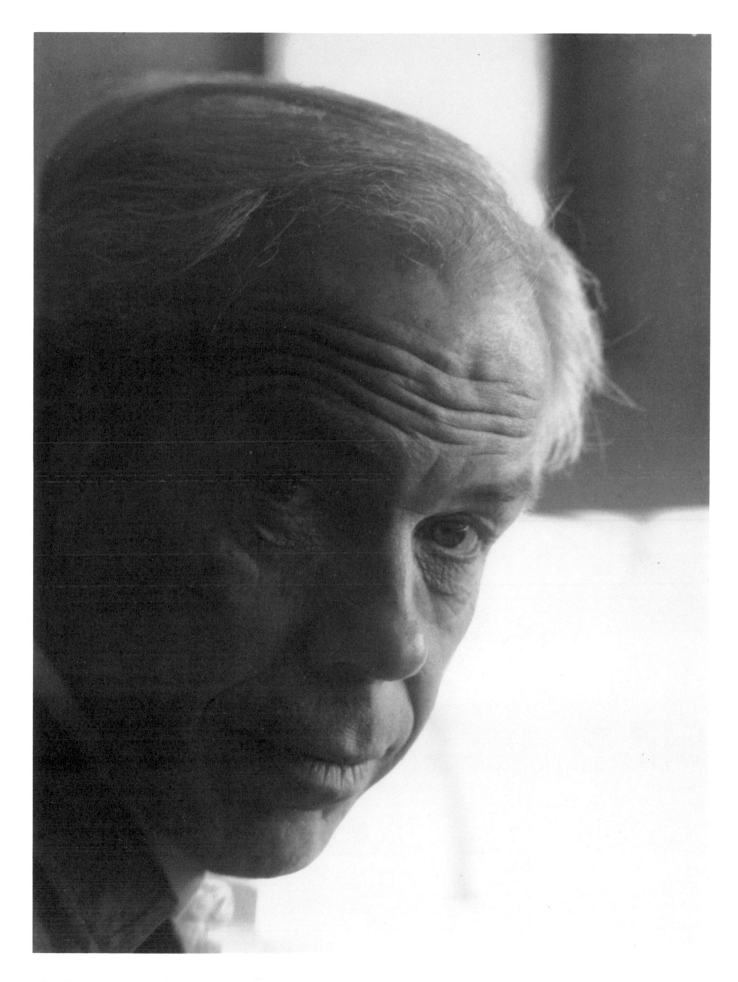

MINOR WHITE, Photographer, Teacher, Deering, N.H., ca. 1962

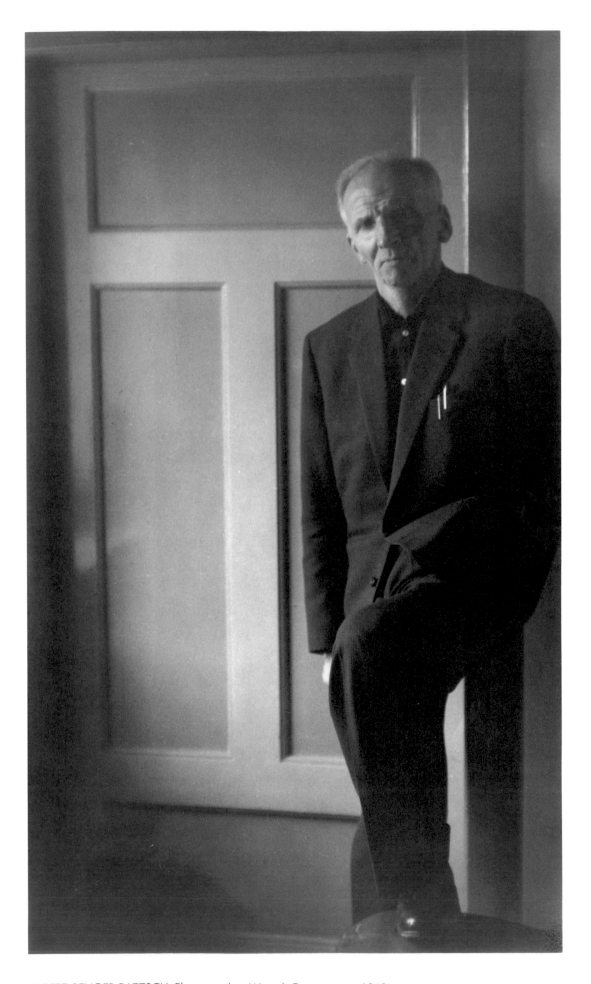

ALBERT RENGER-PATZSCH, Photographer, Wamel, Germany, ca. 1963

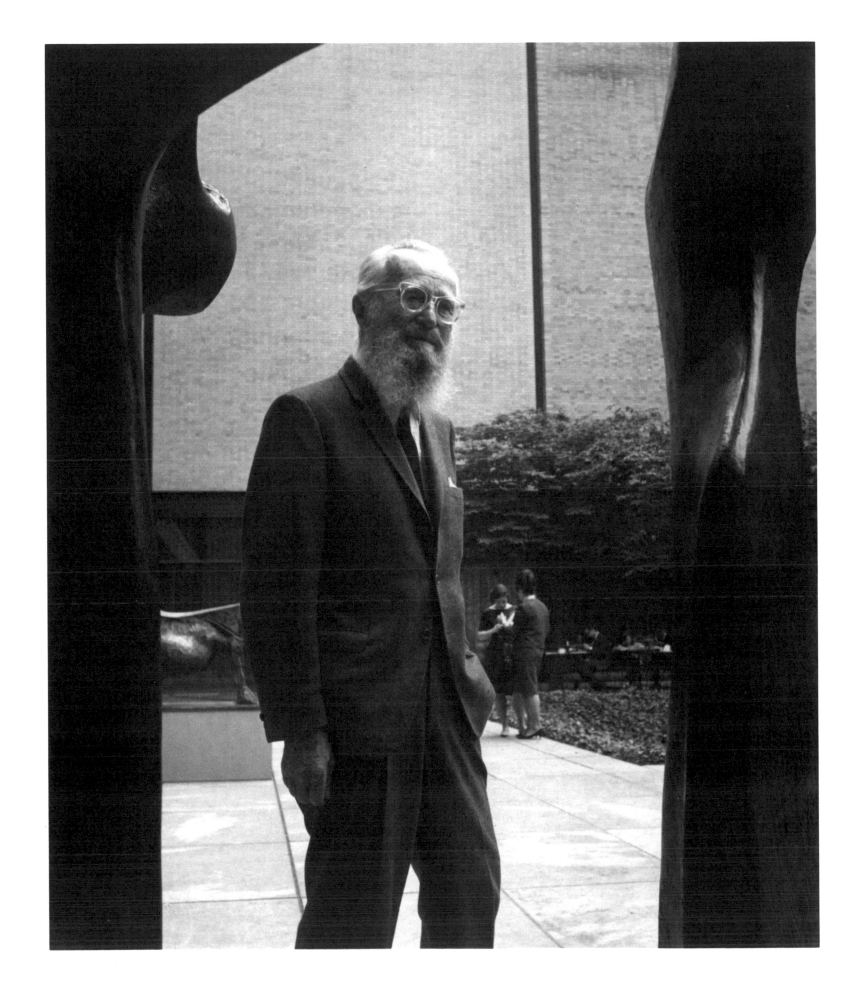

EDWARD STEICHEN, Photographer in the Museum of Modern Art Sculpture Court, New York, ca. 1960

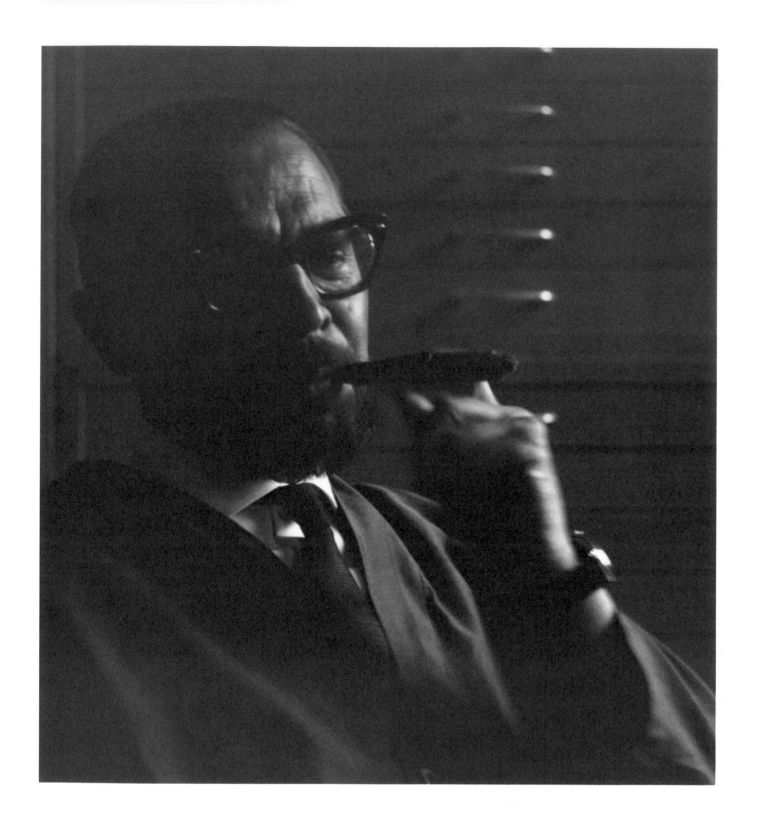

OTTO STEINERT, Photographer, Essen, Germany, 1963

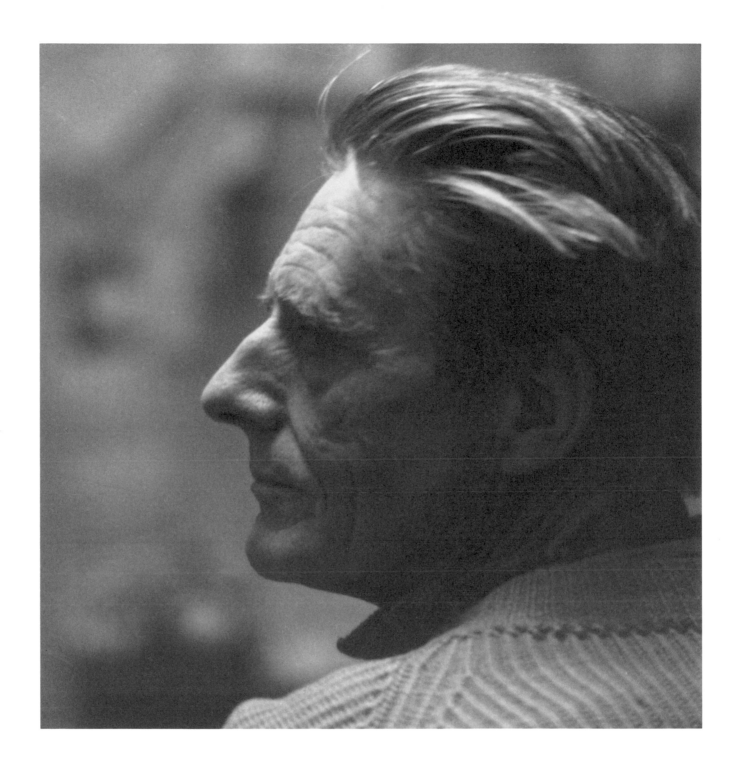

STANLEY WILLIAM HAYTER, Artist, Paris, 1963 87

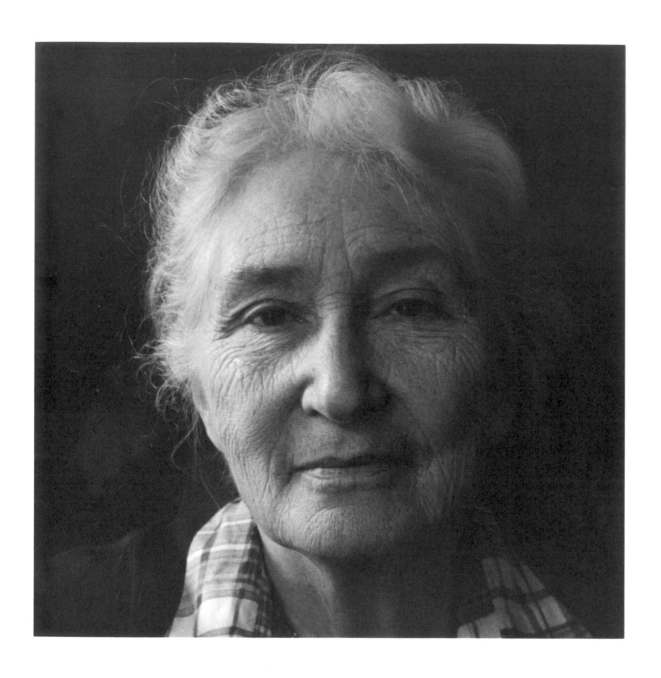

FRANCES FLAHERTY, Photographer, Brattleboro, Vt., ca. 1962

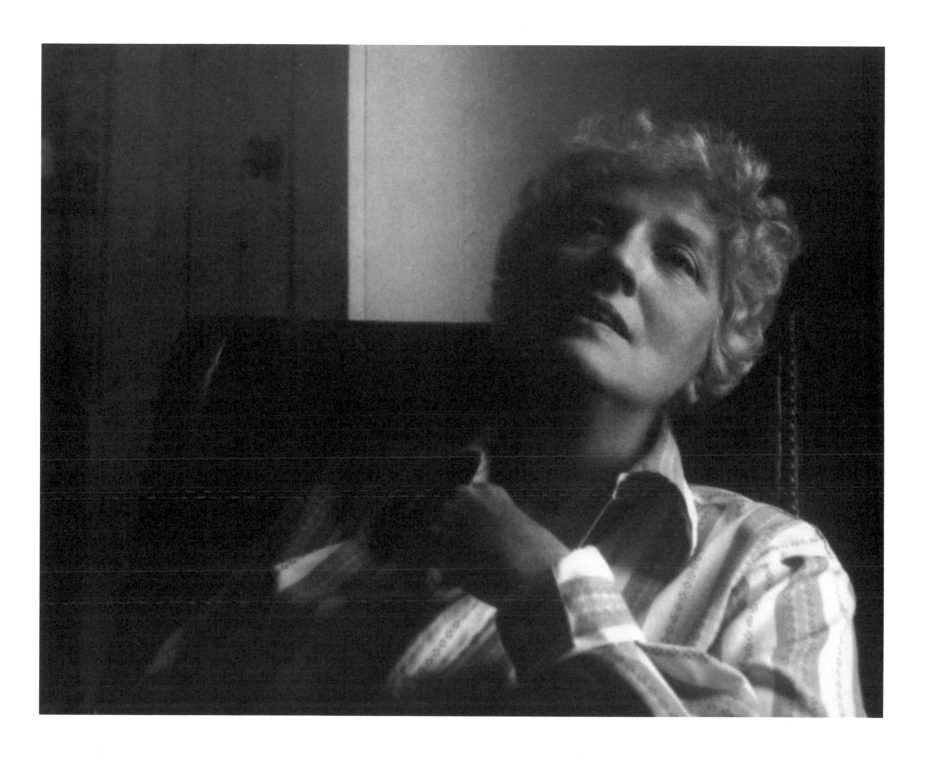

MAY SARTON, Poet, Nelson, N.H., 1970

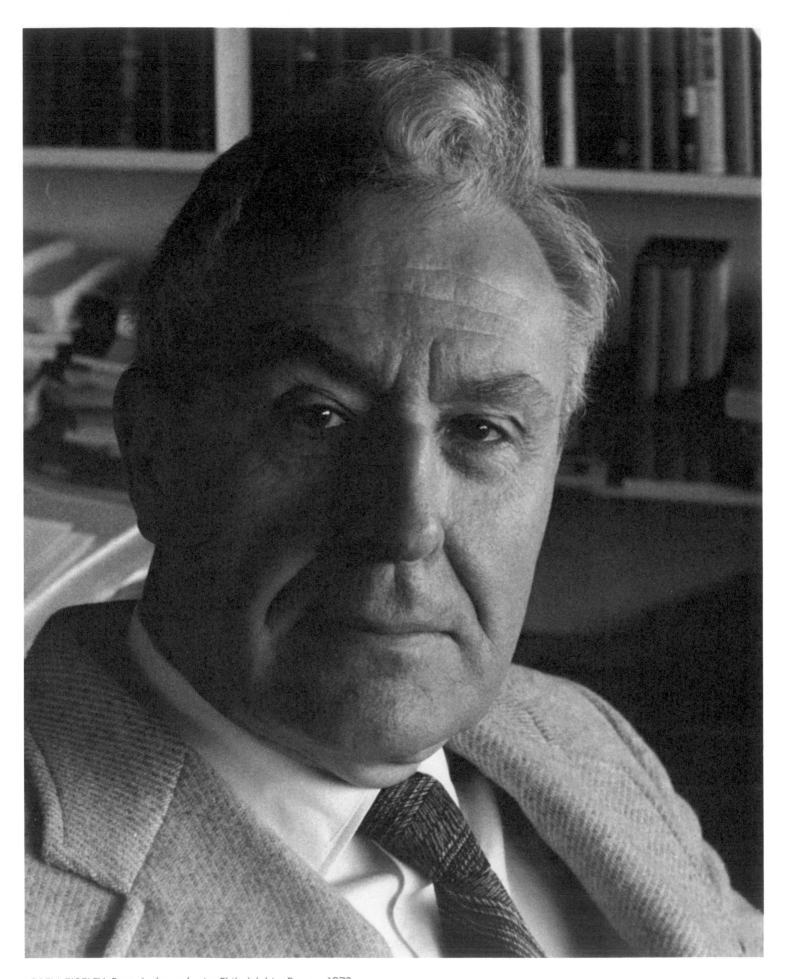

LOREN EISELEY, Poet, Anthropologist, Philadelphia, Pa., ca. 1973

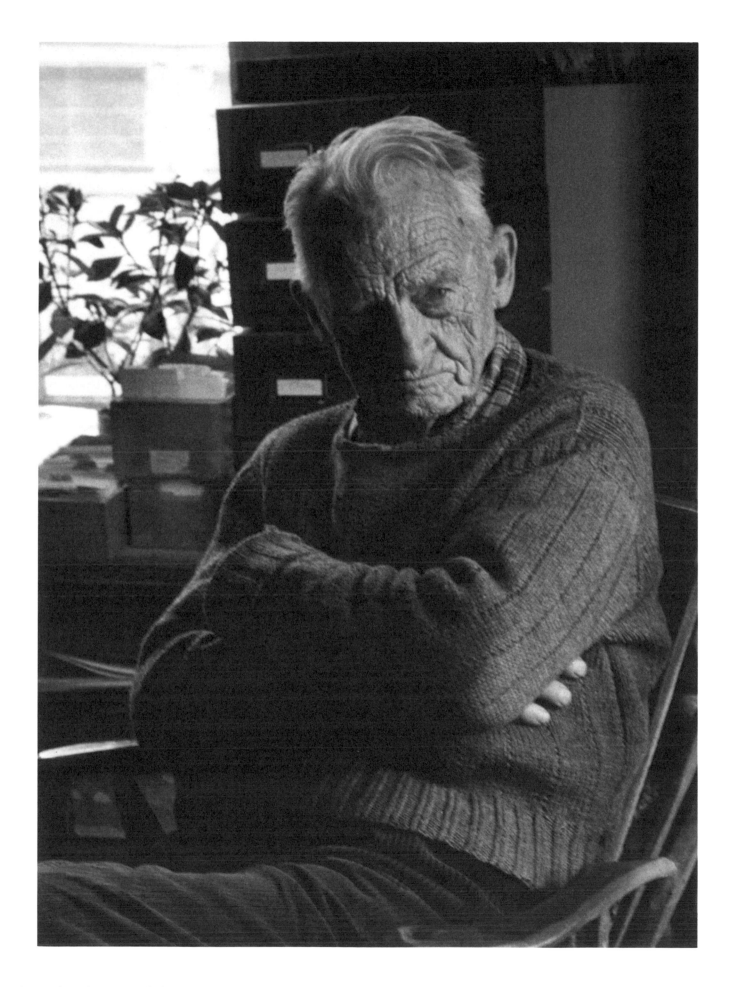

SCOTT NEARING, Writer, Naturalist, Harborside, Maine, 1973

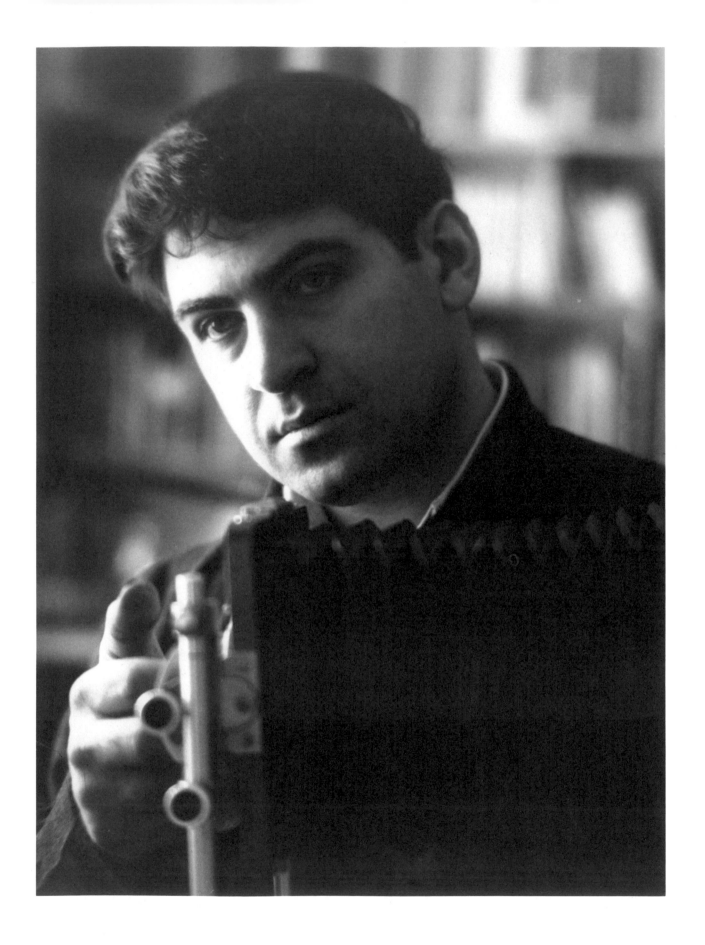

PAUL CAPONIGRO, Photographer, Pianist, Deering, N.H., ca. 1965

Extended Portraits

ALBERT EINSTEIN
THOMAS MANN
ALFRED STIEGLITZ
MARC CHAGALL
ROBERT FROST

ALBERT EINSTEIN, Gatow, Germany, 1927

94

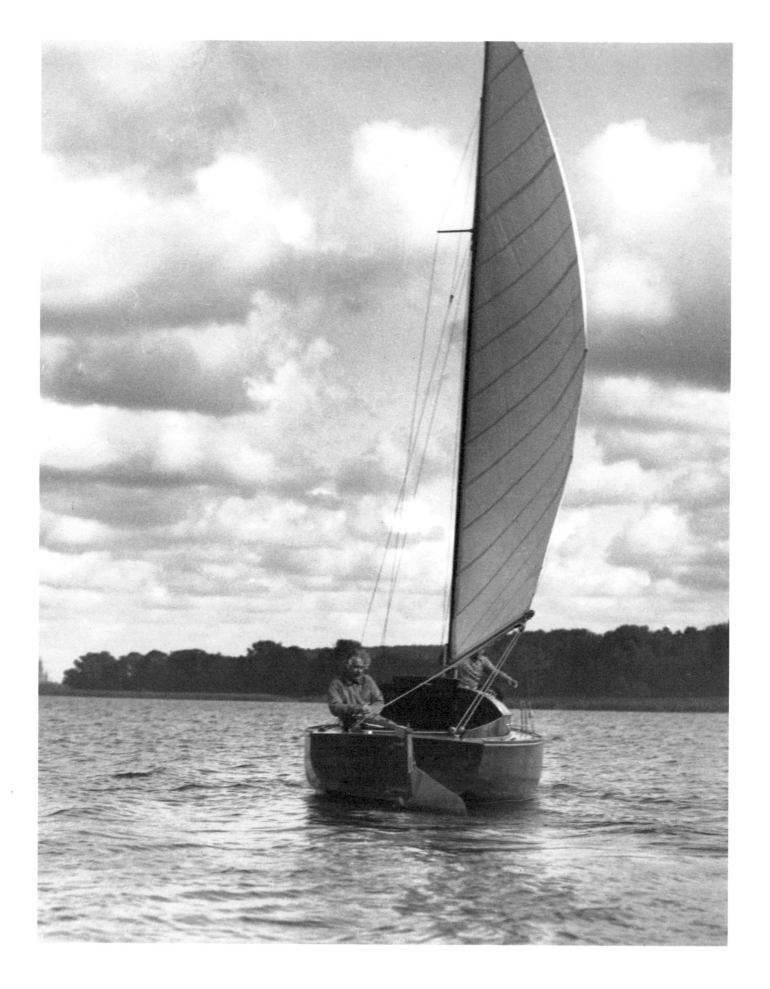

ALBERT EINSTEIN, Caputh, Germany, 1928

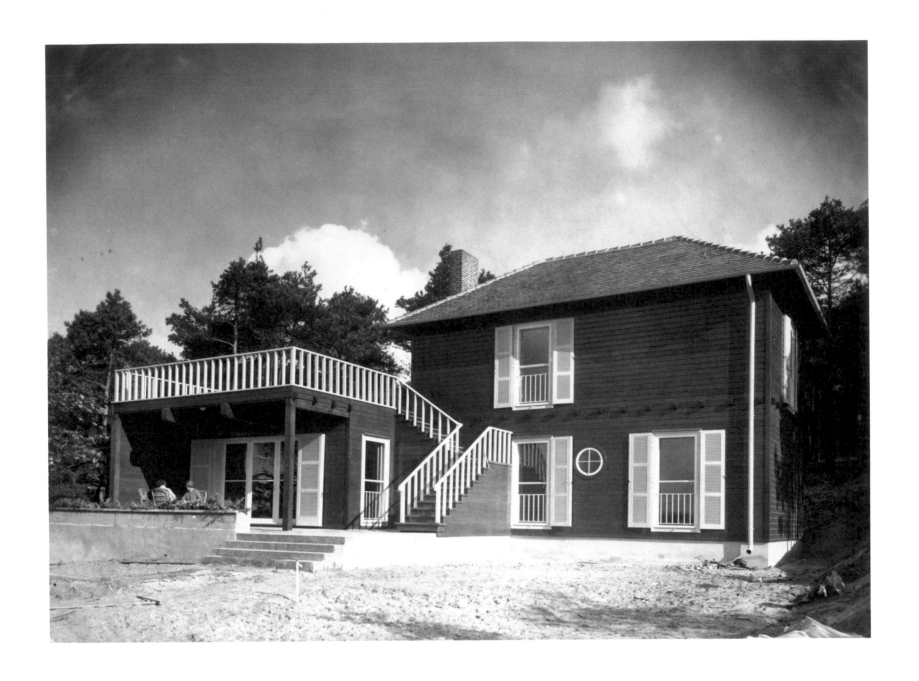

Einstein's house, Caputh, Germany, 1928

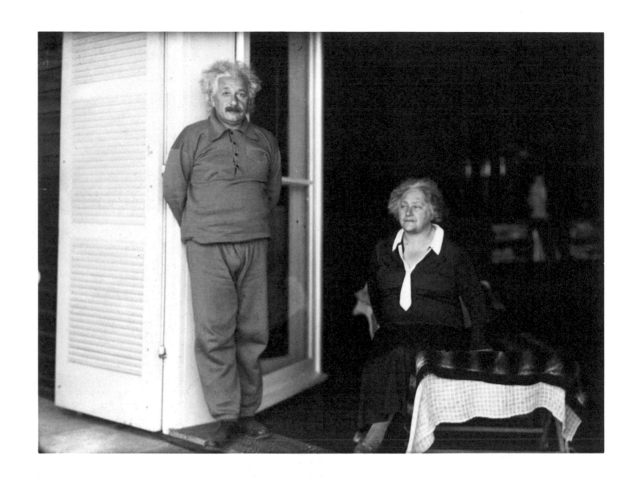

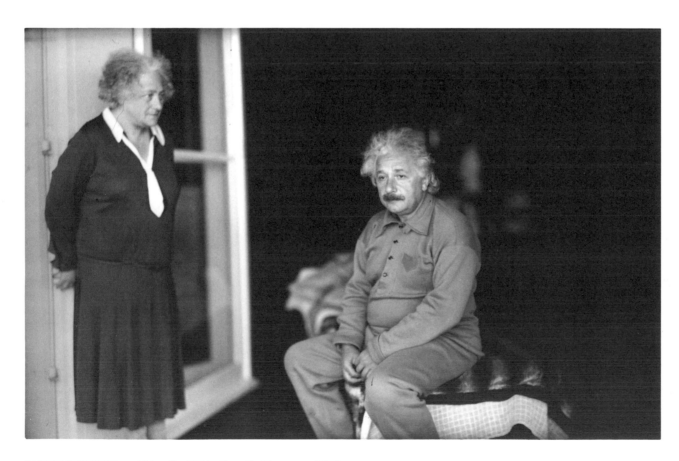

ALBERT EINSTEIN, and his wife, ELSA, Caputh, Germany, 1928

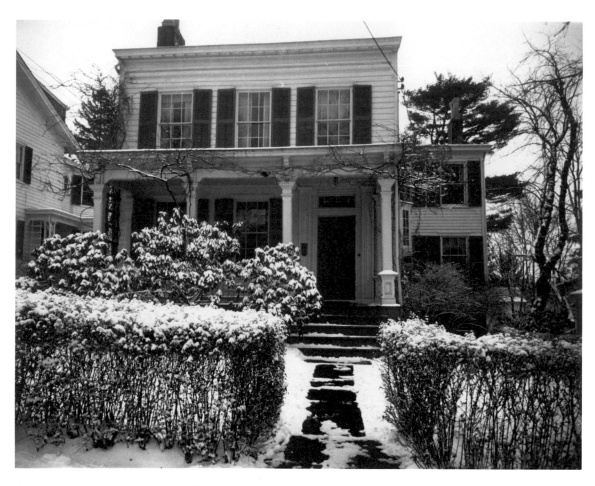

Einstein's House, Princeton, N.J., 1938

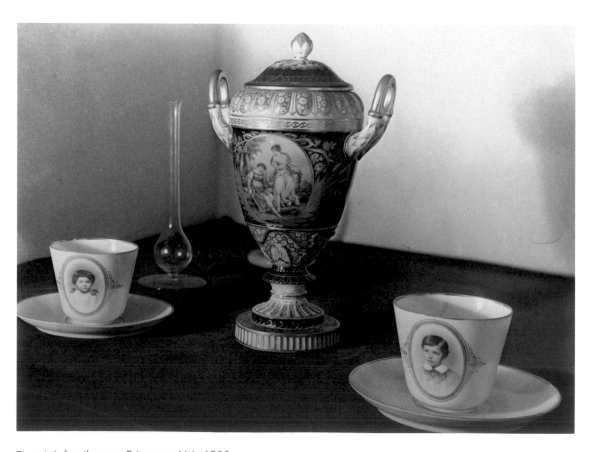

Einstein's family cups, Princeton, N.J., 1938

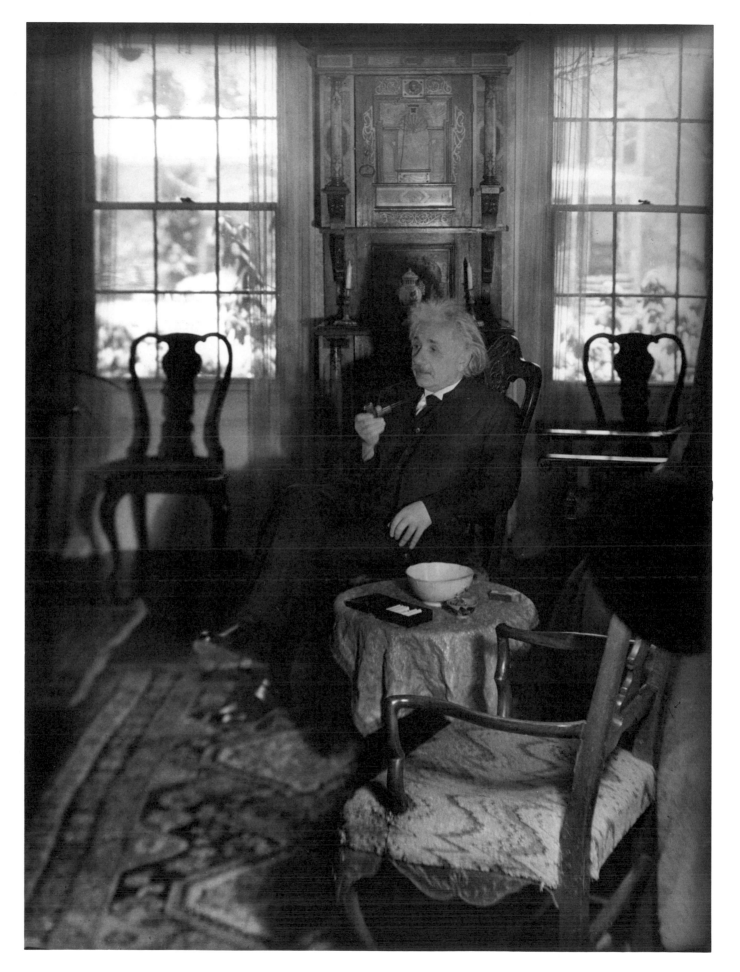

ALBERT EINSTEIN, Physicist, Nobel Prize Winner, Princeton, N.J., 1938

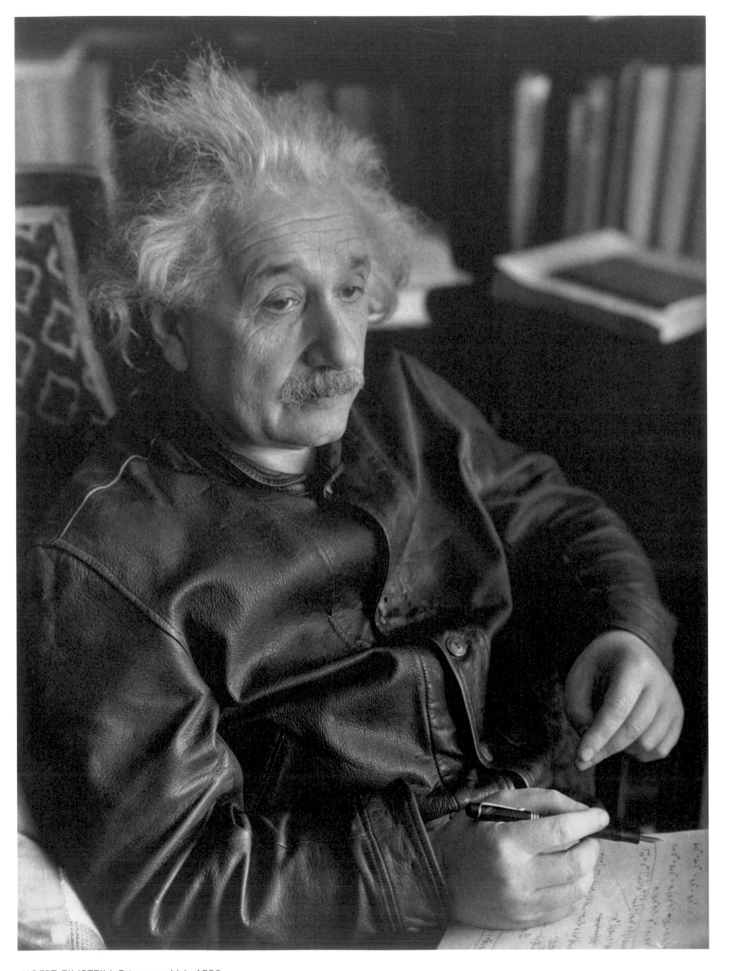

ALBERT EINSTEIN, Princeton, N.J., 1938

Einstein's music stand, Princeton, N.J., 1938

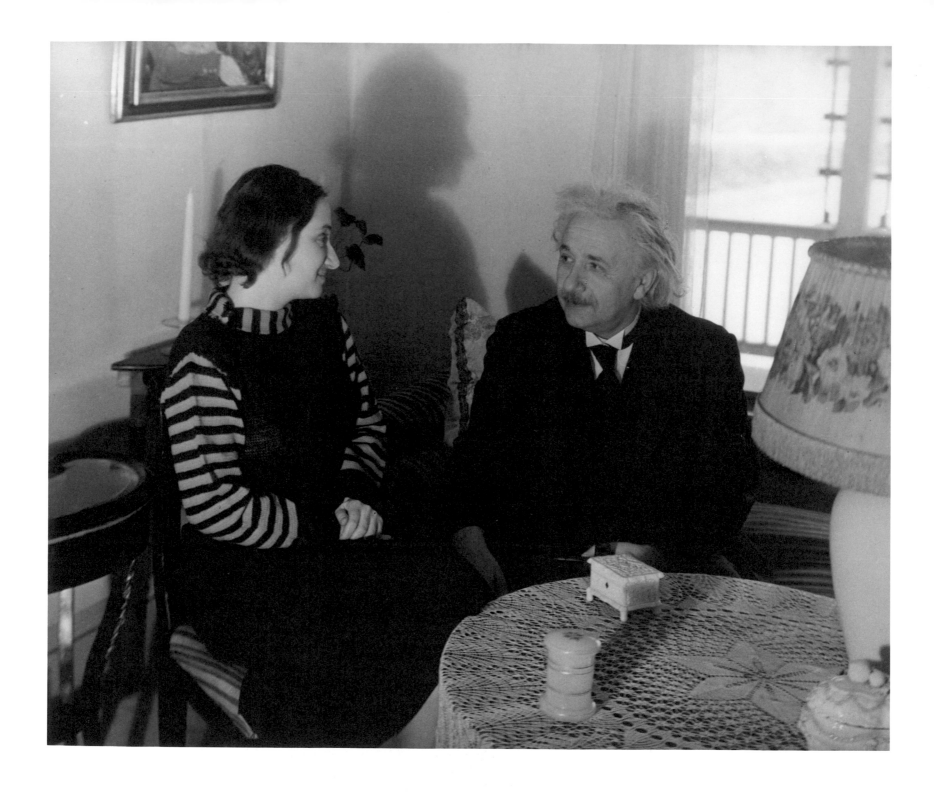

ALBERT EINSTEIN, and his daughter, MARGOT, Princeton, N.J., 1938

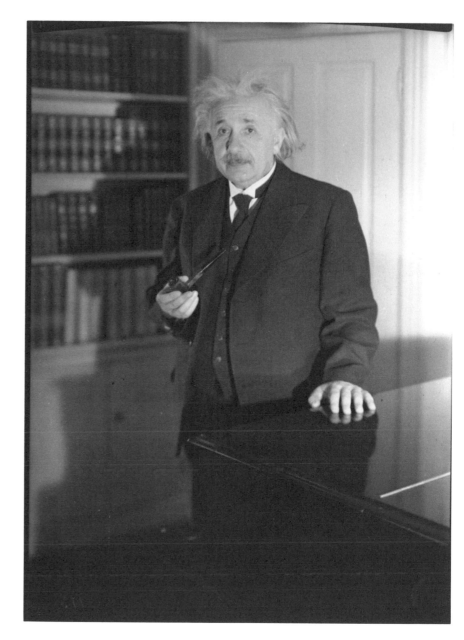

ALBERT EINSTEIN, Princeton, N.J., 1938

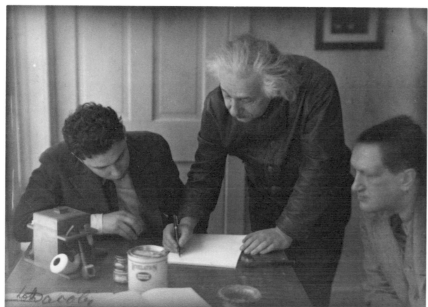

ALBERT EINSTEIN with DR. LEOPOLD INFELD and PETER G. BERGMANN, Princeton, N.J. 1938

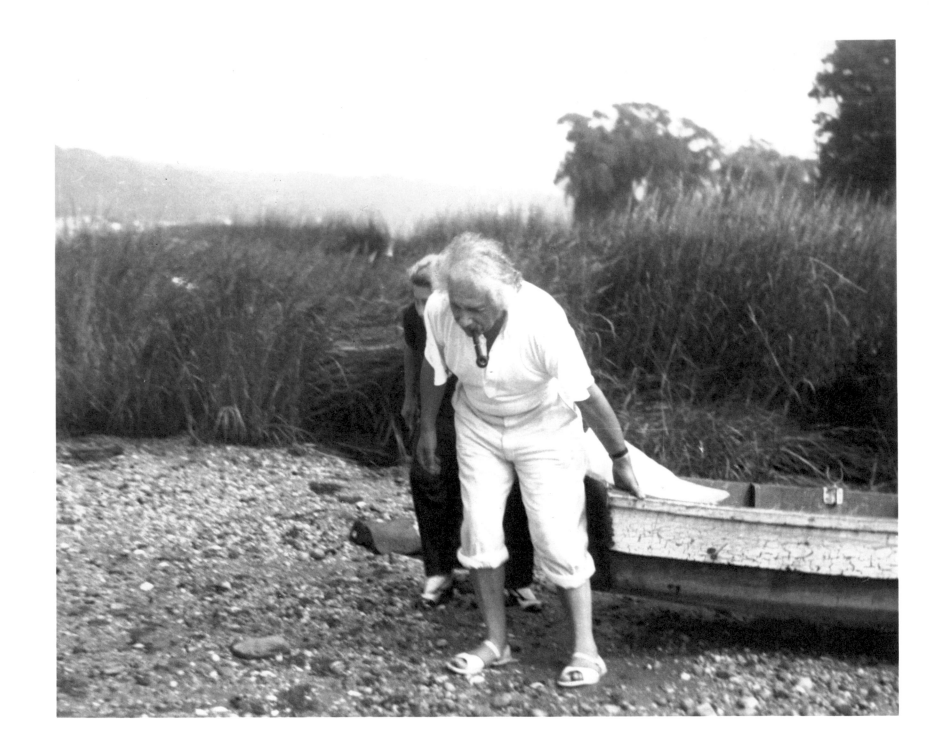

ALBERT EINSTEIN, Huntington, Long Island, New York, 1937

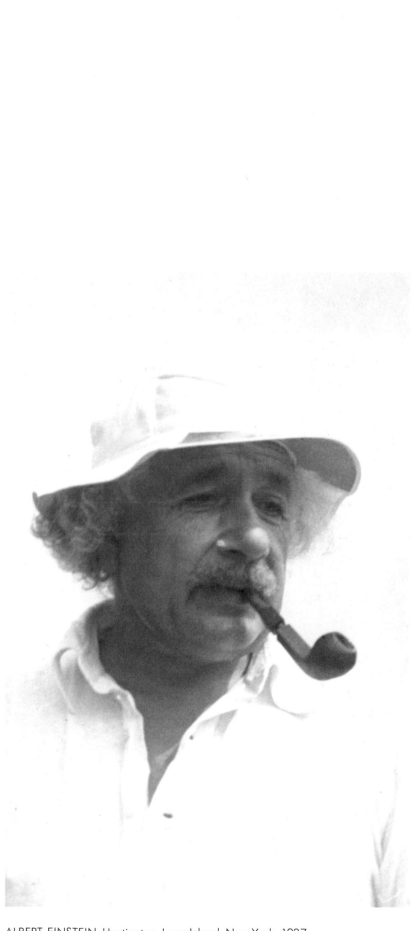

ALBERT EINSTEIN, Huntington, Long Island, New York, 1937

THOMAS MANN with his wife, KATJA, Princeton, N.J., ca. 1936

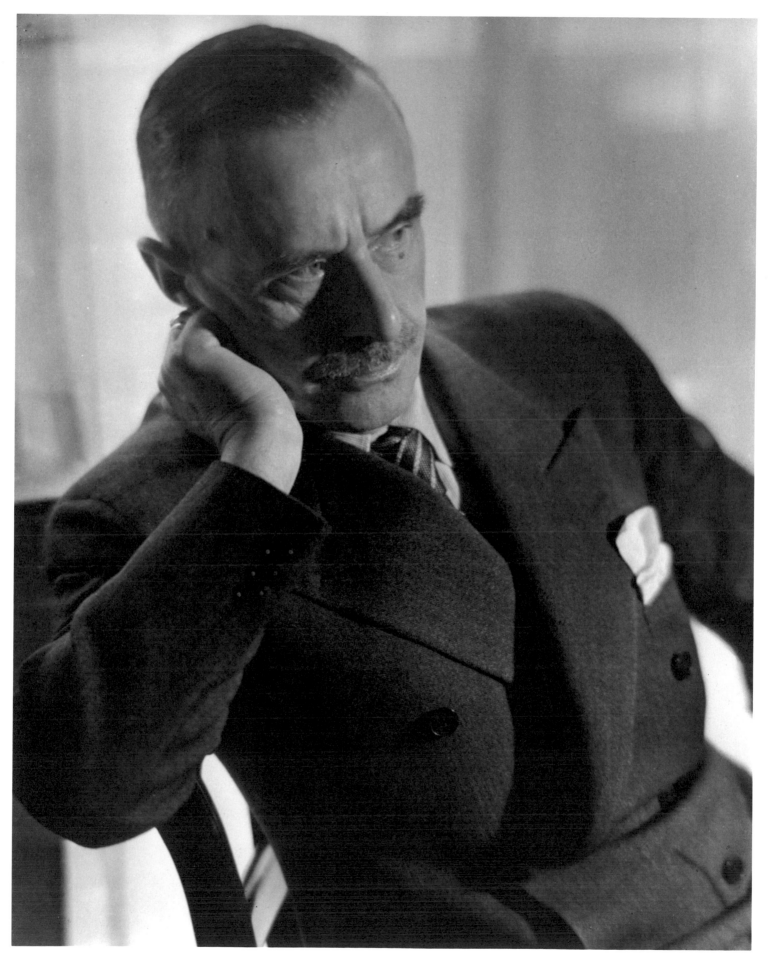

THOMAS MANN, Writer, Princeton, N.J., ca. 1936

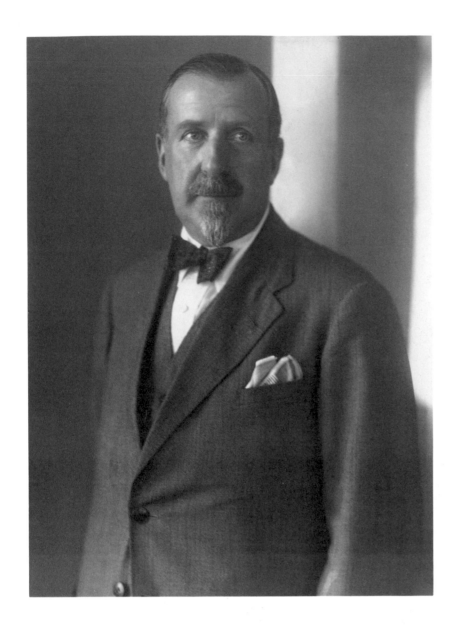

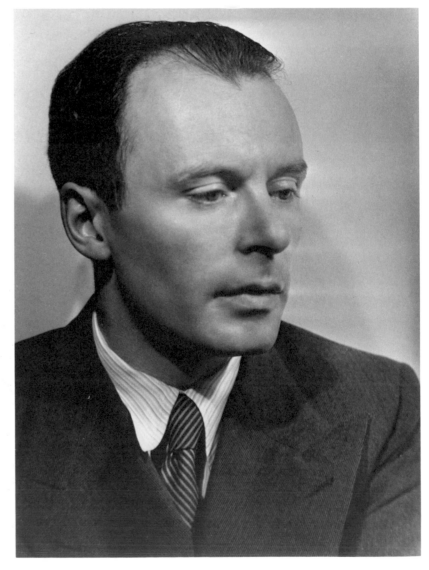

HEINRICH MANN, Writer, Berlin, ca. 1930

KLAUS MANN, Writer, New York, ca. 1939

THOMAS MANN, Princeton, N.J., ca. 1936

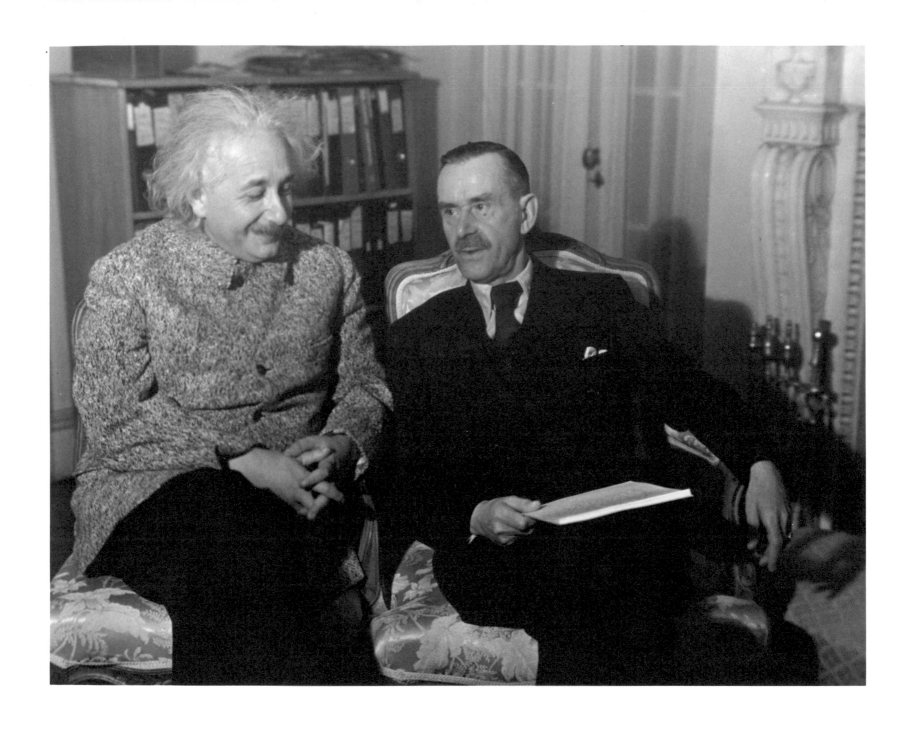

ALBERT EINSTEIN and THOMAS MANN, Princeton, N.J., 1938

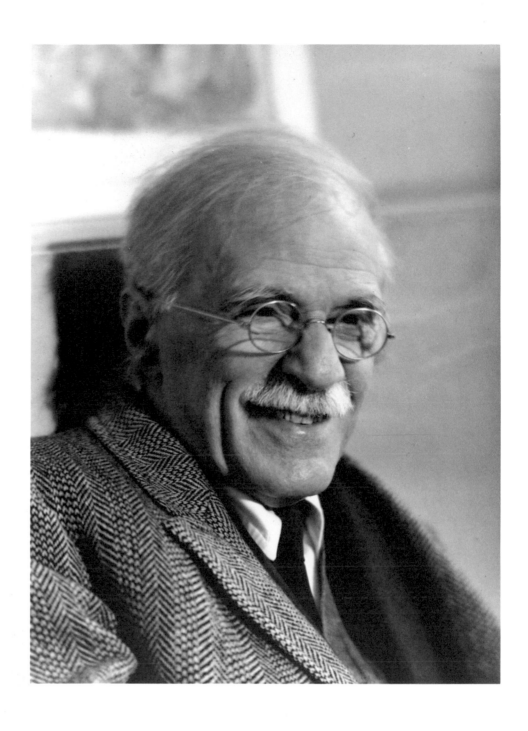

ALFRED STIEGLITZ, Photographer, New York, 1938 111

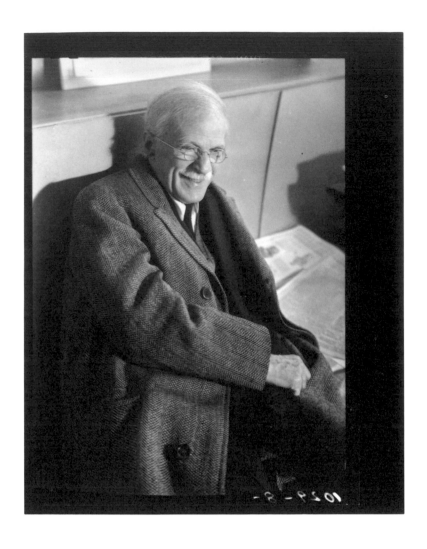

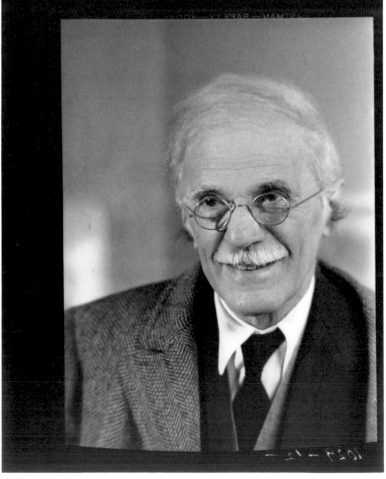

ALFRED STIEGLITZ, contact prints, 1938

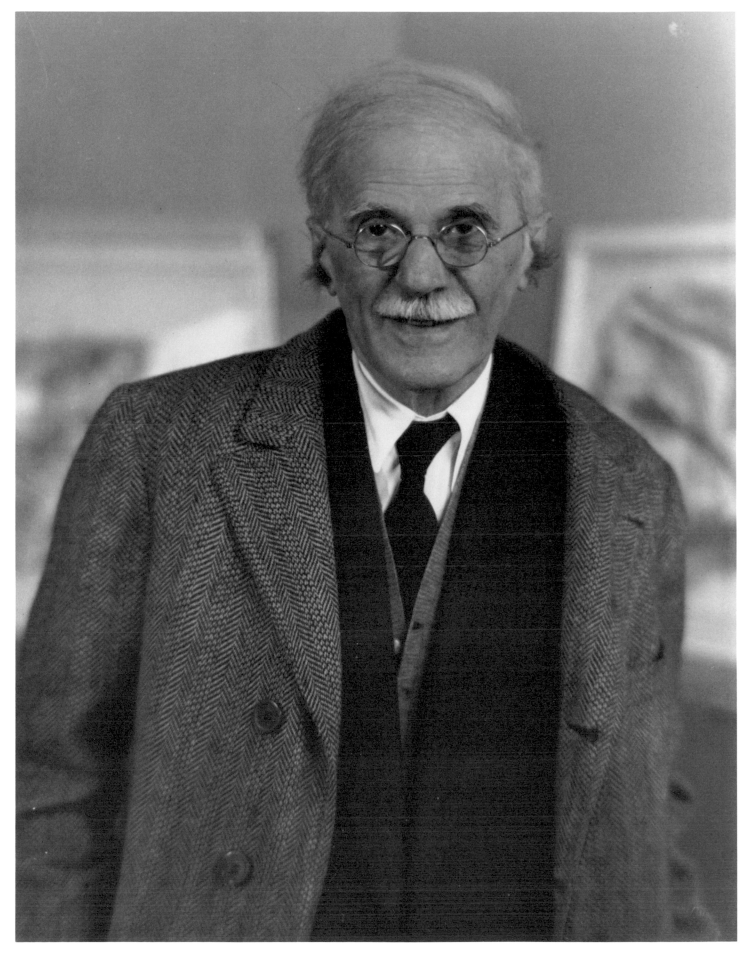

ALFRED STIEGLITZ, New York, 1938 113

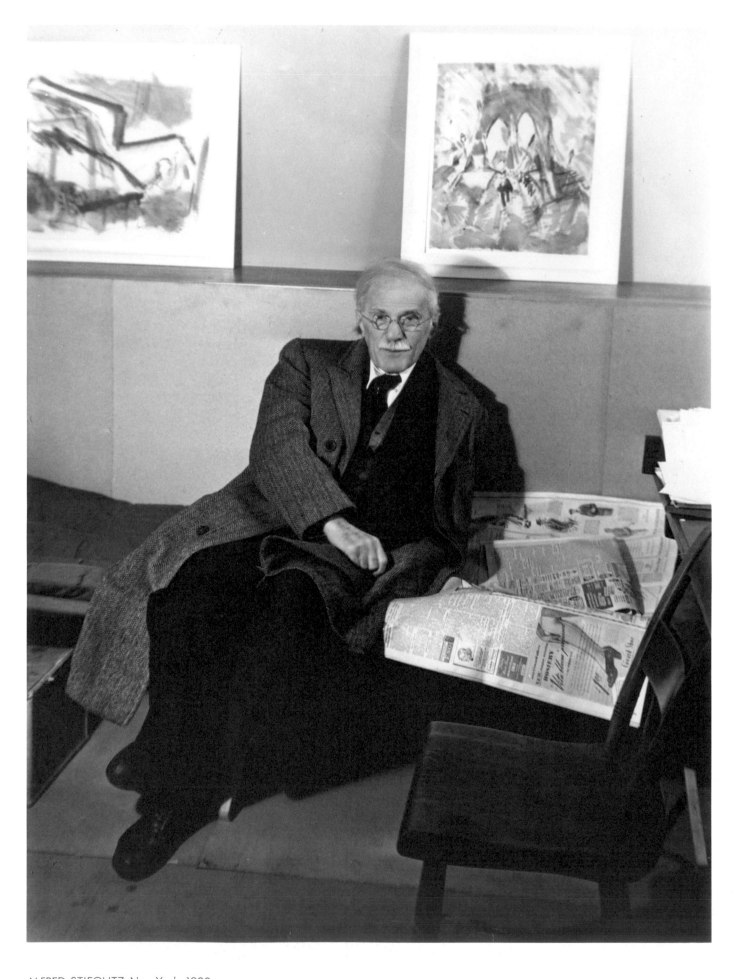

ALFRED STIEGLITZ, New York, 1938

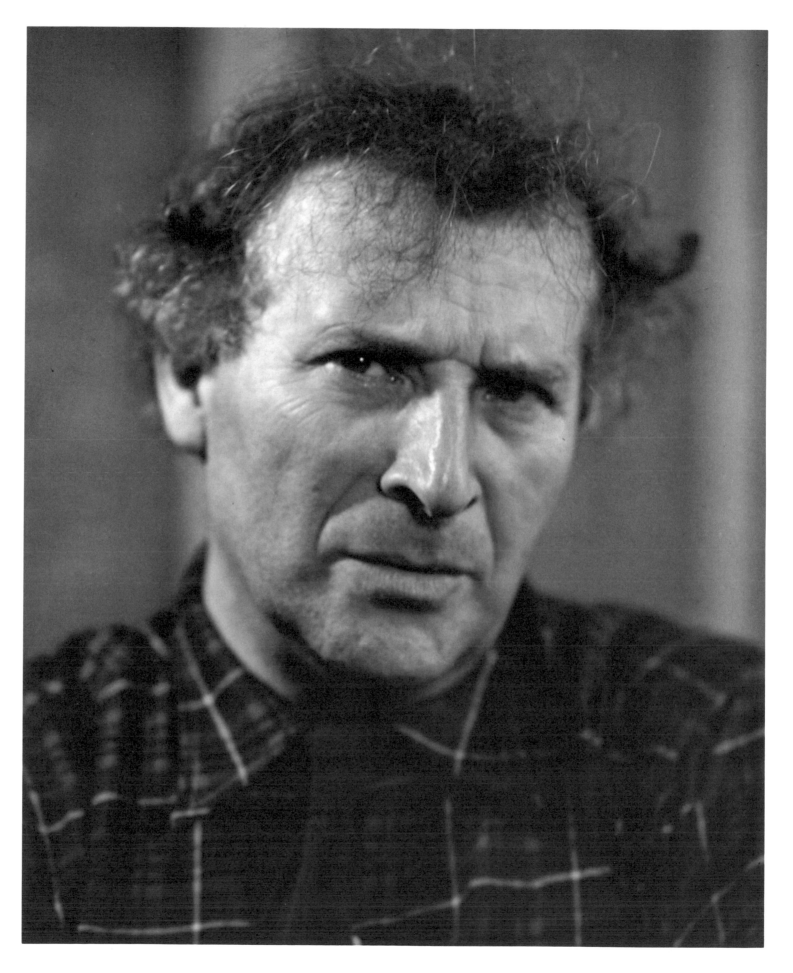

MARC CHAGALL, Artist, New York, 1942

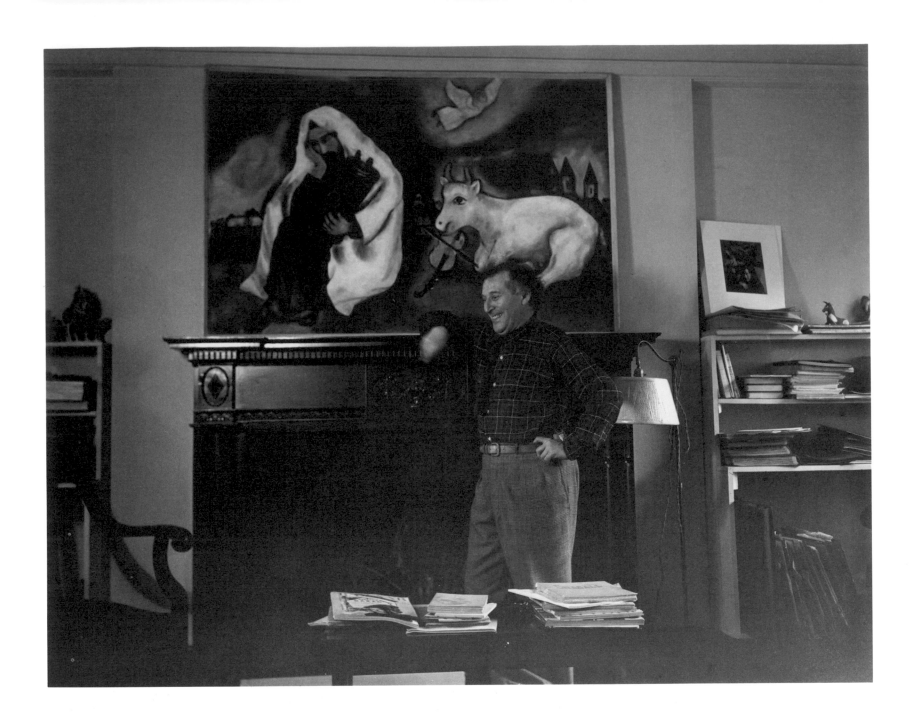

MARC CHAGALL, New York, 1942

IDA CHAGALL, New York, 1945

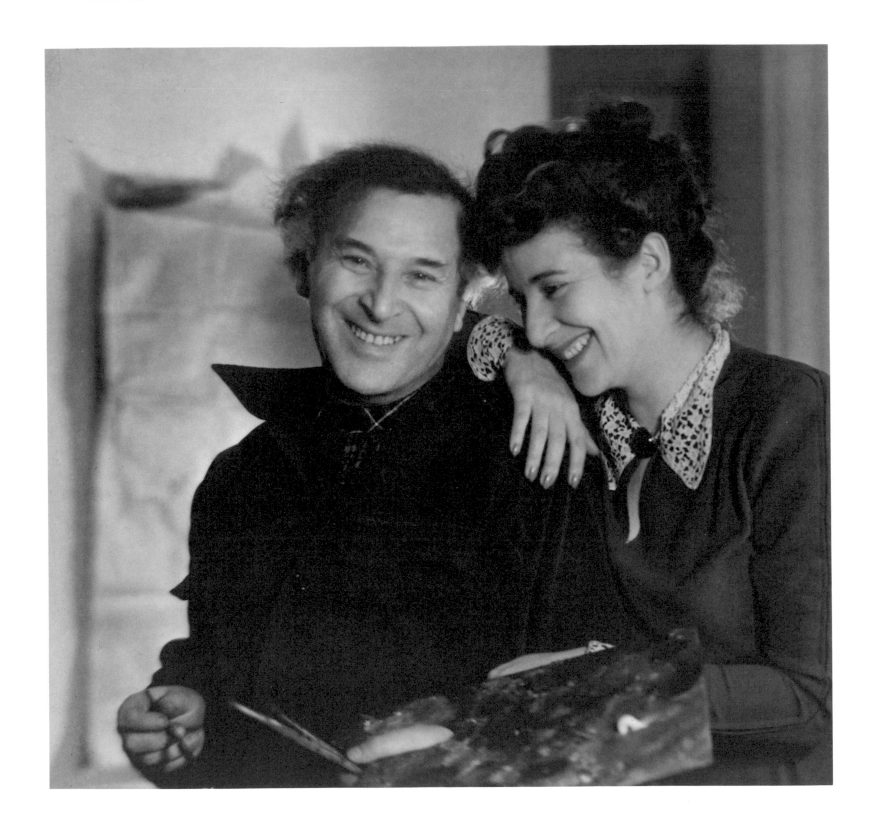

MARC CHAGALL and his daughter, IDA, New York, 1945

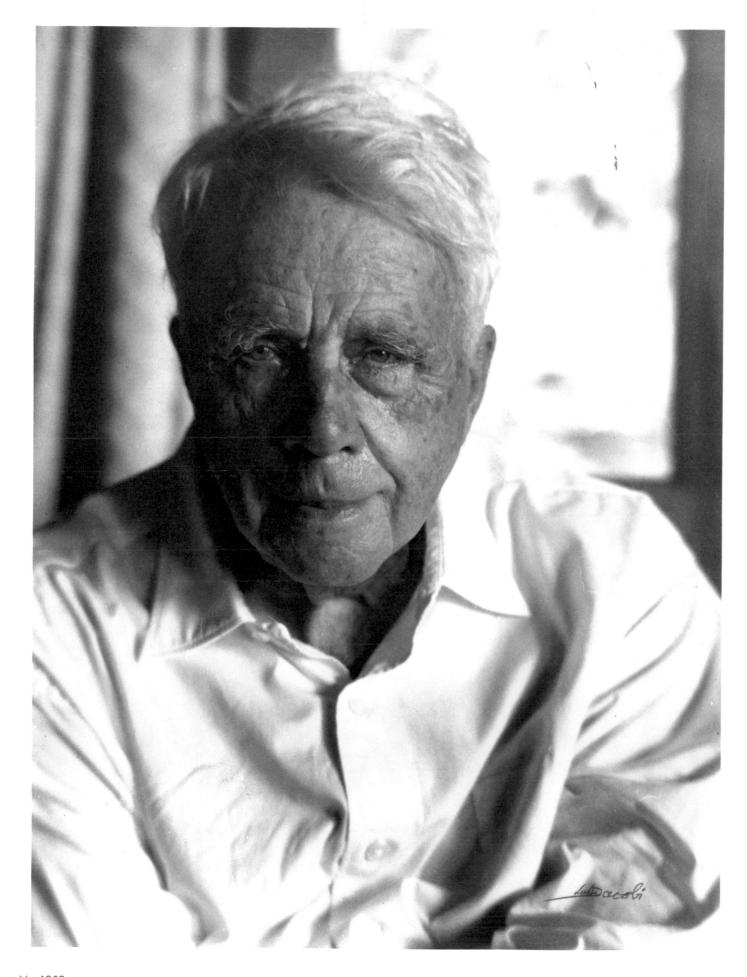

ROBERT FROST, Poet, Ripton, Vt., 1959

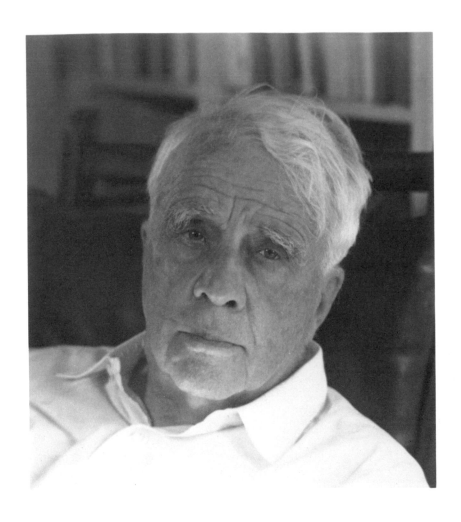

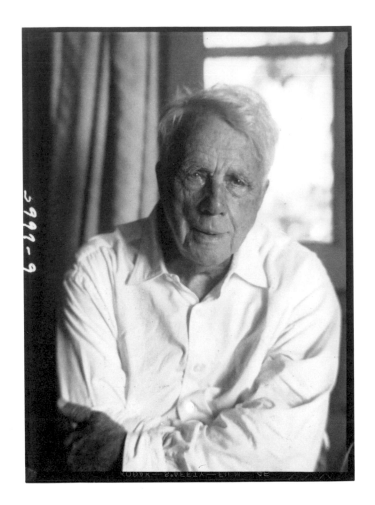

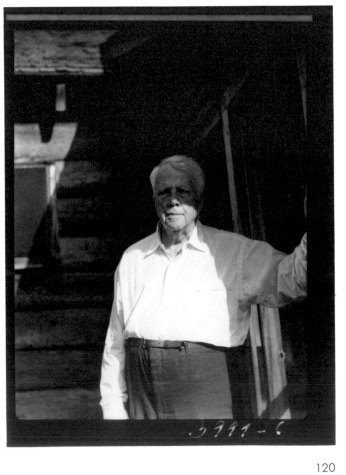

ROBERT FROST, contact prints, 1959

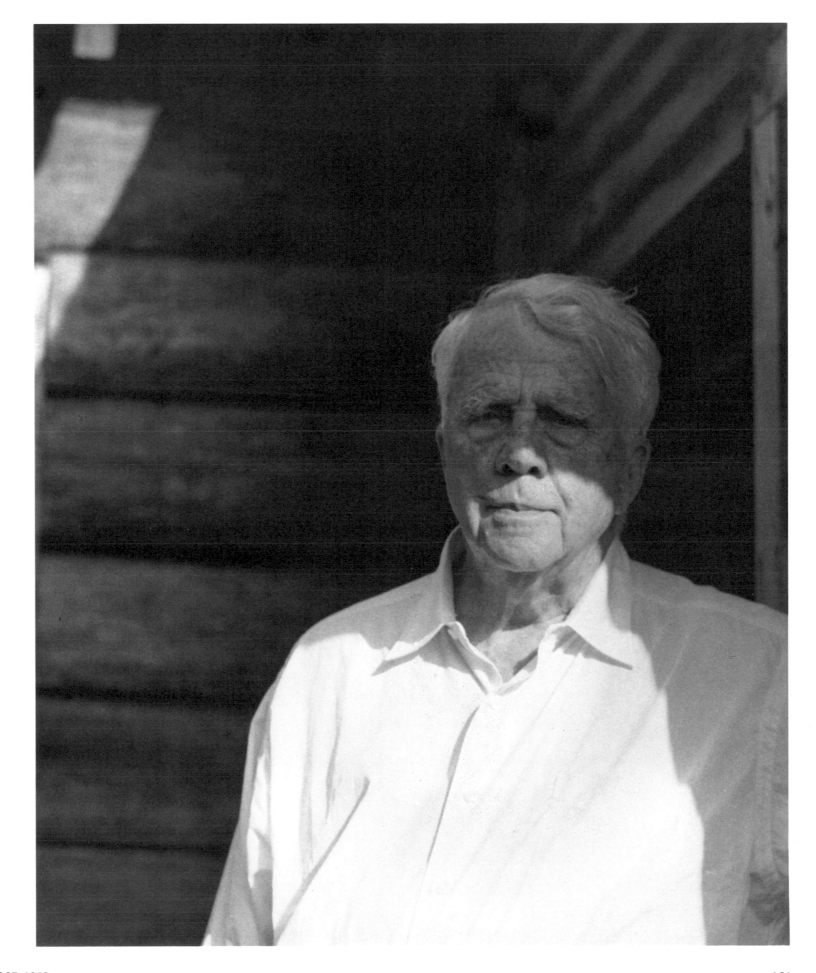

ROBERT FROST, 1959 121

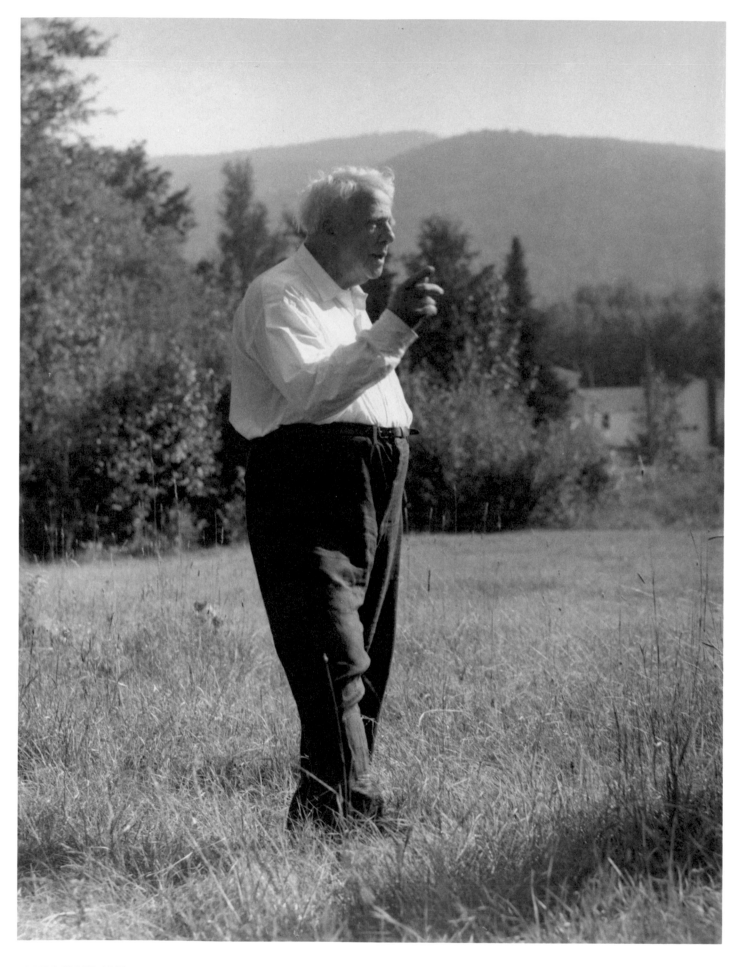

ROBERT FROST, 1959

Sixties

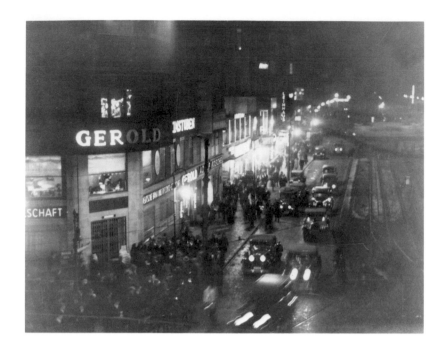

Berlin, Germany, ca. 1928

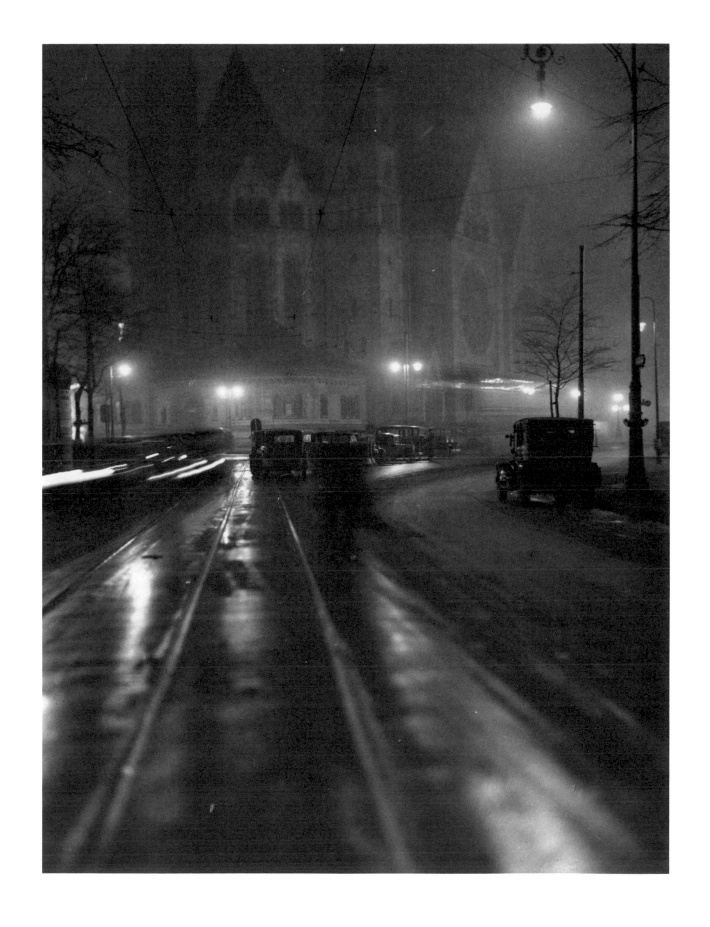

Berlin, Germany, ca. 1932

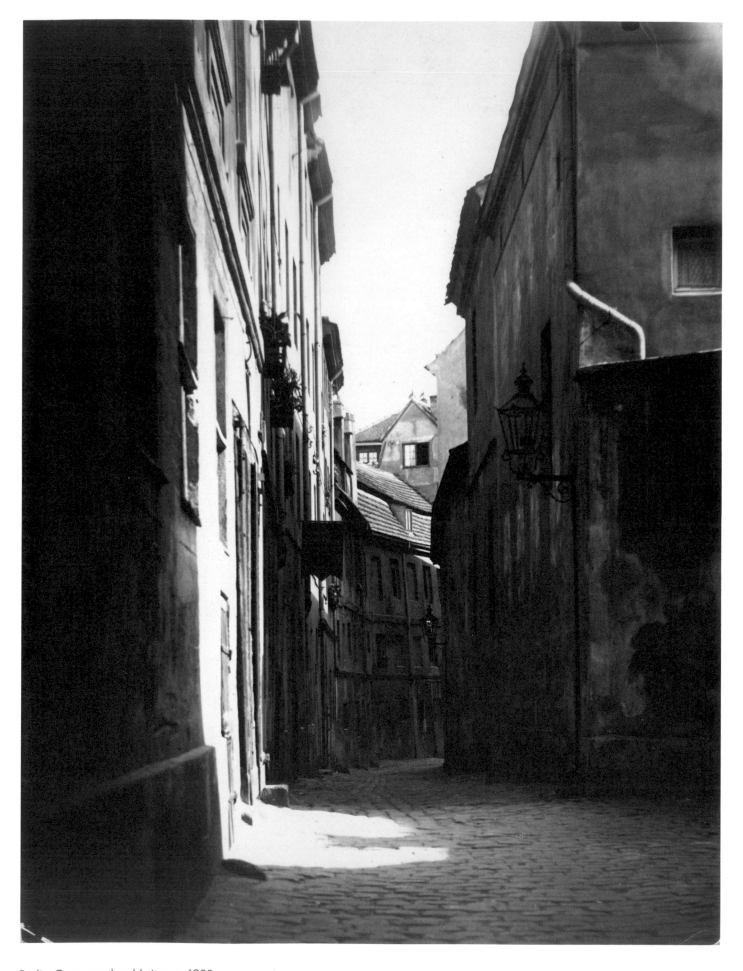

Berlin, Germany, the old city, ca. 1928

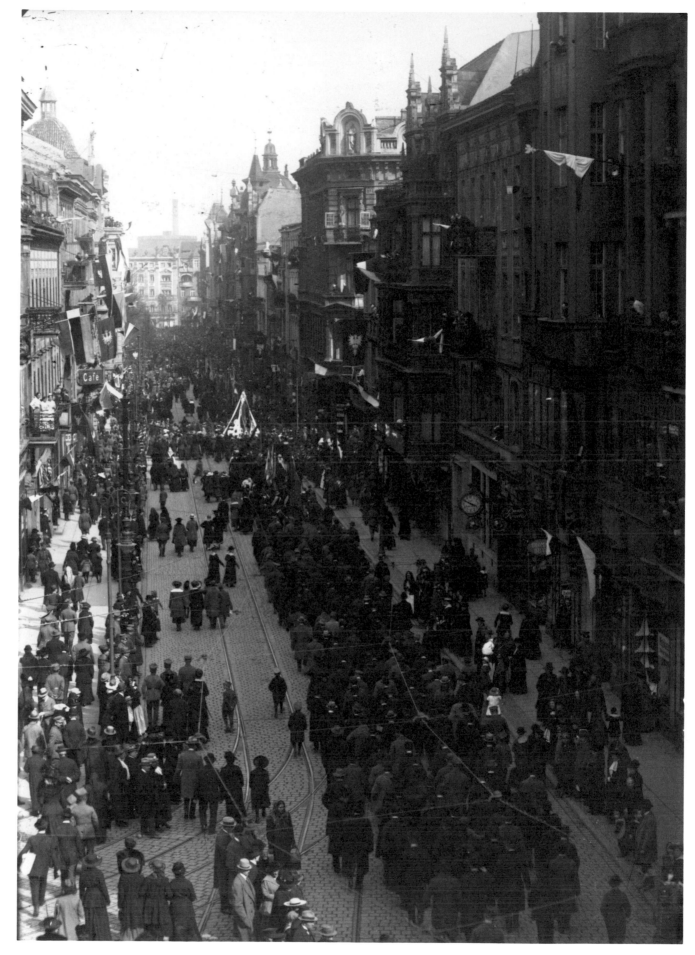

Posen, Germany, ca. 1918

Hamburg, Germany, ca. 1934

Hamburg, Germany, ca. 1934

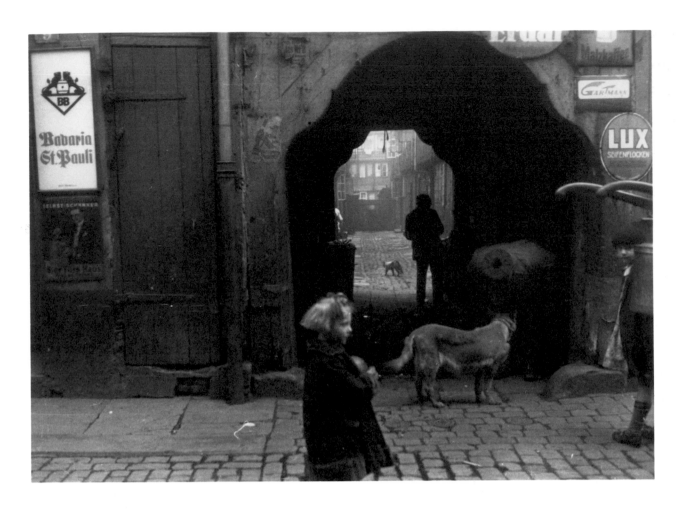

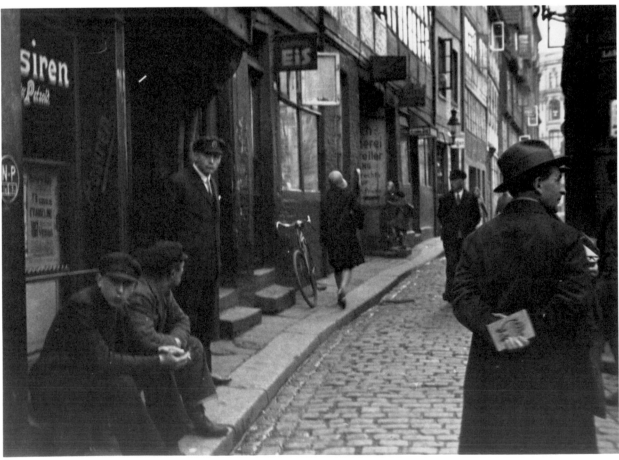

Hamburg, Germany, ca. 1934

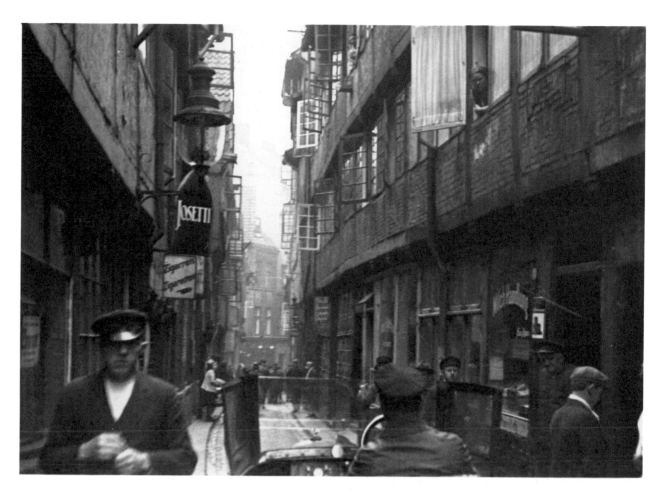

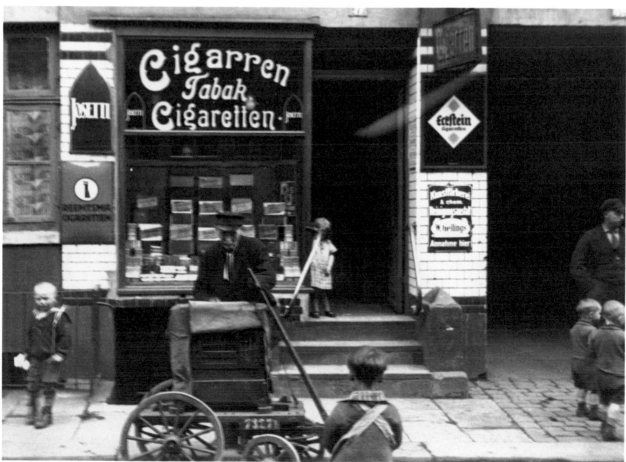

Hamburg, Germany, ca. 1934

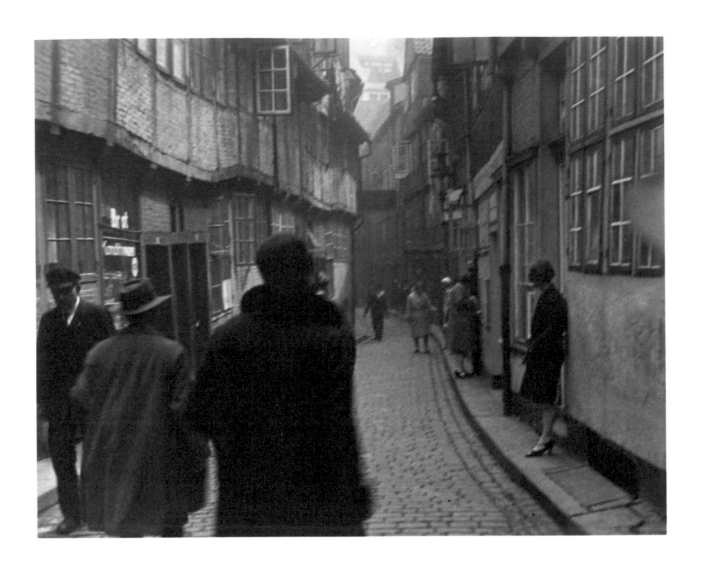

Hamburg, Germany, ca. 1934

Theatre and Dance

ALBERS
DURIEUX
DAGOVER
MOSHEIM
LENYA
KAROW
KREUTZBERG
JANNINGS
SHOOP
GROCK
SOKOLOFF
TAUBER
SCHWARZ
LES FRATELLINI
MICHOLS
SISKIN
GRANACH
FRITSCH
MOHOLY-NAGY
KORTNER
BARD
WIGMAN
BAUROFF
VON SWAIN
FELGER
KONER

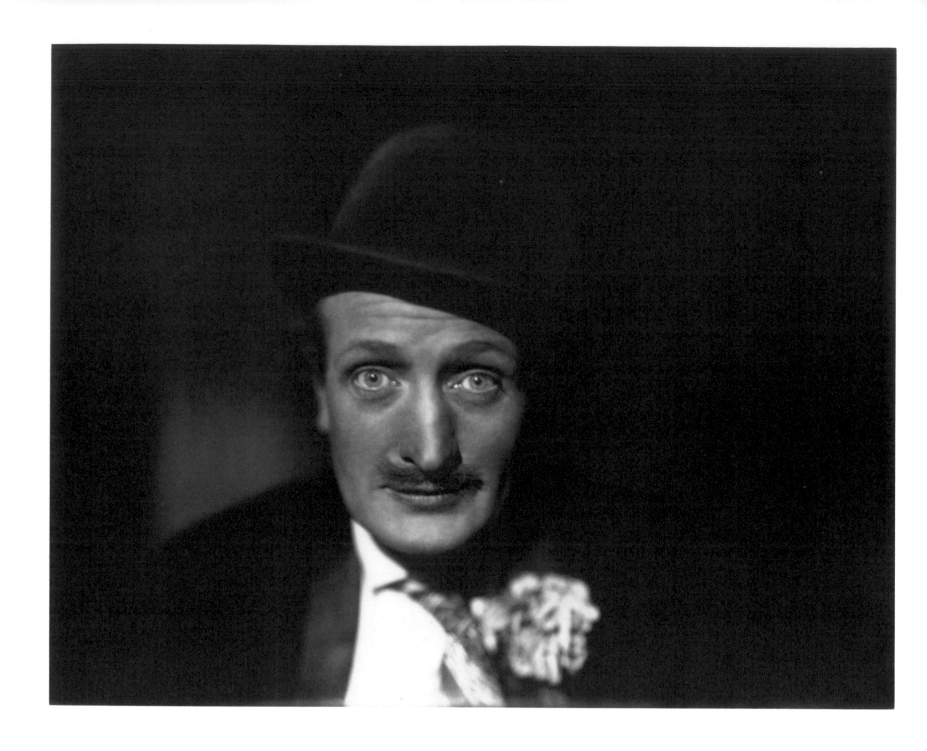

HANS ALBERS, Actor, Berlin, ca. 1930 134

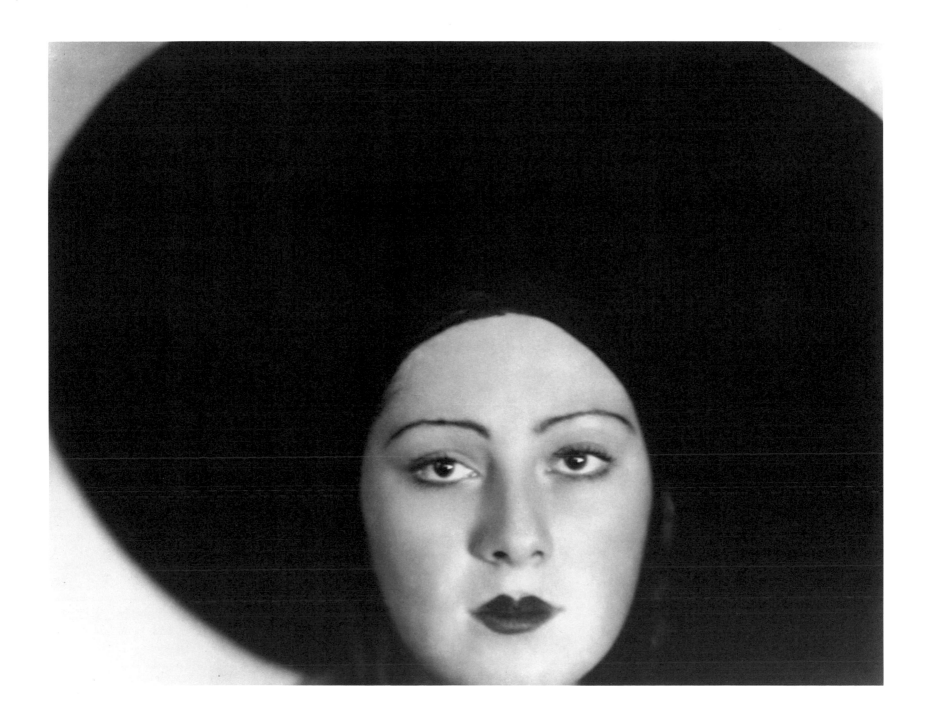

Head of a Dancer, Berlin, ca. 1929

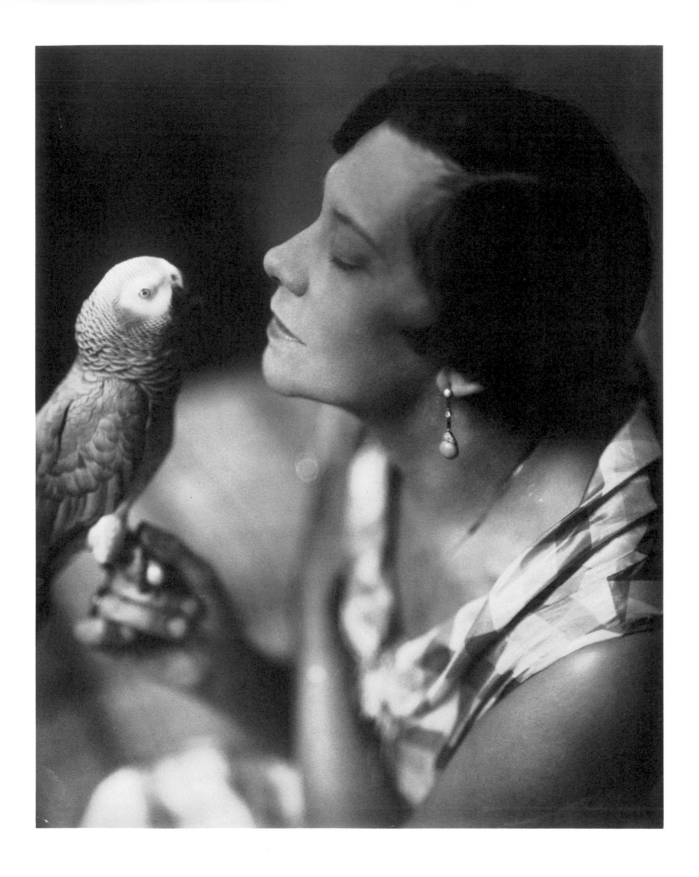

TILLA DURIEUX, Actress, Berlin, ca. 1930

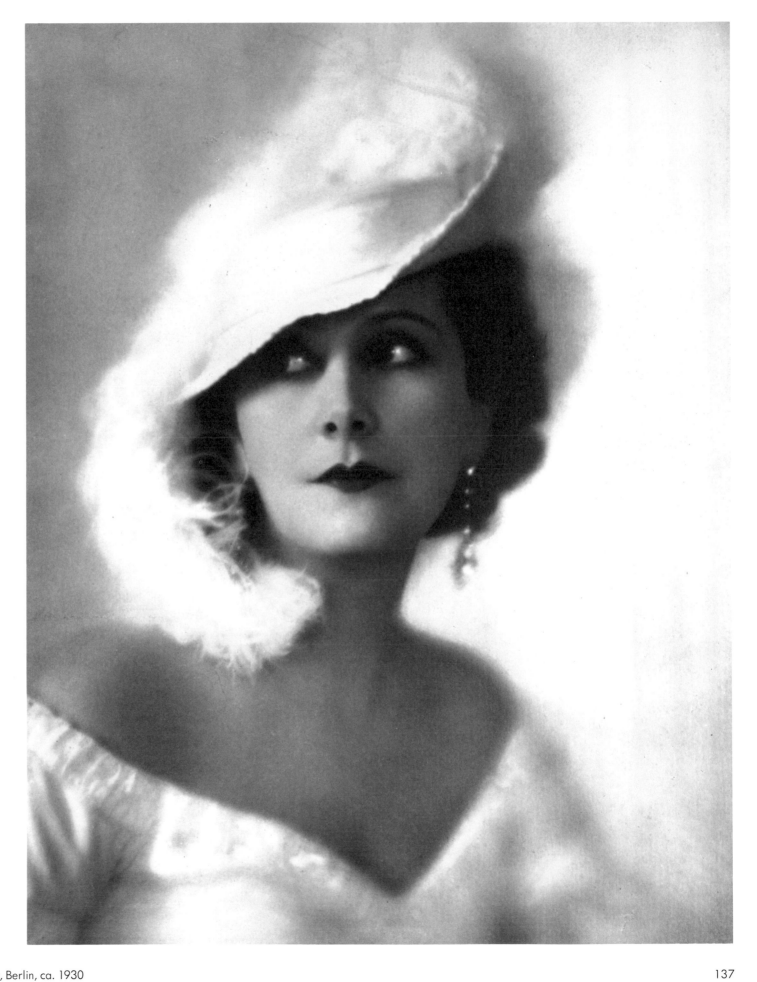

LIL DAGOVER, Actress, Berlin, ca. 1930

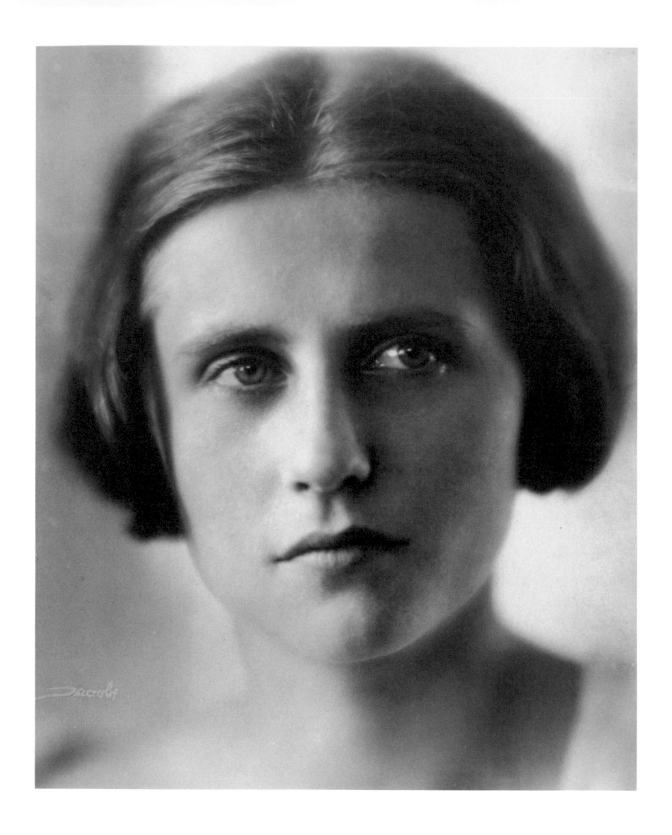

GRETE MOSHEIM, Actress, Berlin, ca. 1930

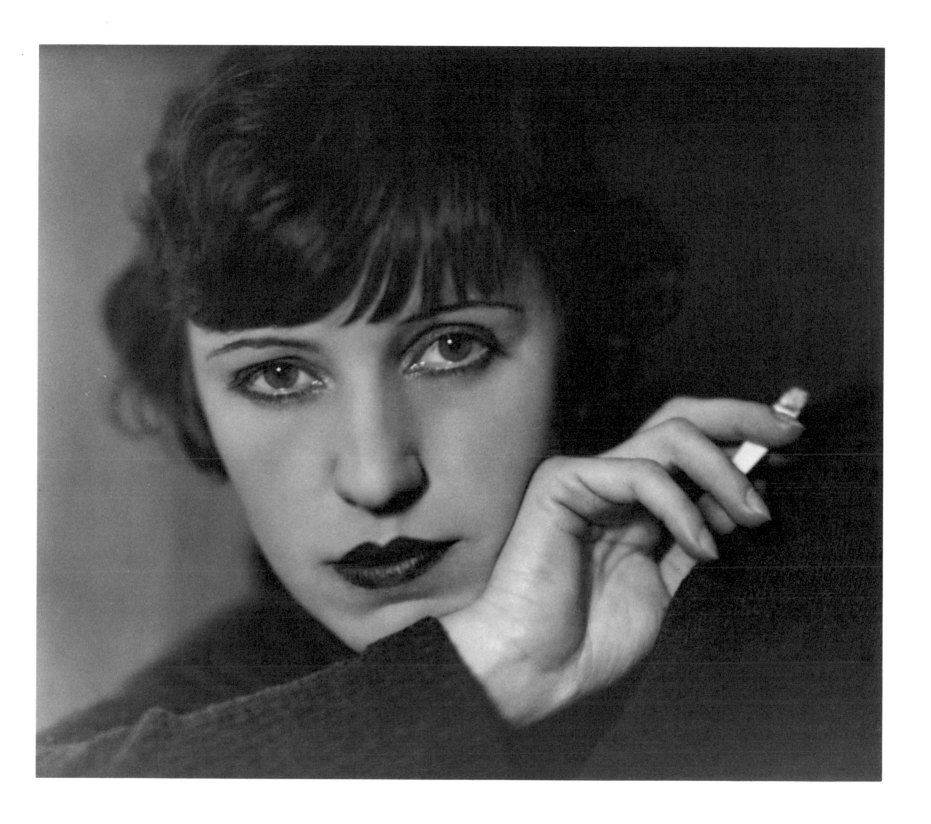

LOTTE LENYA, Actress, Berlin, ca. 1930

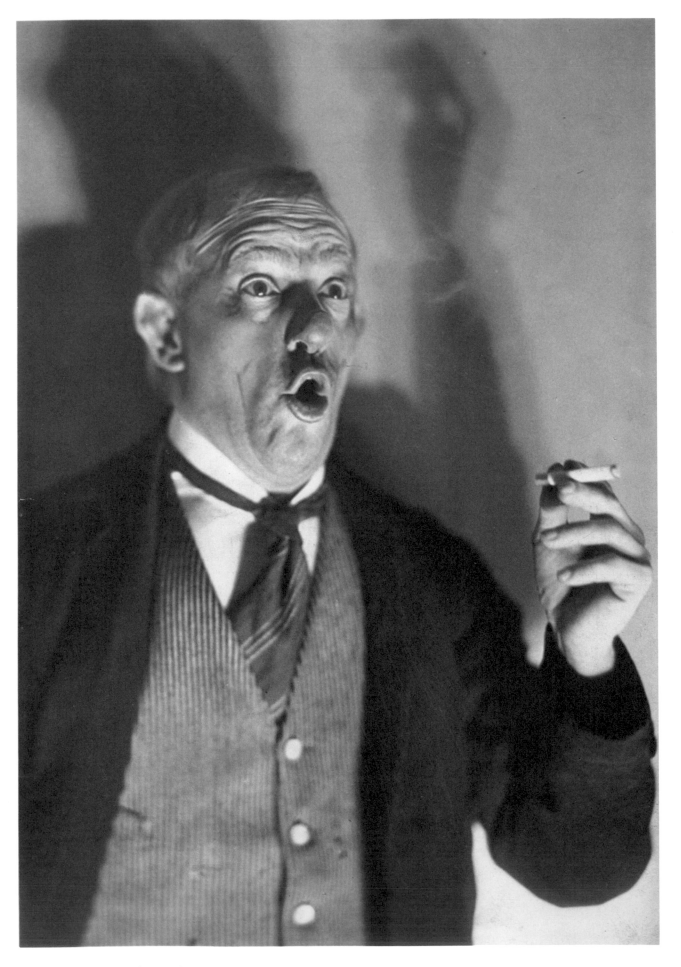

ERICH KAROW, Comedian, Berlin, ca. 1930

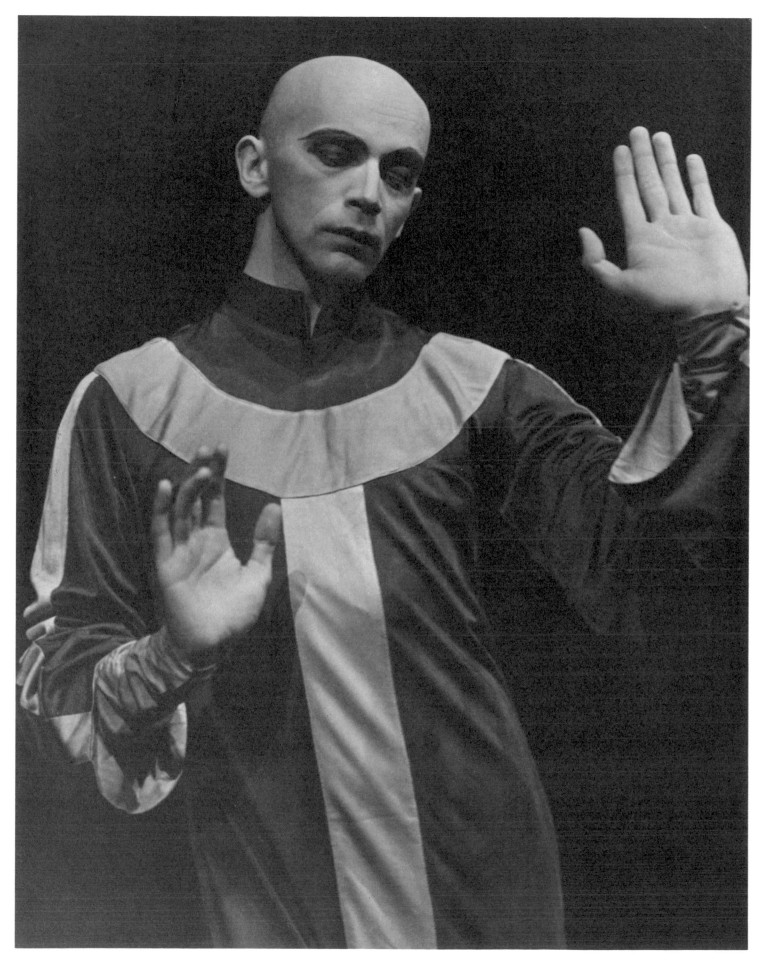

HAROLD KREUTZBERG, Dancer, Berlin, ca. 1930

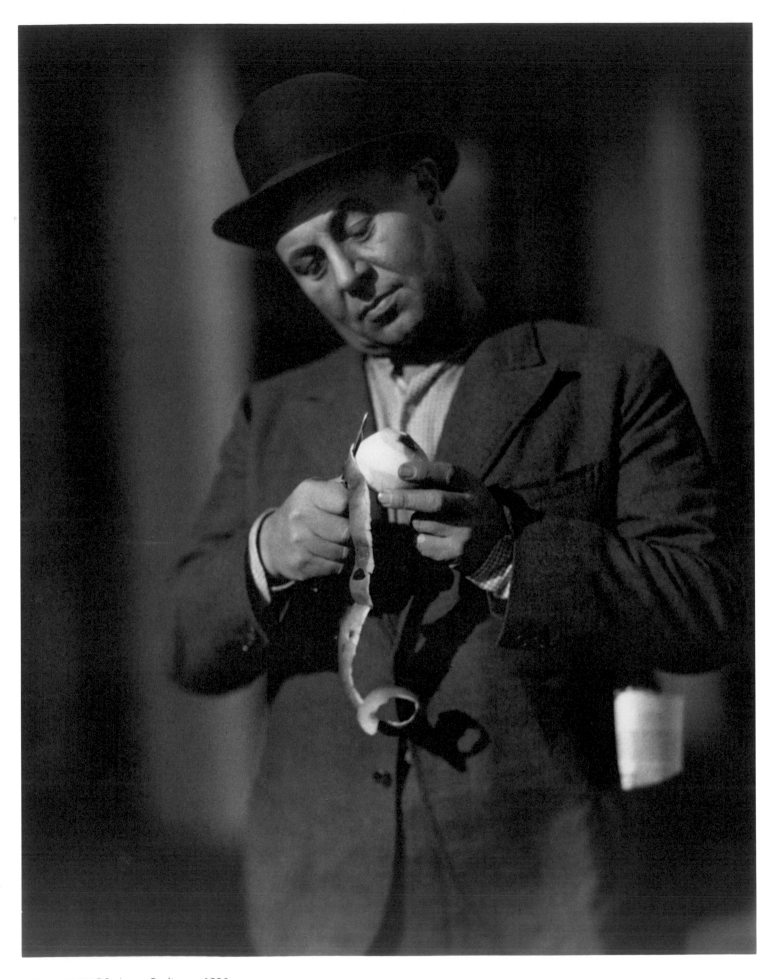

EMIL JANNINGS, Actor, Berlin, ca. 1930

142

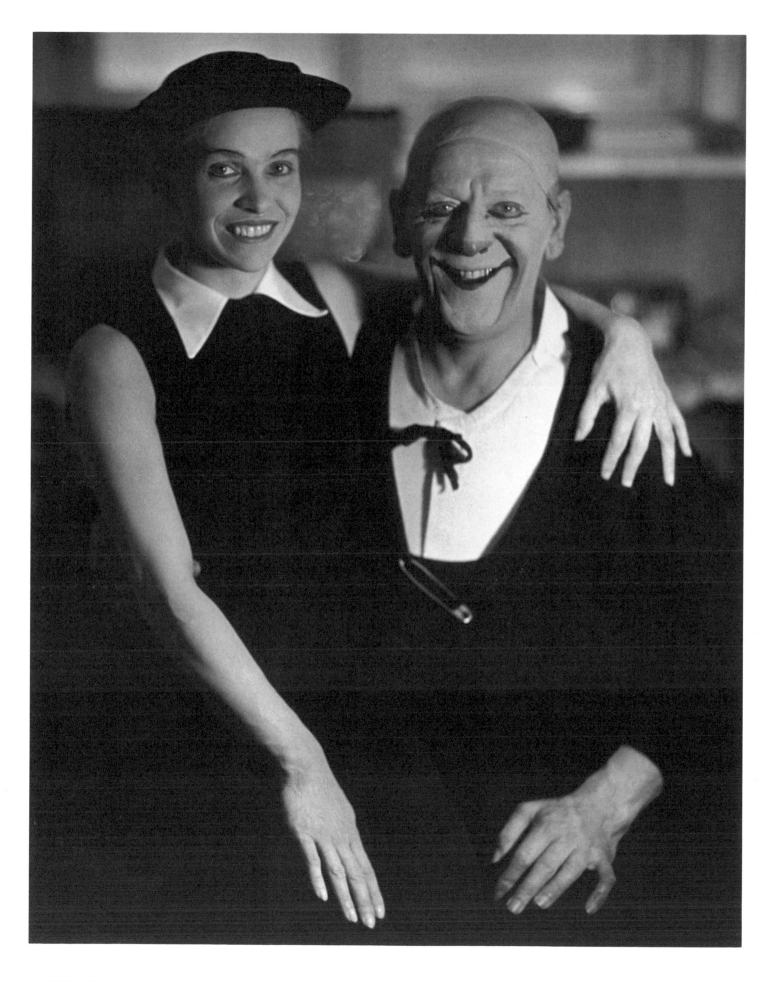

TRUDI SHOOP, Dancer, and GROCK, Clown, Artist, Berlin, ca. 1931

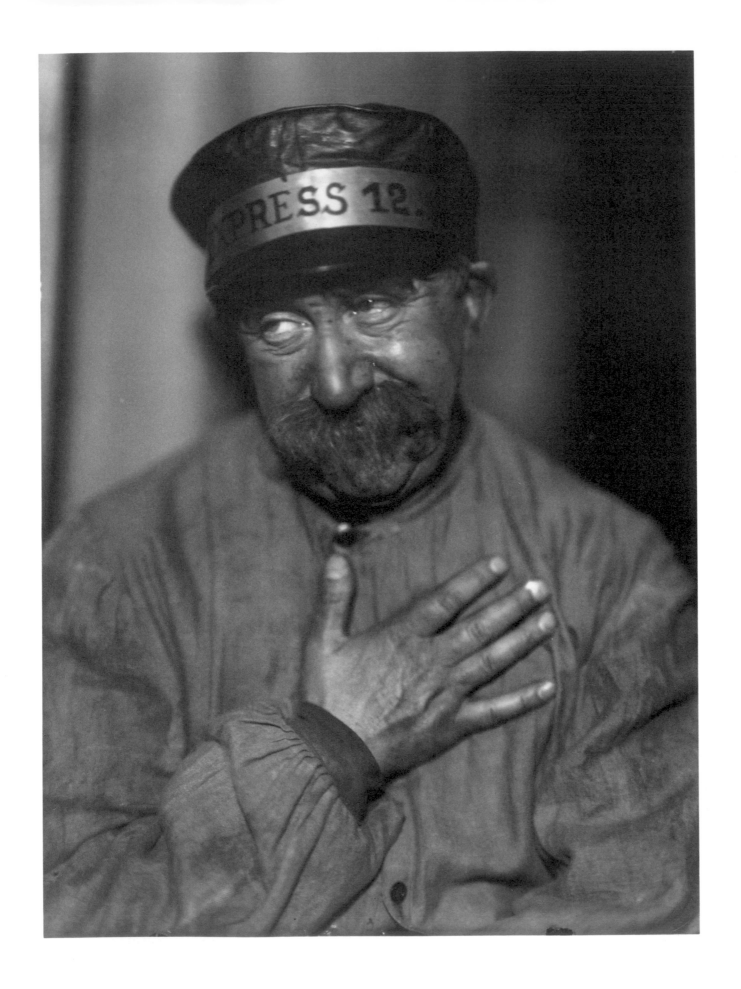

SOKOLOFF (?), Actor, Berlin, ca. 1930

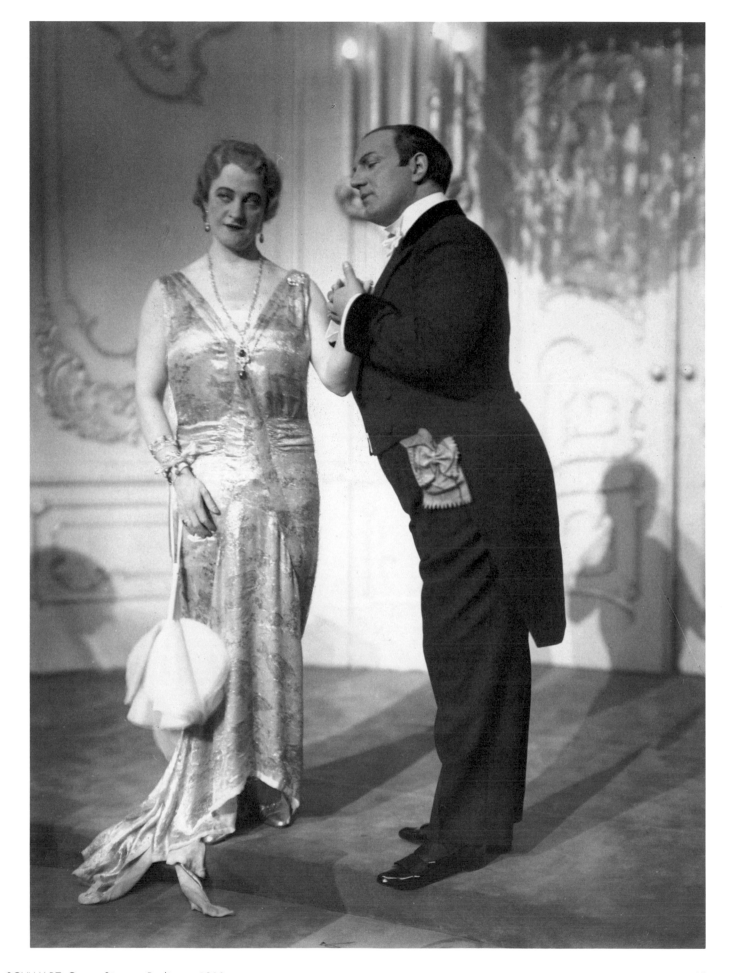

RICHARD TAUBER and VERA SCHWARZ, Opera Singers, Berlin, ca. 1930

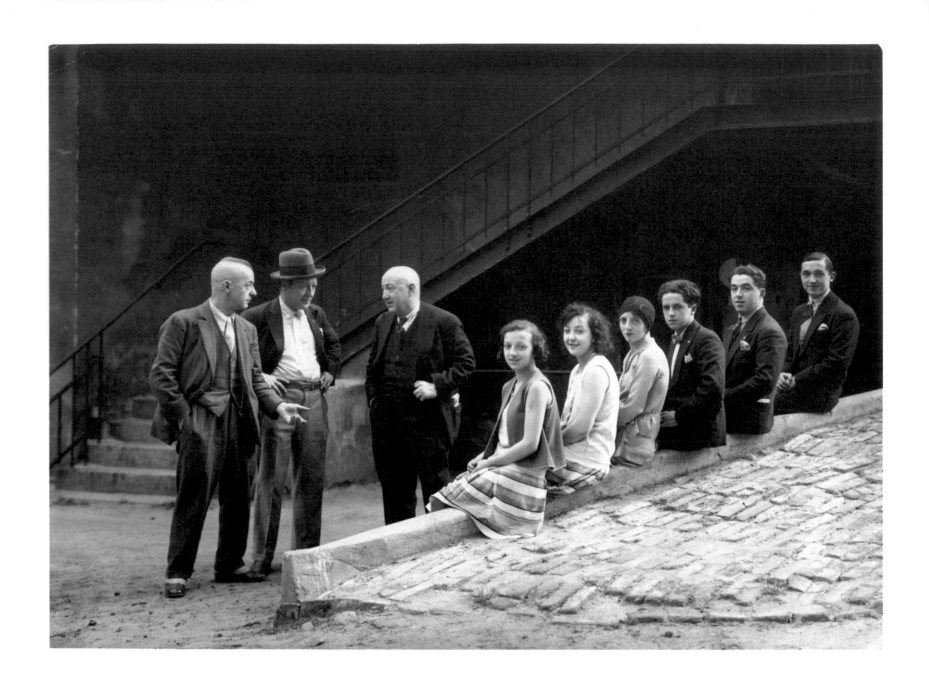

LES FRATELLINI, French Circus Family, Berlin, ca. 1930

146

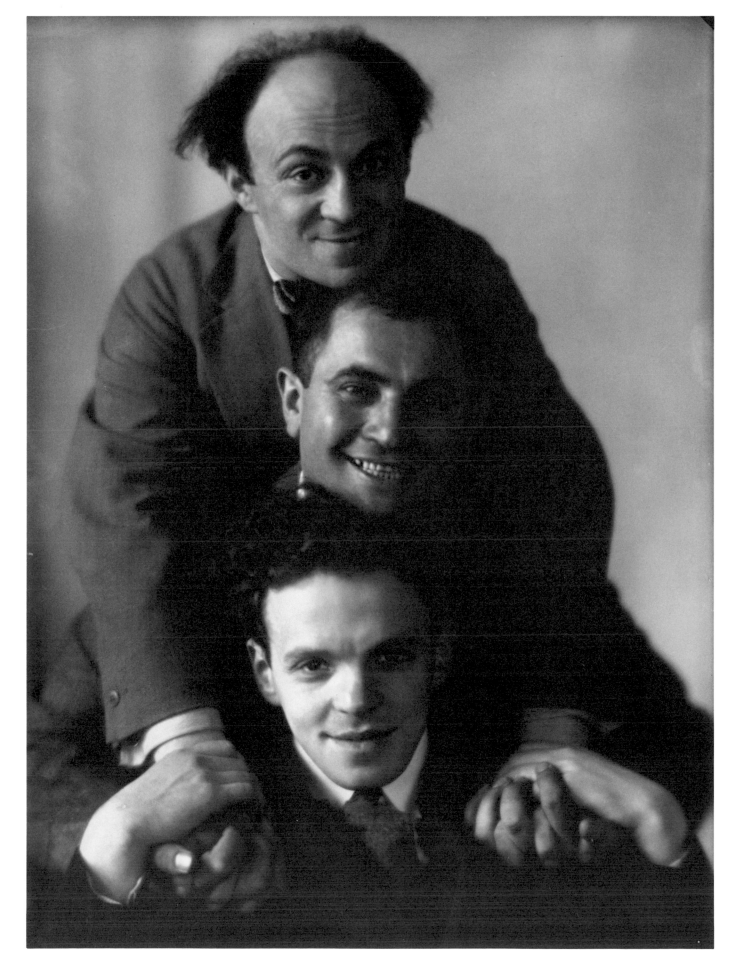

MICHOLS, SISKIN, and GRANACH, Actors, Berlin, ca. 1929 147

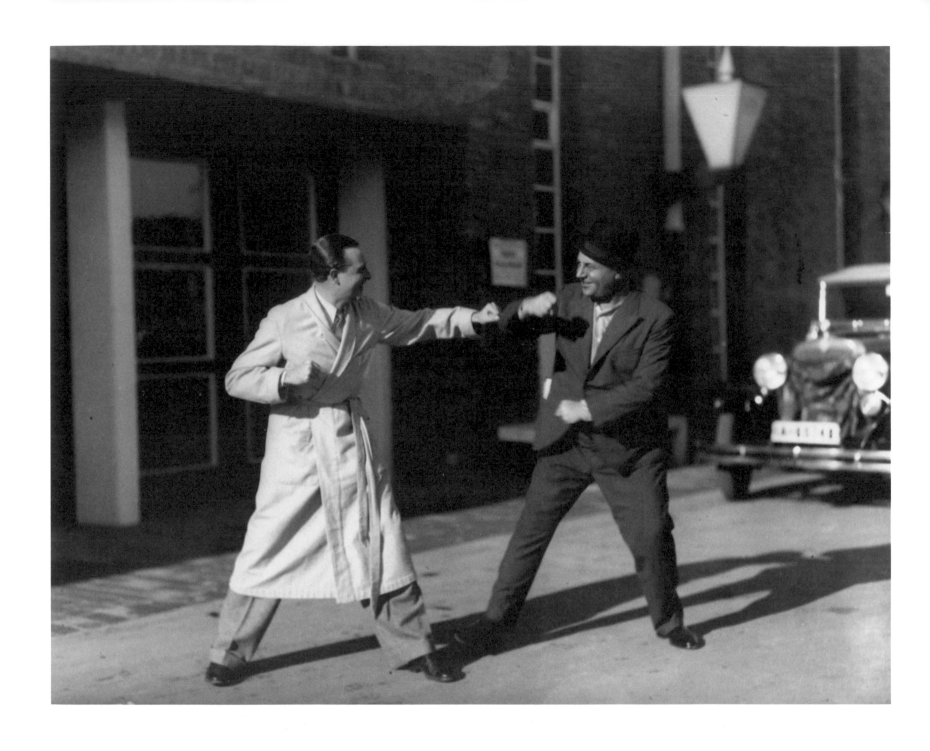

WILLY FRITSCH and EMIL JANNINGS, Actors, Berlin, ca. 1932

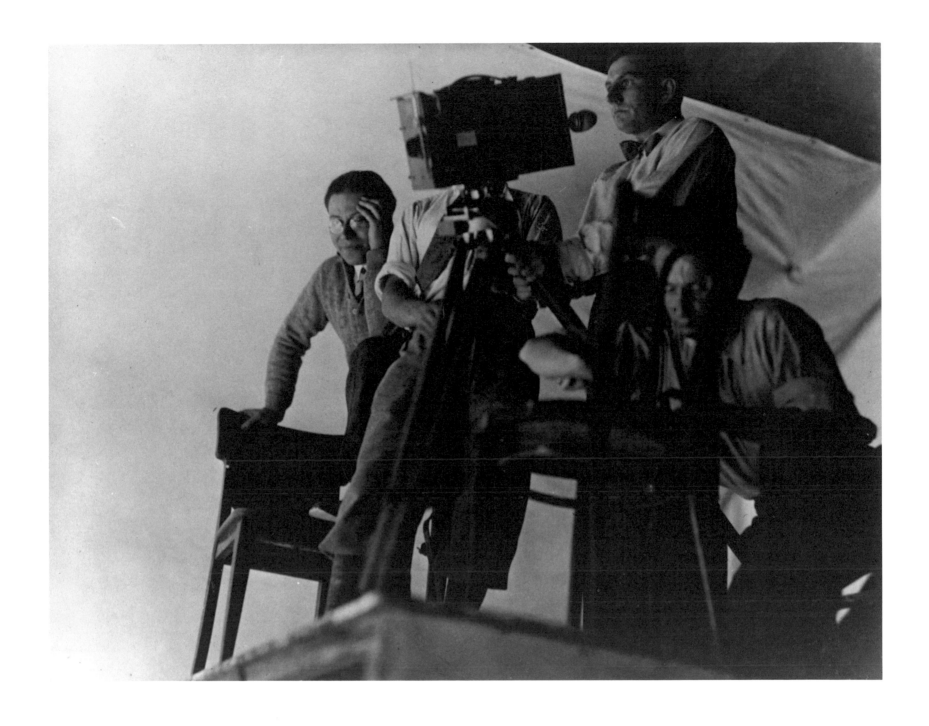

LASZLO MOHOLY-NAGY, Photographer, Artist, Teacher, ca. 1929

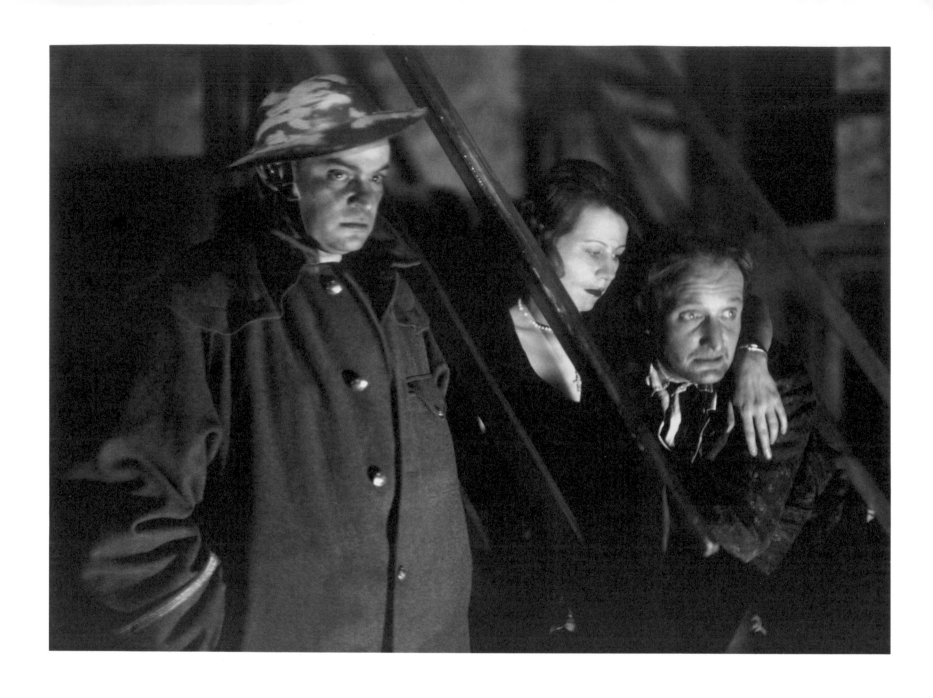

FRITZ KORTNER, MARIA BARD, and HANS ALBERS, in *Rivalen*, Berlin, ca. 1930

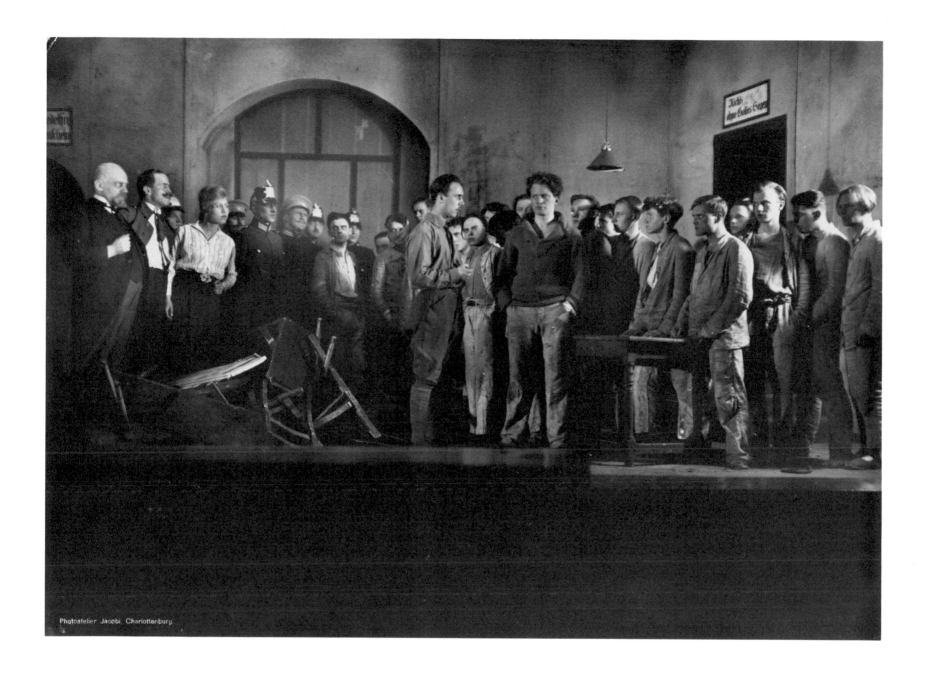

Revolte im Erziehungsheim, Drama, Berlin, ca. 1930

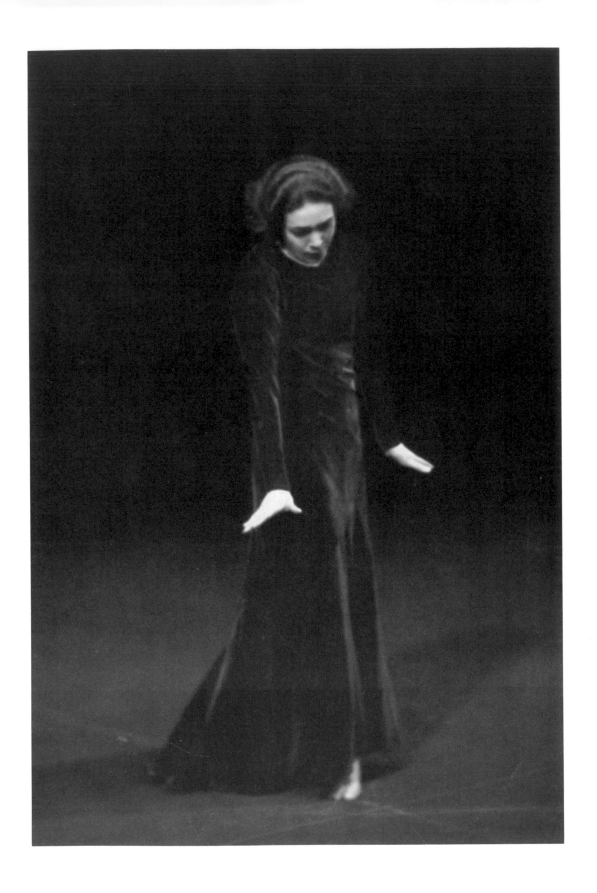

MARY WIGMAN, Dancer, Berlin, ca. 1930

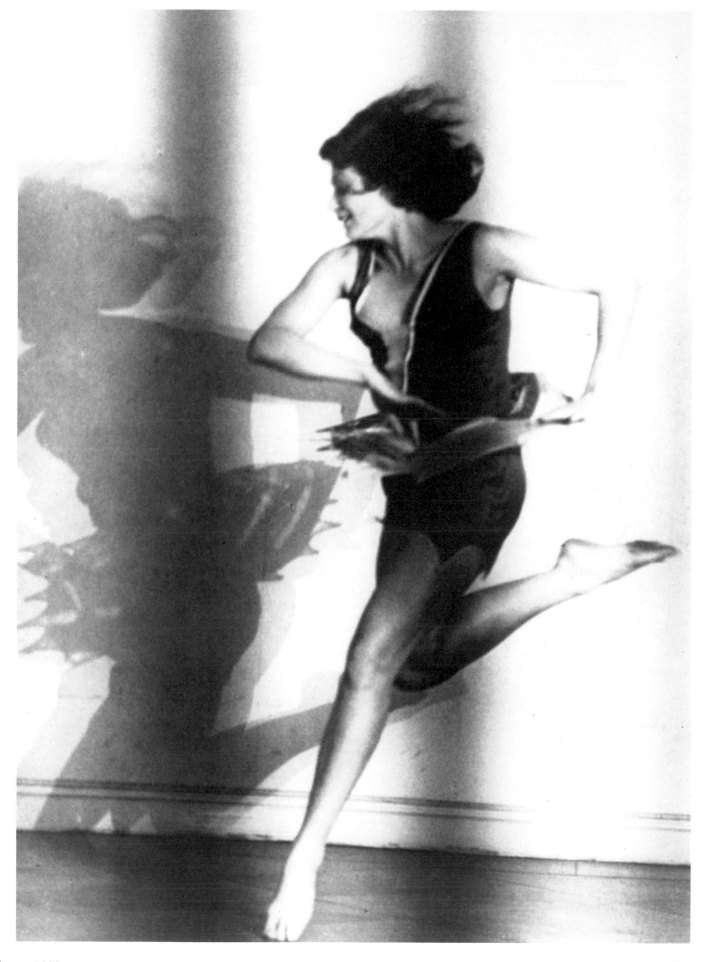

CLAIRE BAUROFF, Dancer, Berlin, ca. 1928

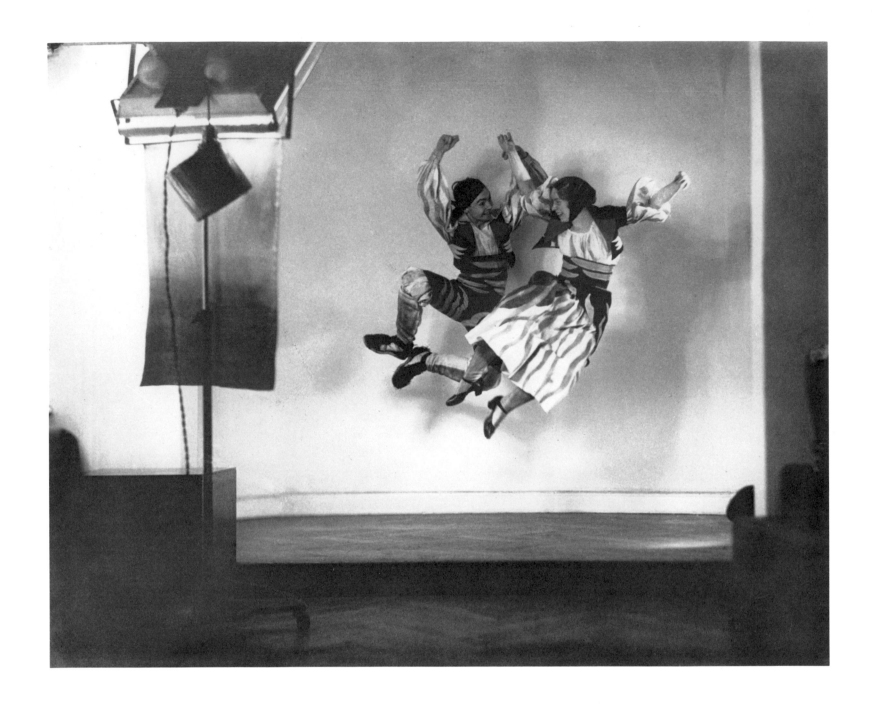

ALEX VON SWAINE and Partner, Dancers, Berlin, ca. 1930

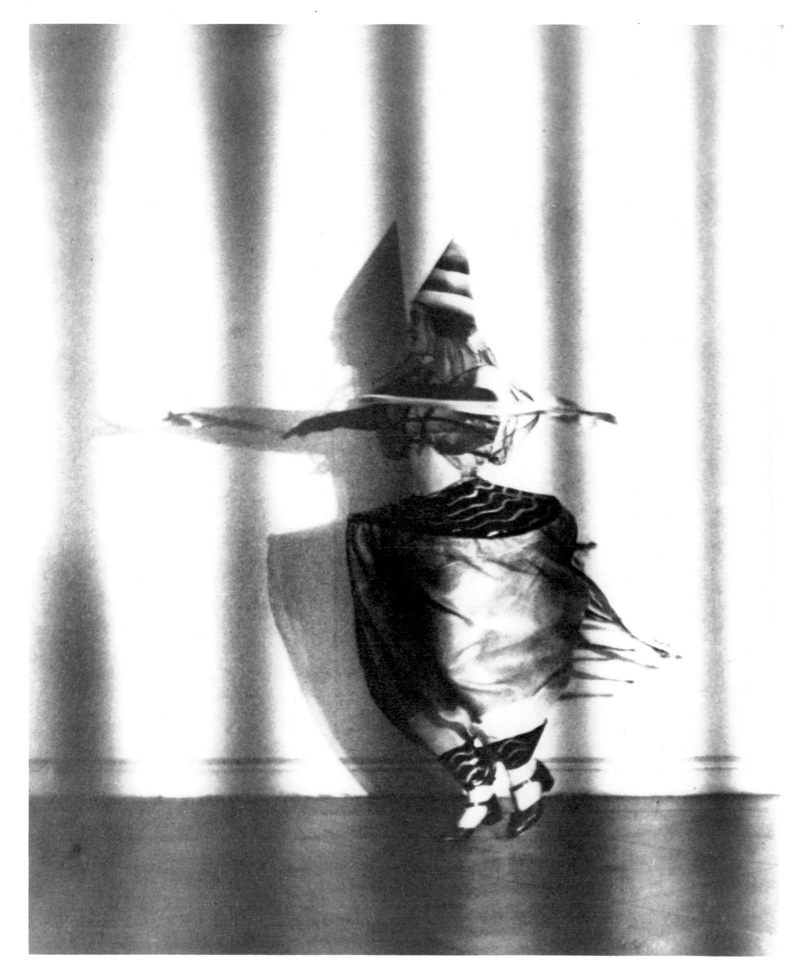

LIESELOTTE FELGER, Dancer, Berlin, ca. 1930

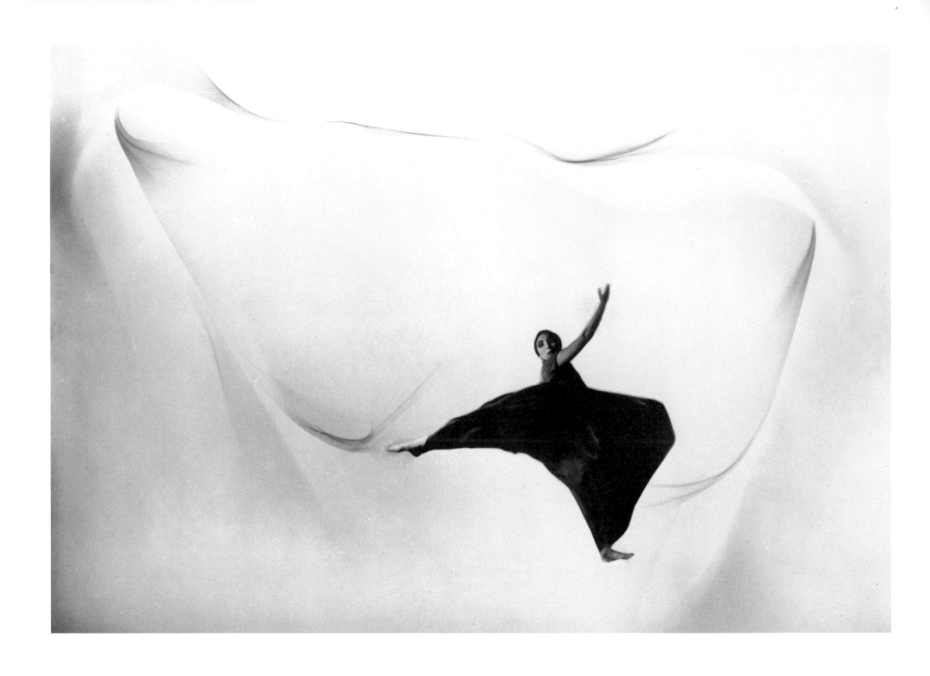

PAULINE KONER, Dancer, New York, ca. 1937

Photogenics

Most *Photogenics* were made in New York
between 1946 and 1955

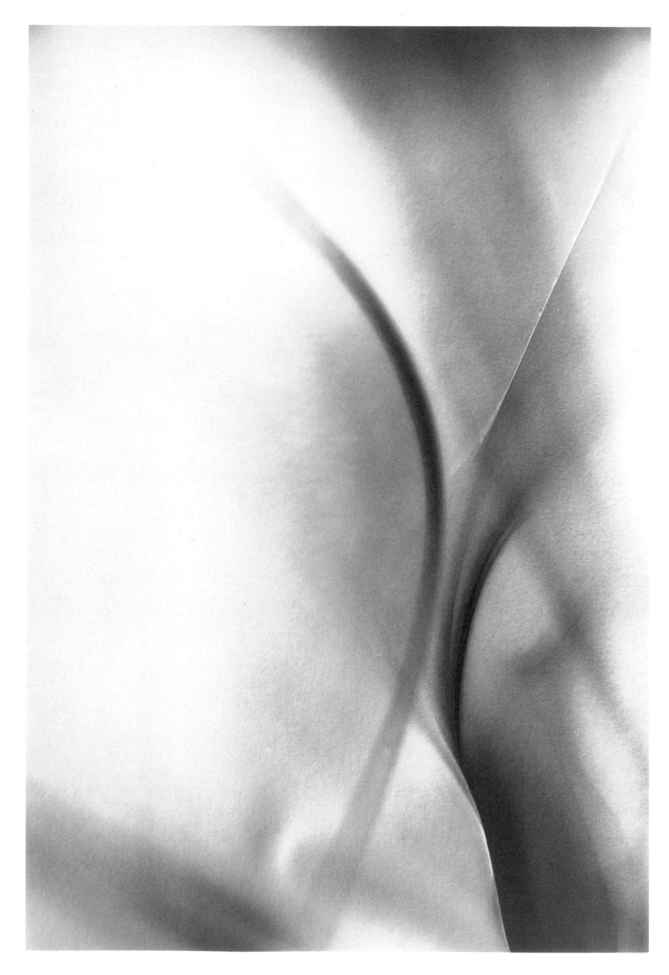

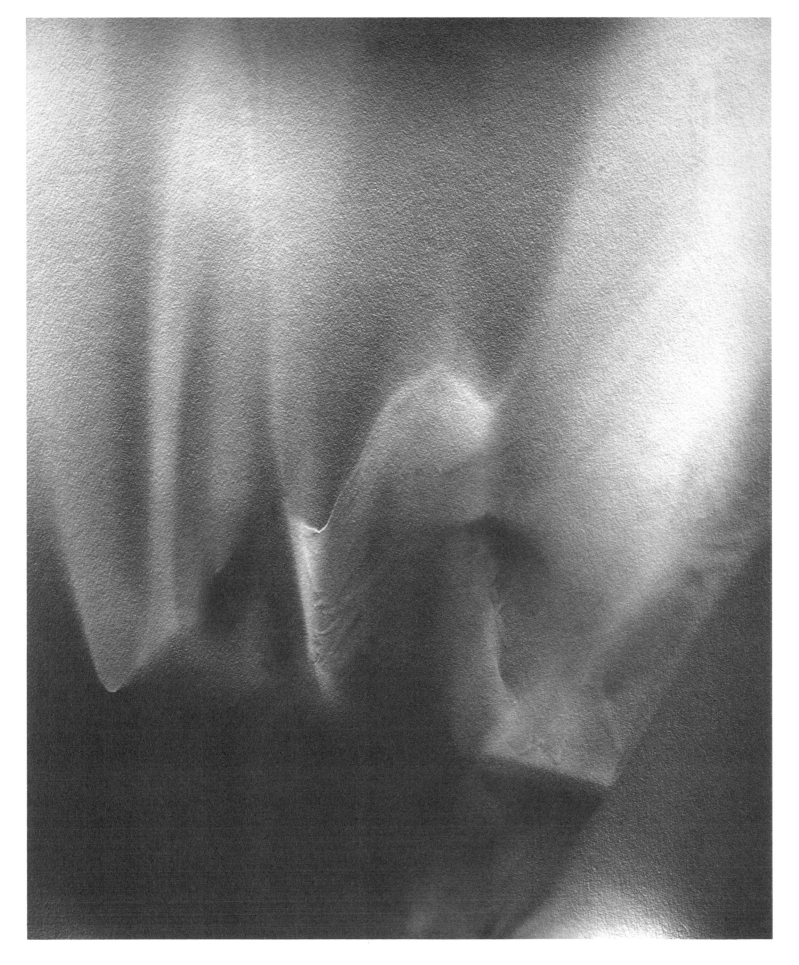

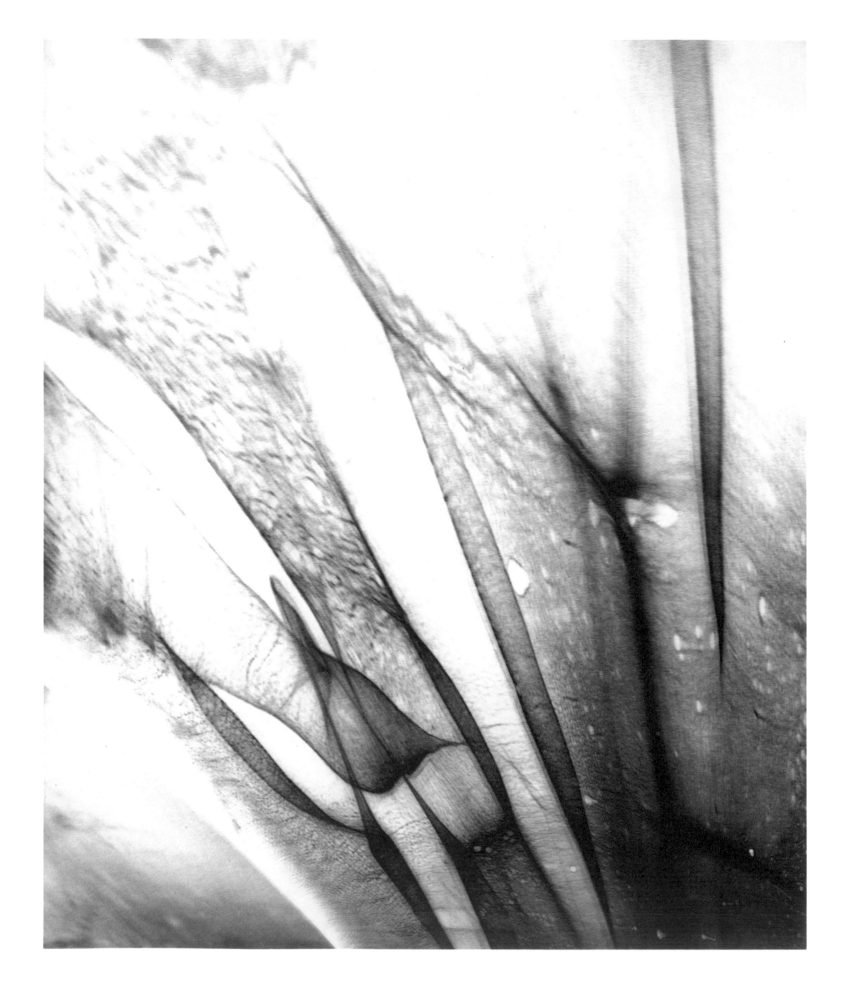

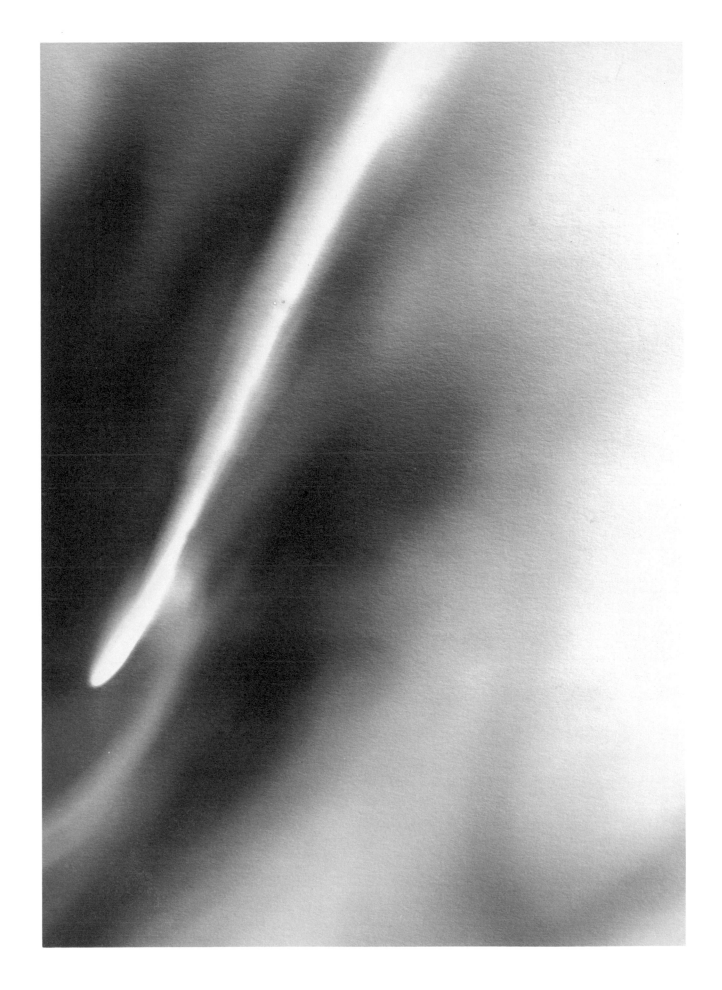

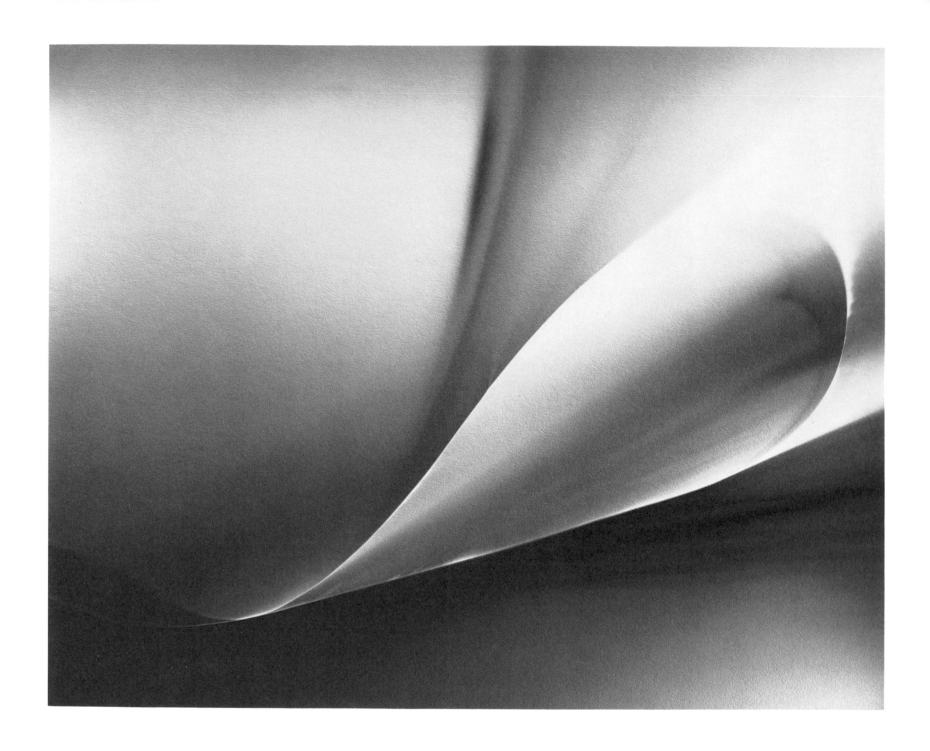

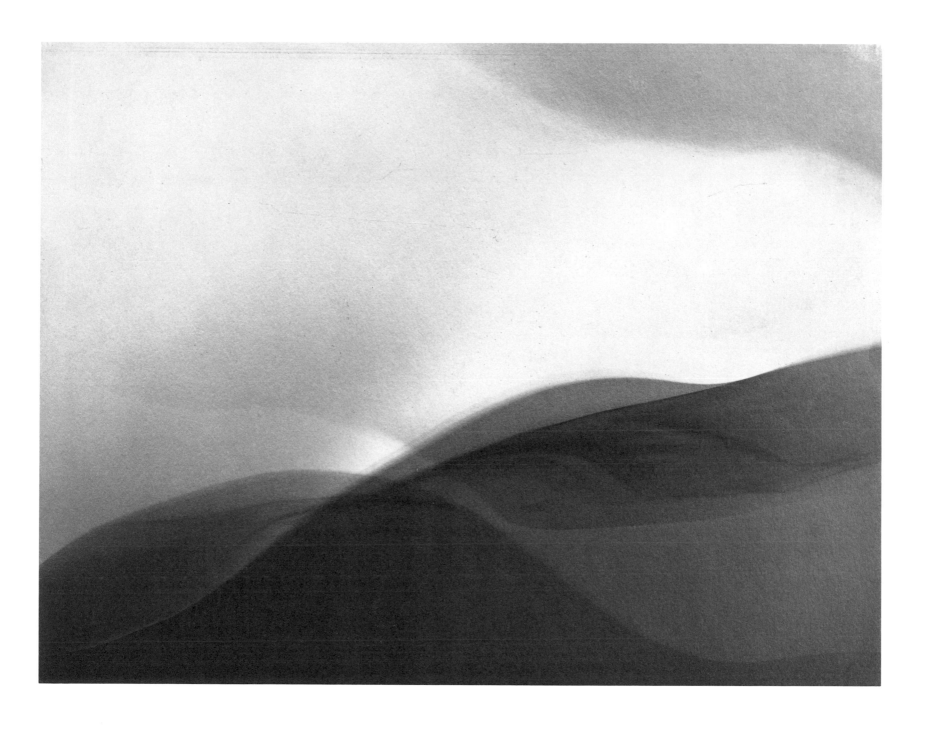

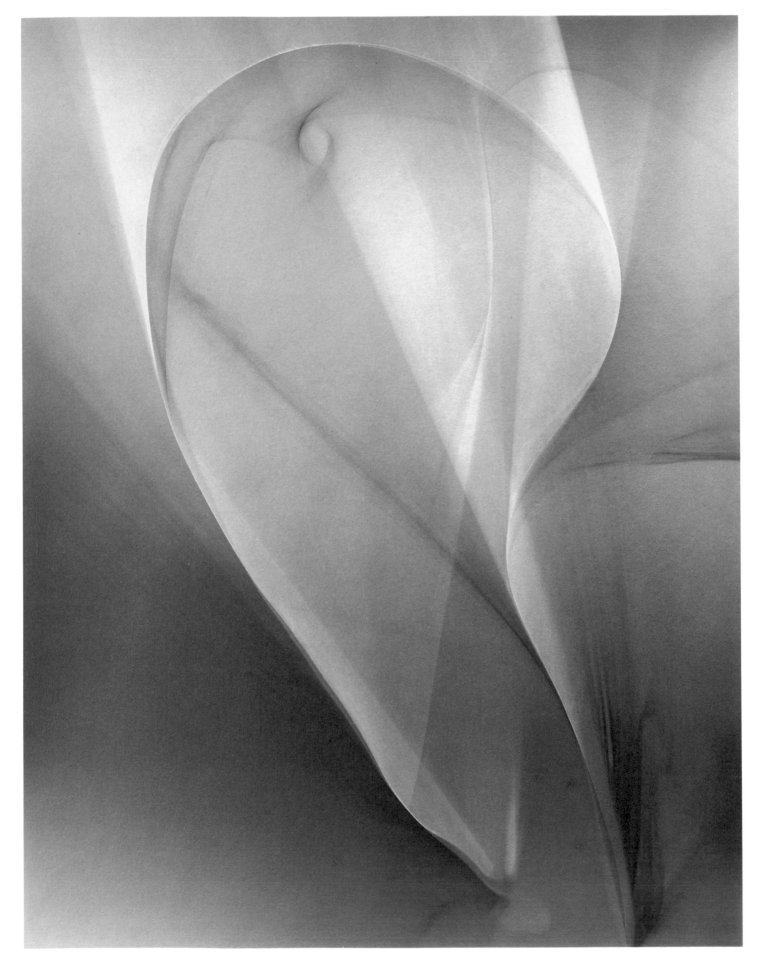

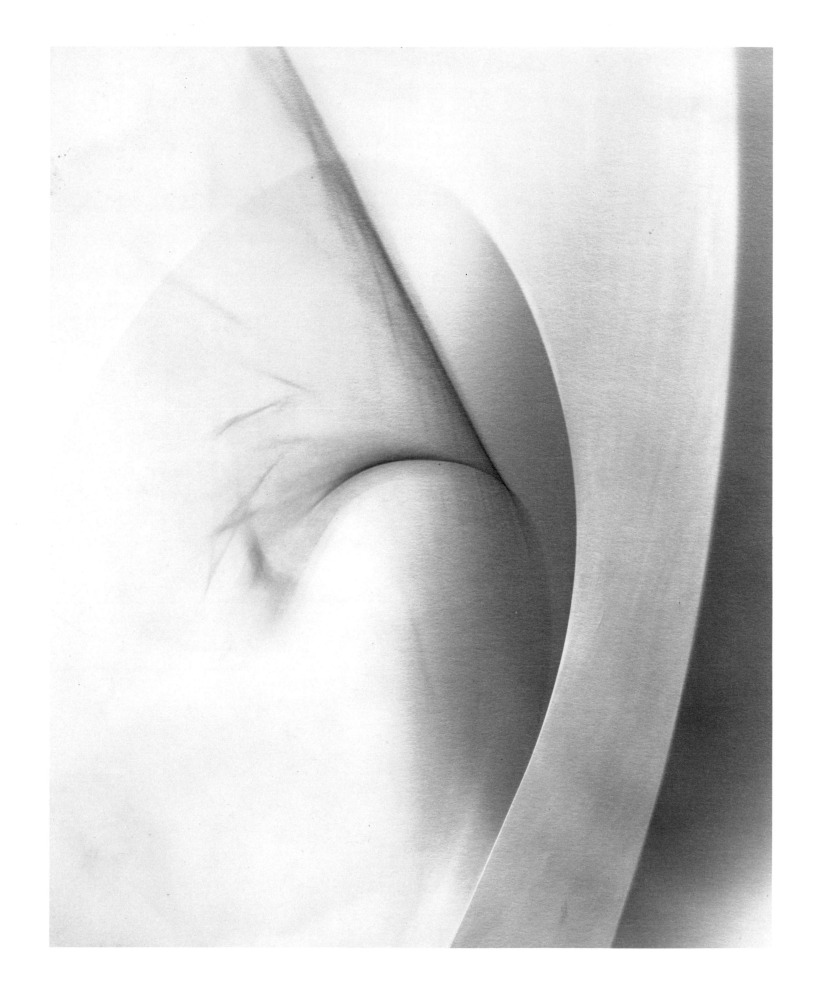

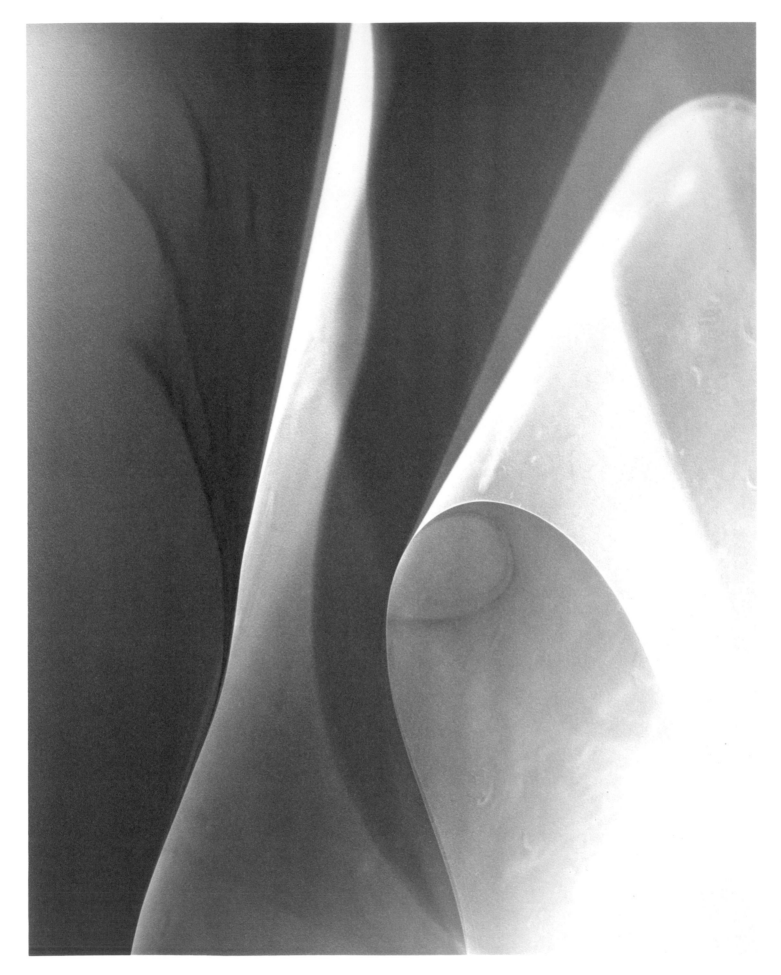

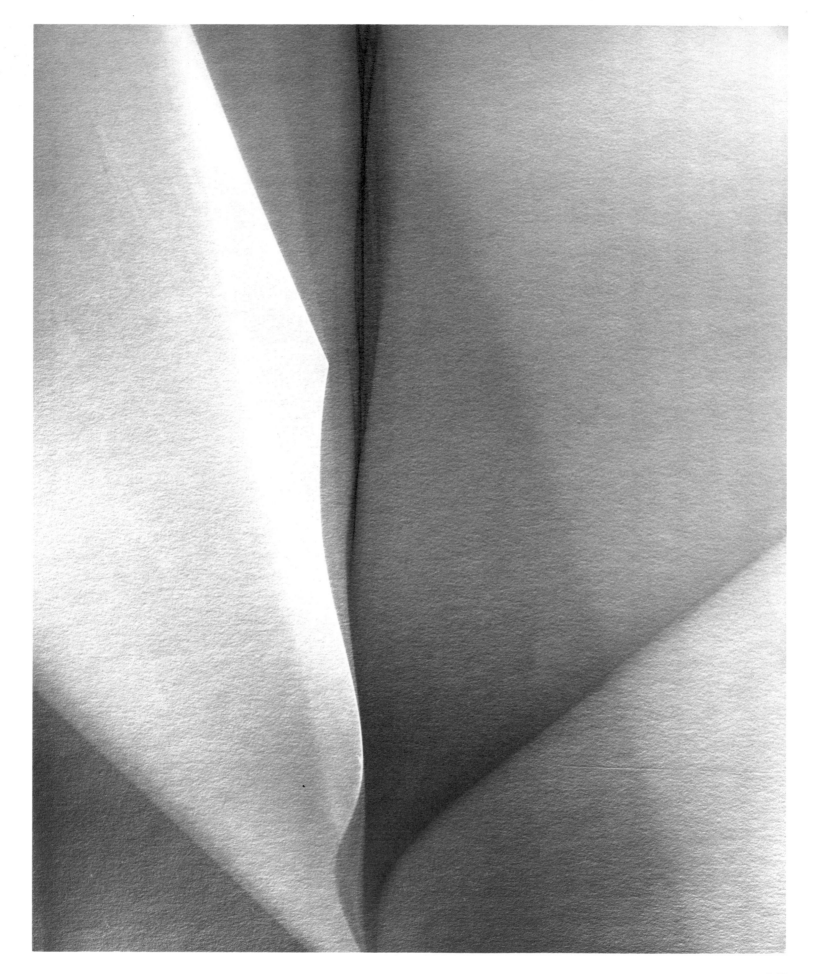

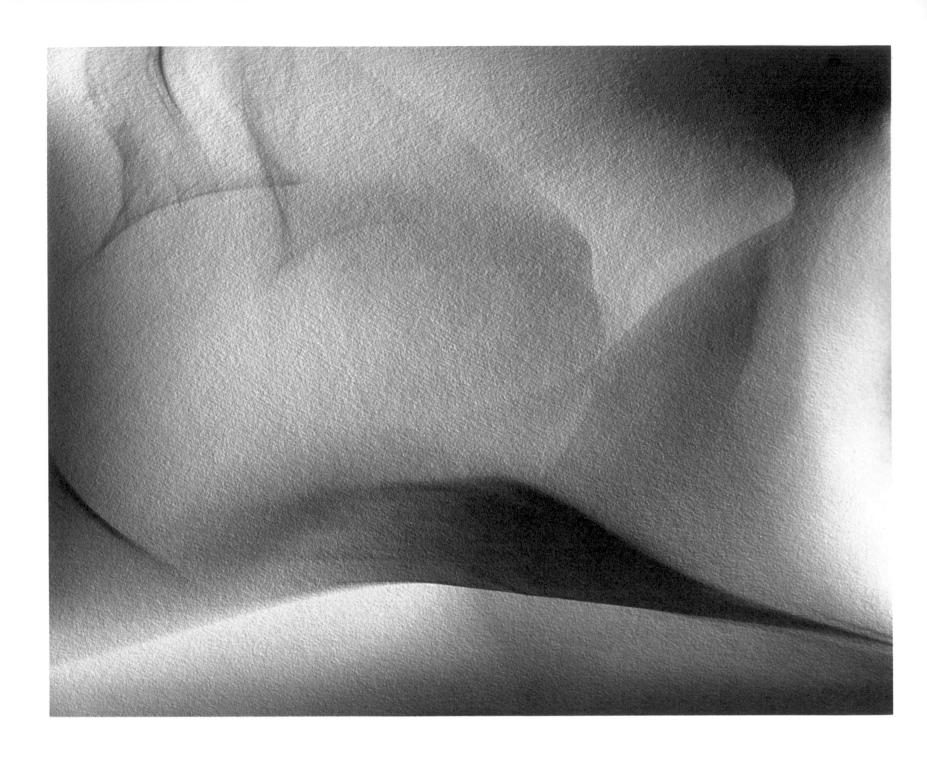

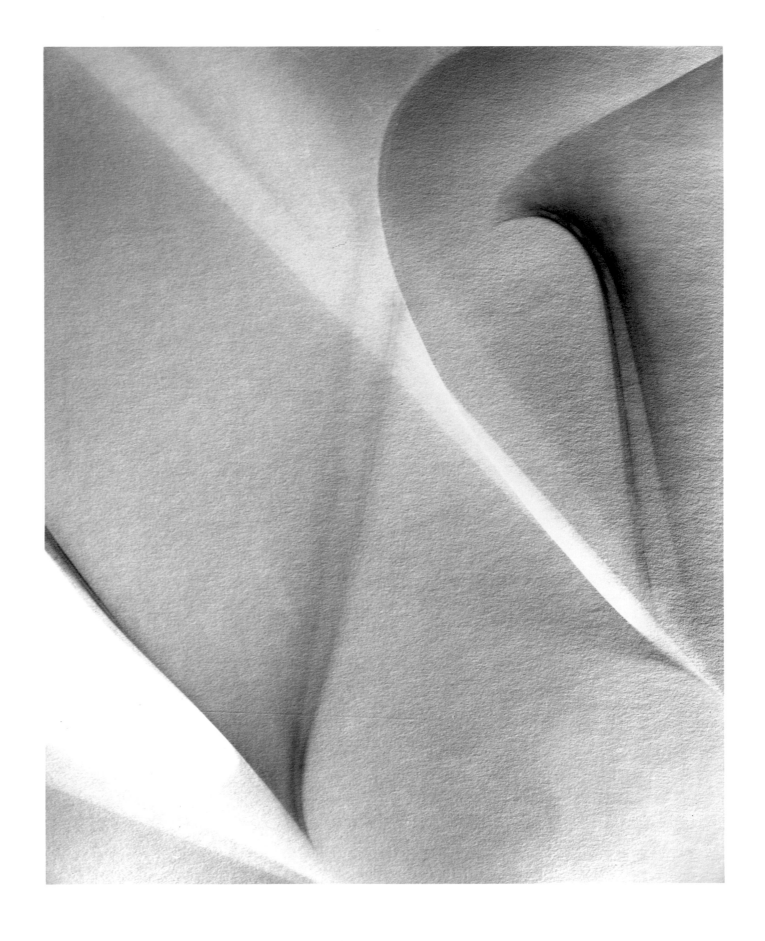

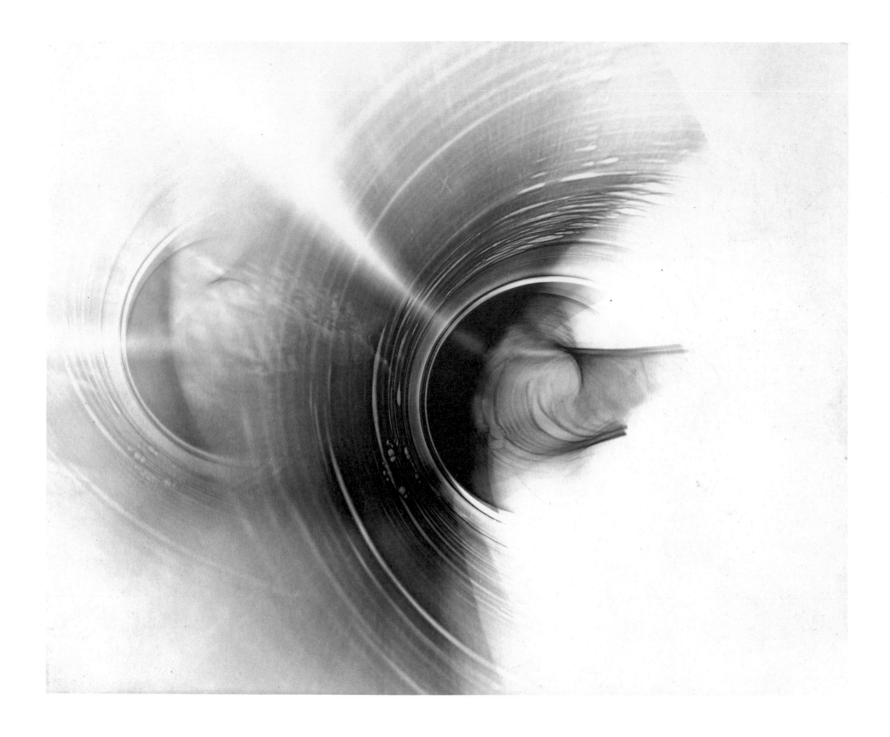

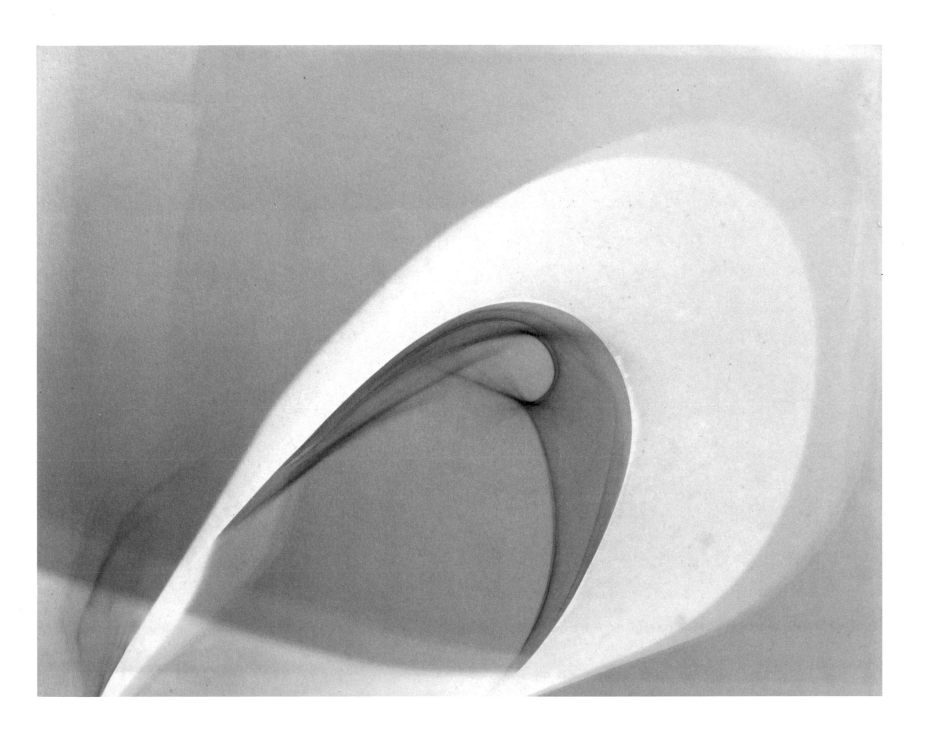

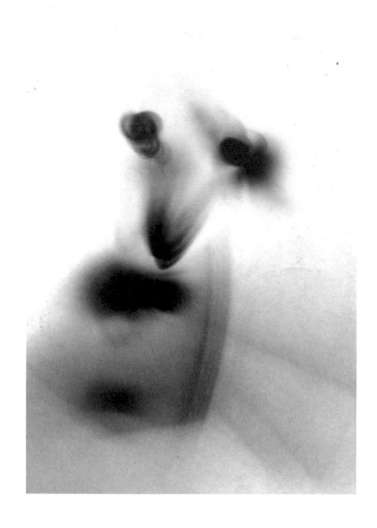

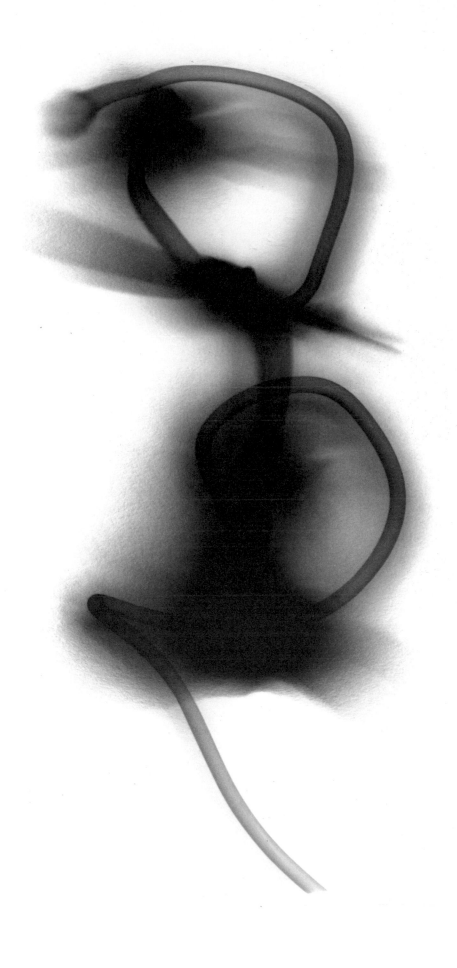

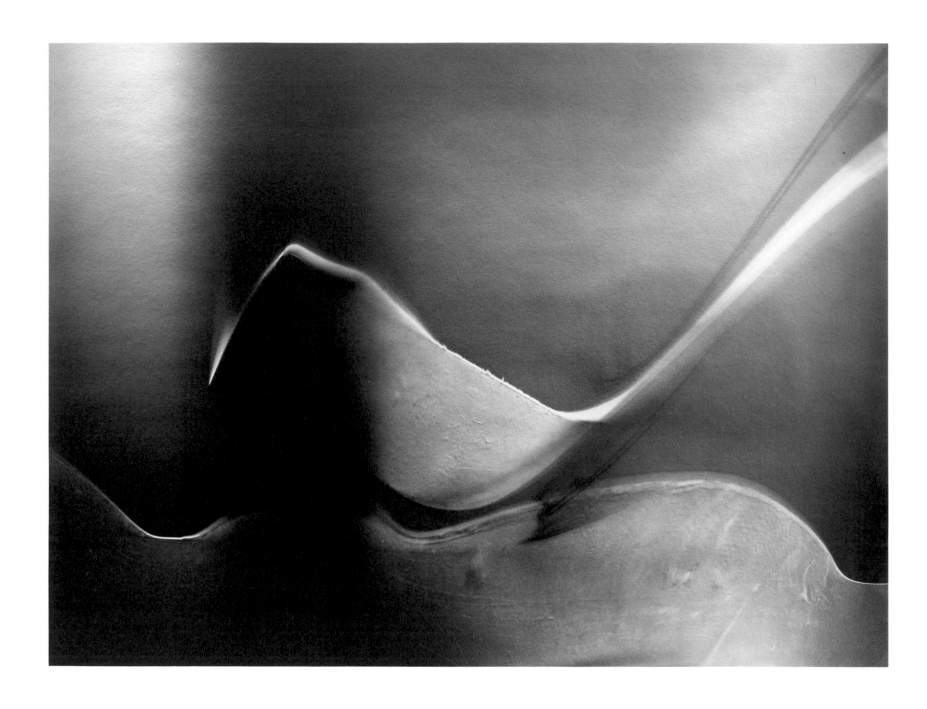

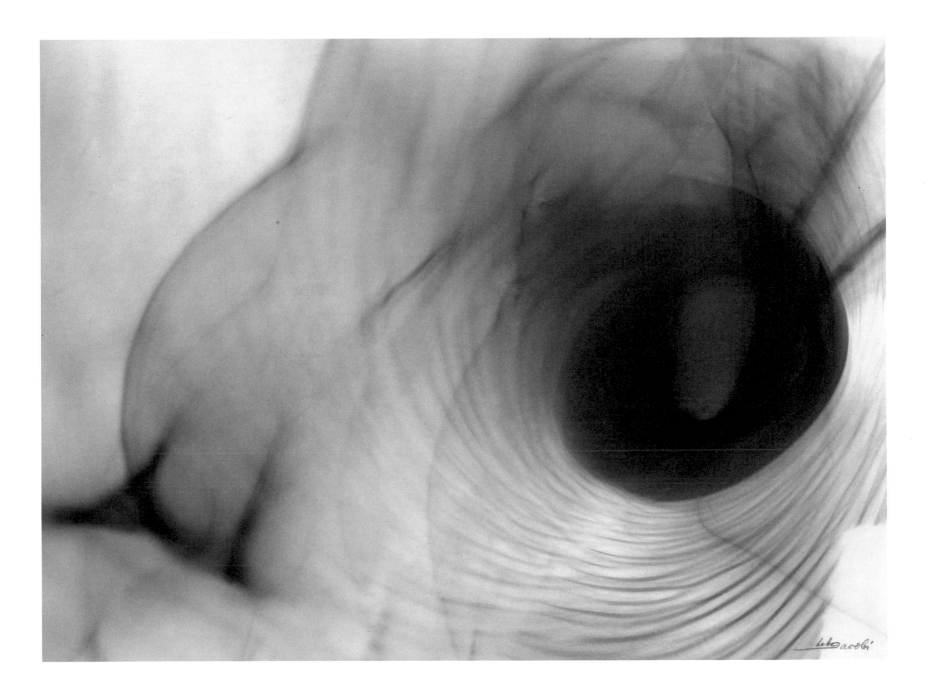

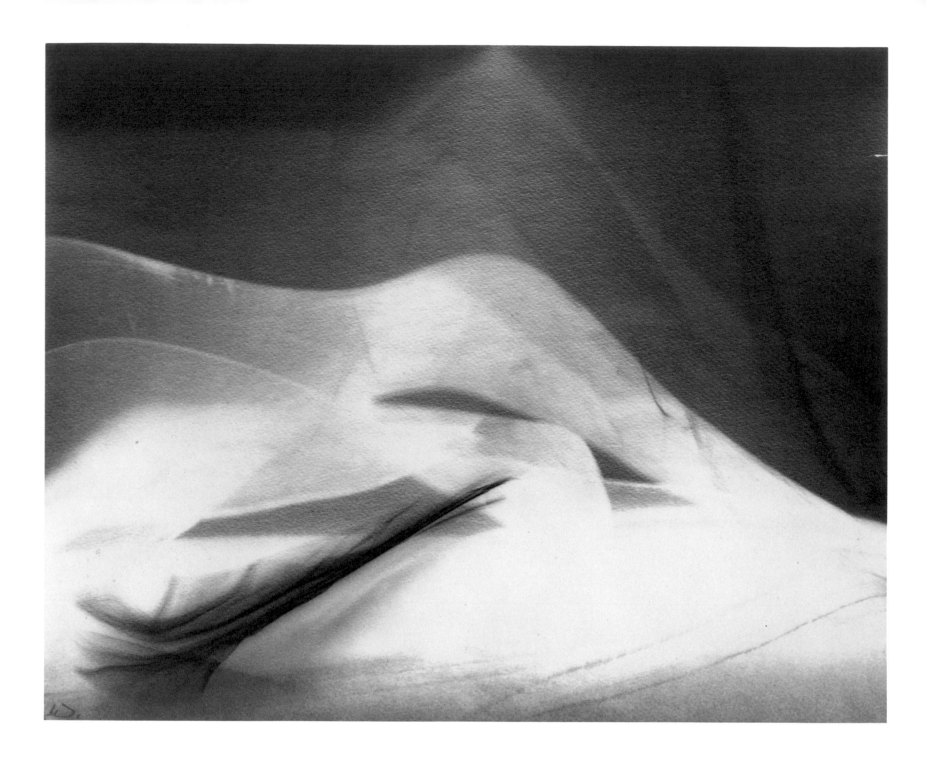

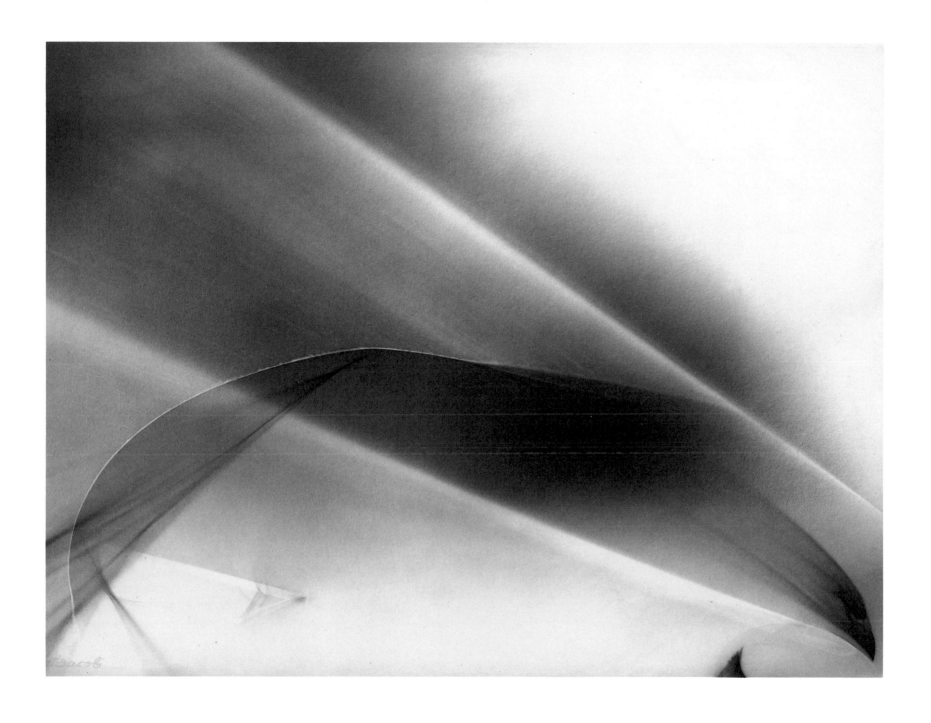

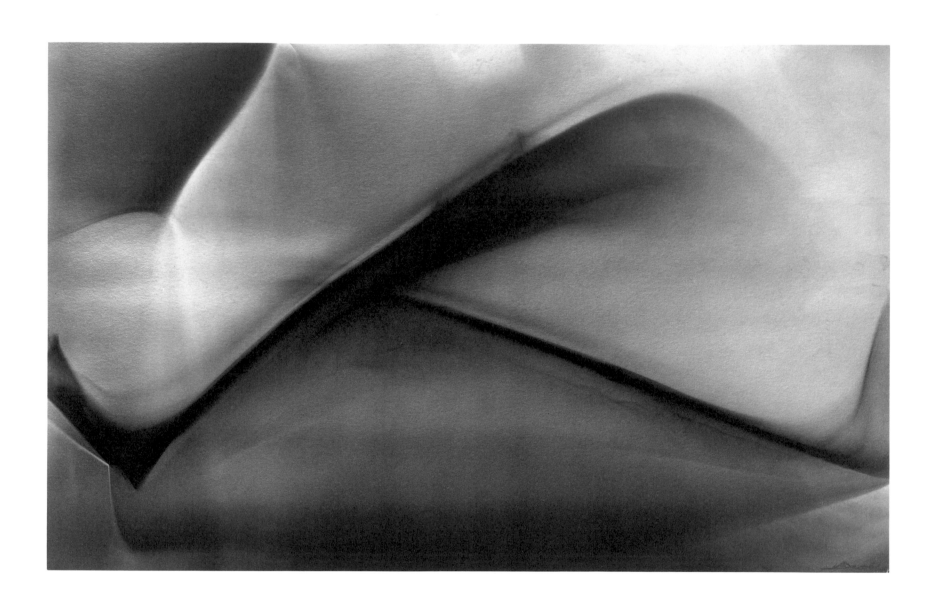

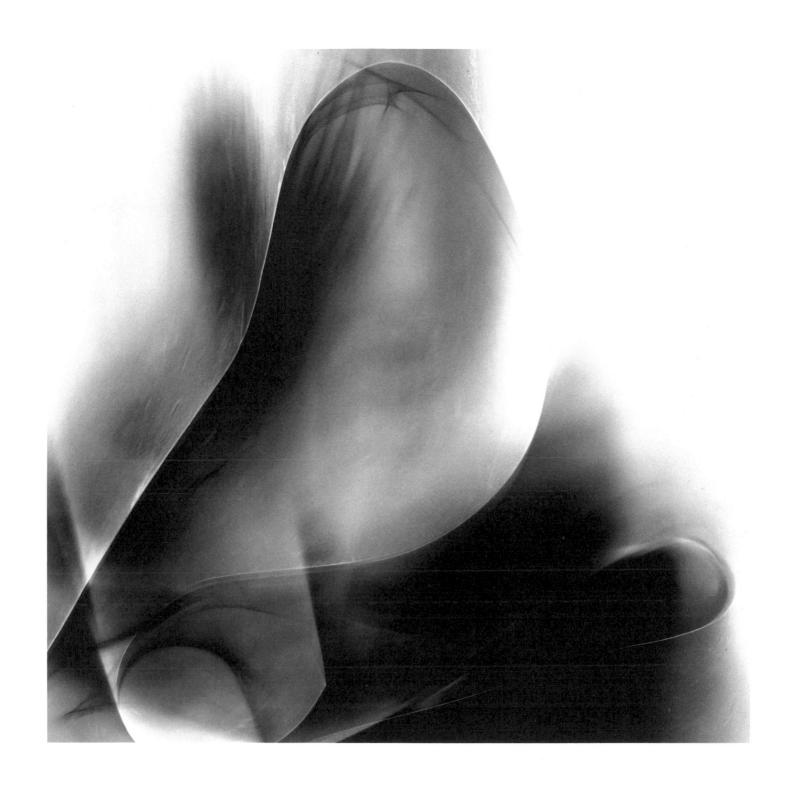

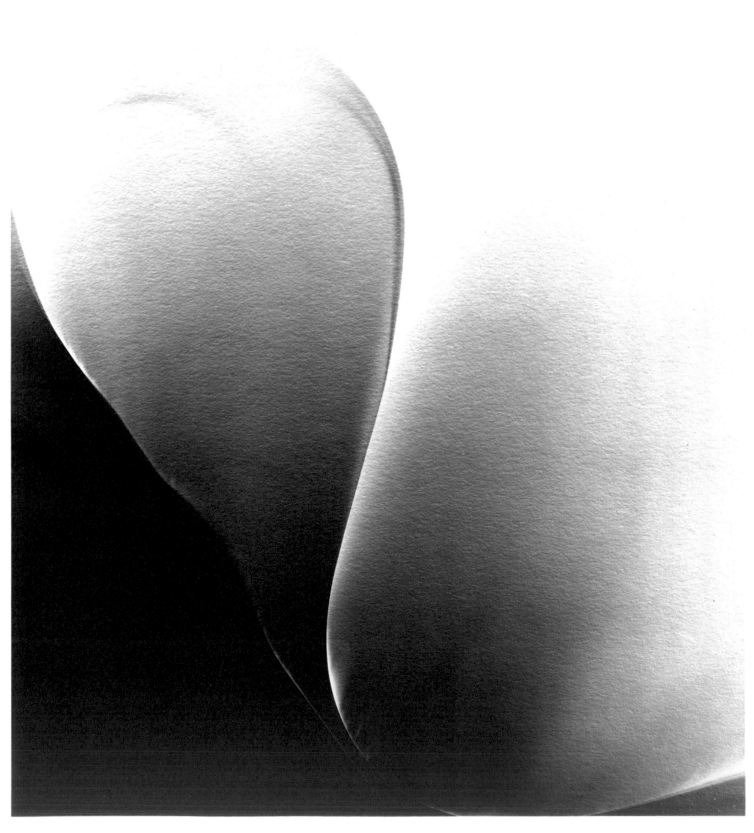

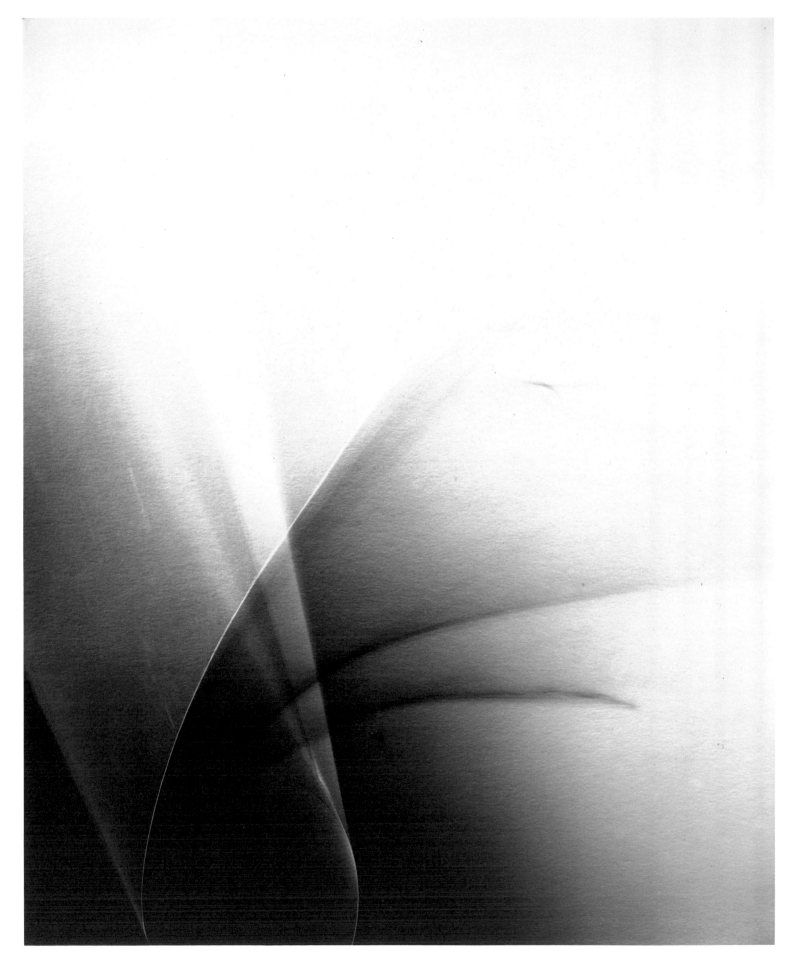

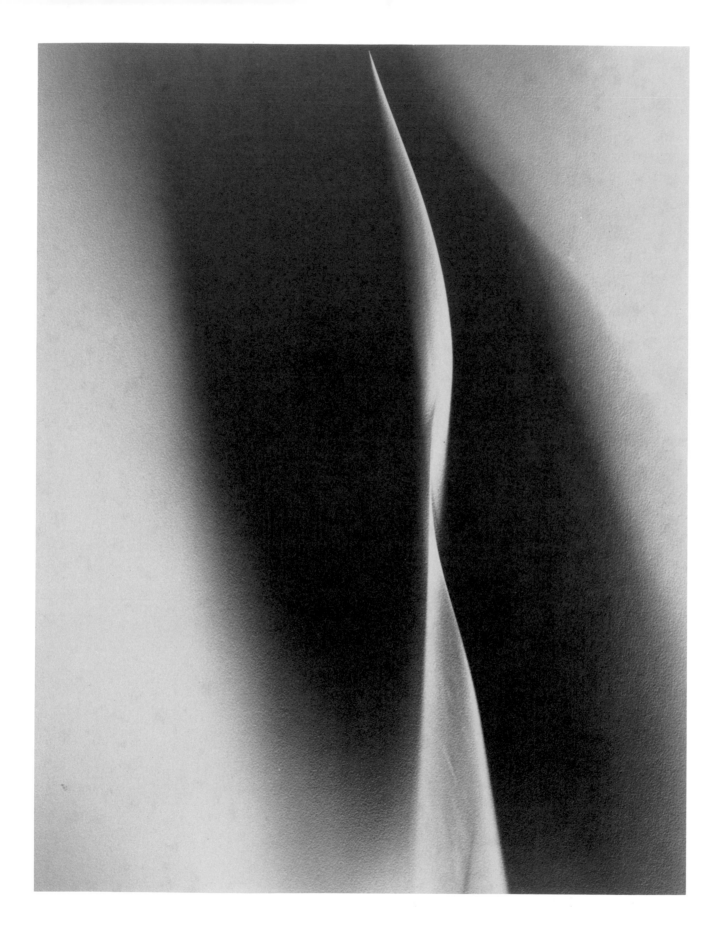

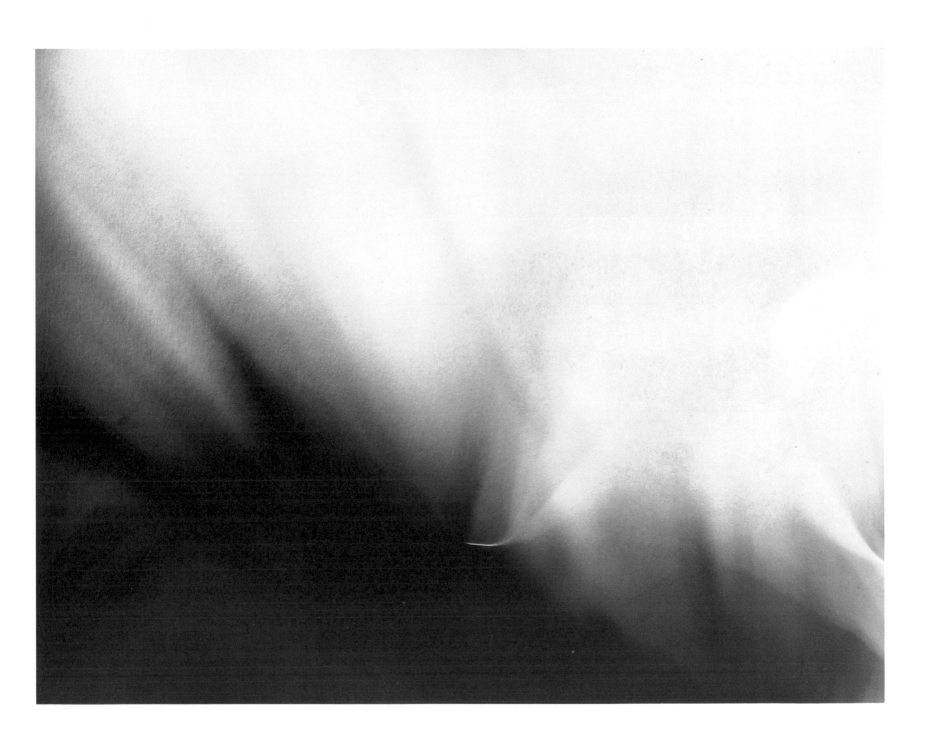

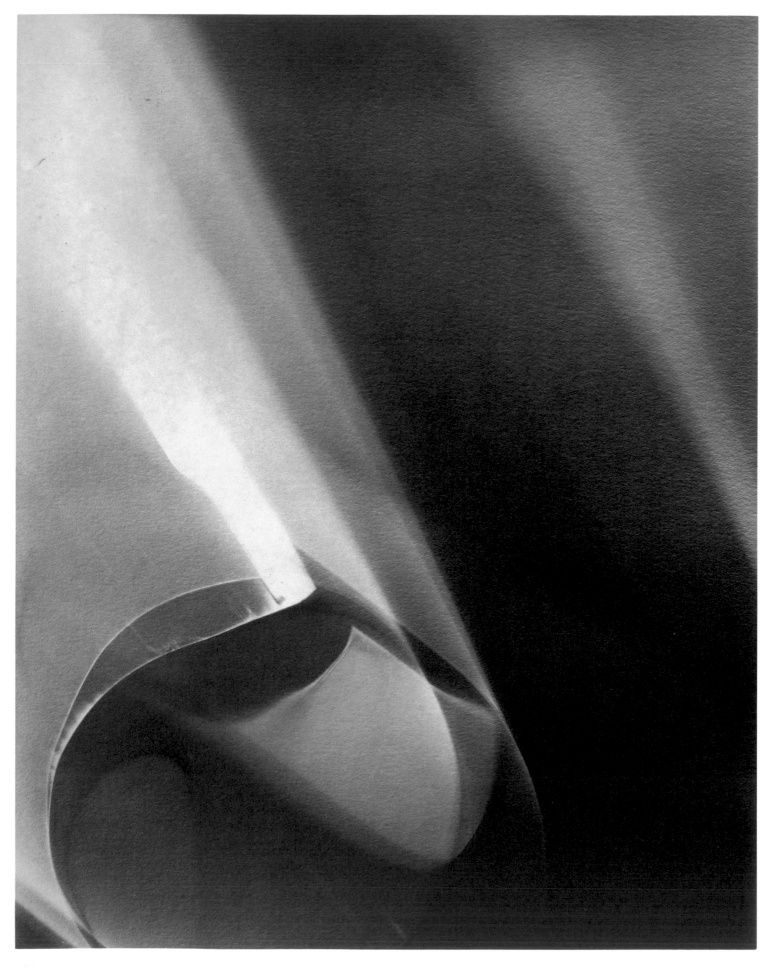

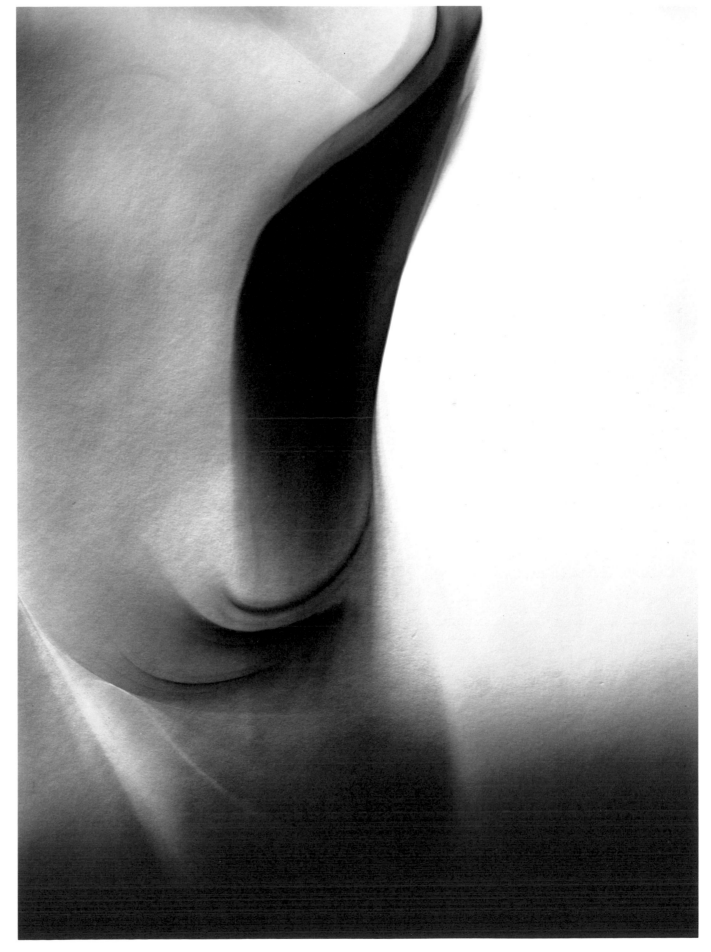

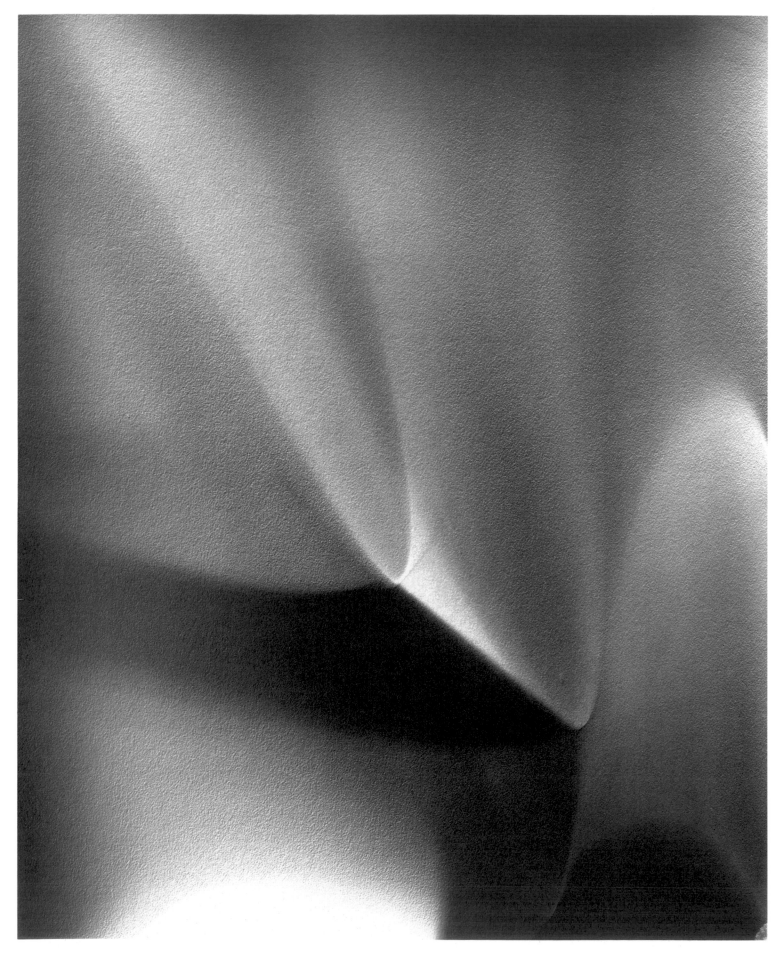

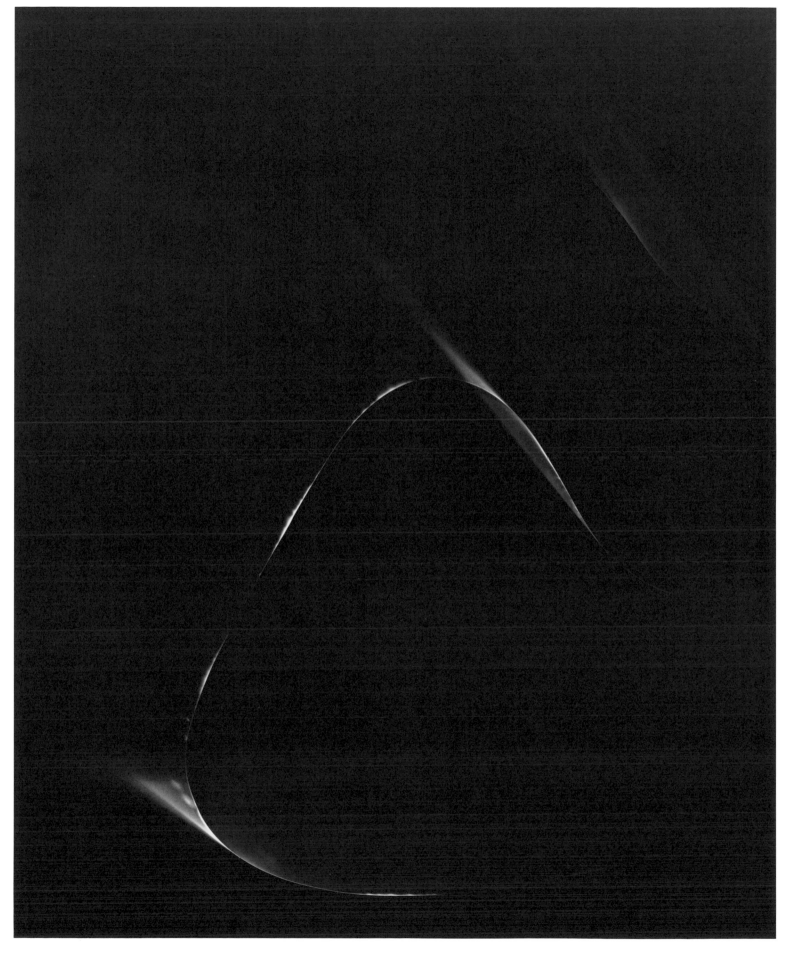